Painting the Towns

MURALS OF CALIFORNIA

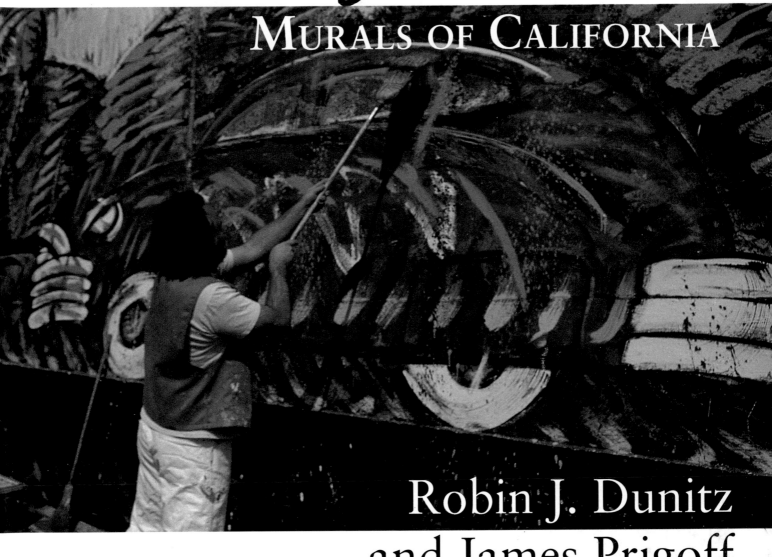

Robin J. Dunitz
and James Prigoff

RJD Enterprises Los Angeles

In memory of Sydney J. Dunitz (1917-1997)

RJD Enterprises
Post Office Box 64668
Los Angeles, California 90064

Publisher's Cataloging-in-Publication Data
Dunitz, Robin J. and James Prigoff
 Painting the towns: murals of California / by
Robin J. Dunitz and James Prigoff.
 p. cm.
 Includes bibliographical references and index.
 ISBN: 0-9632867-4-2 (pbk.)
 ISBN: 0-9632867-5-0 (cloth)
 1. Public art–California. 2. Ethnic art–
California. 3. Travel–California.
I. Title.
N756.4 D918-1 1997

 92169

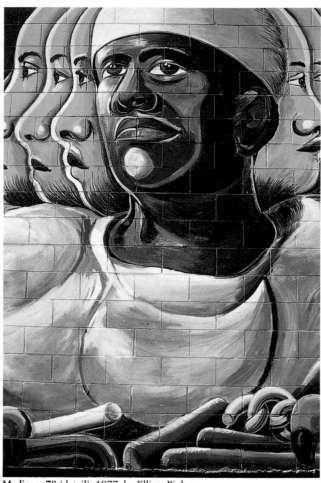

Medicare 78 (detail), 1977, by Elliott Pinkney,
920 South Alamada, Compton.

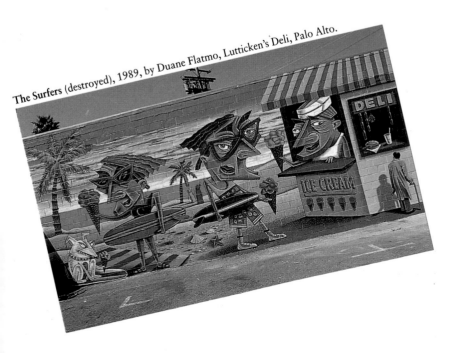

The Surfers (destroyed), 1989, by Duane Flatmo, Lutticken's Deli, Palo Alto.

Front cover mural:
Street of Eternity (Calle de Eternidad)
by Johanna Poethig
© 1993 by the Social and Public Art Resource Center
All rights reserved.

Back cover mural:
Maestrapeace,
© 1994 by Juana Alicia, Miranda Bergman,
Edythe Boone, Susan Cervantes,
Meera Desai, Yvonne Littleton,
Irene Pérez.
All rights reserved.

Title page mural:
Going to the Olympics (detail), 1984,
by Frank Romero (pictured),
Hollywood Freeway (101) at San Pedro Street,
Downtown Los Angeles.

CONTENTS

Aztec Pride, 1992, by José de la Cruz with youth, 14958 Delano Street, Van Nuys (Los Angeles).

Tuzuri Watu (We Are a Beautiful People), 1987, by Brooke Fancher, 4900 Third Street at Palau, Hunter's Point, San Francisco.

CALIFORNIA

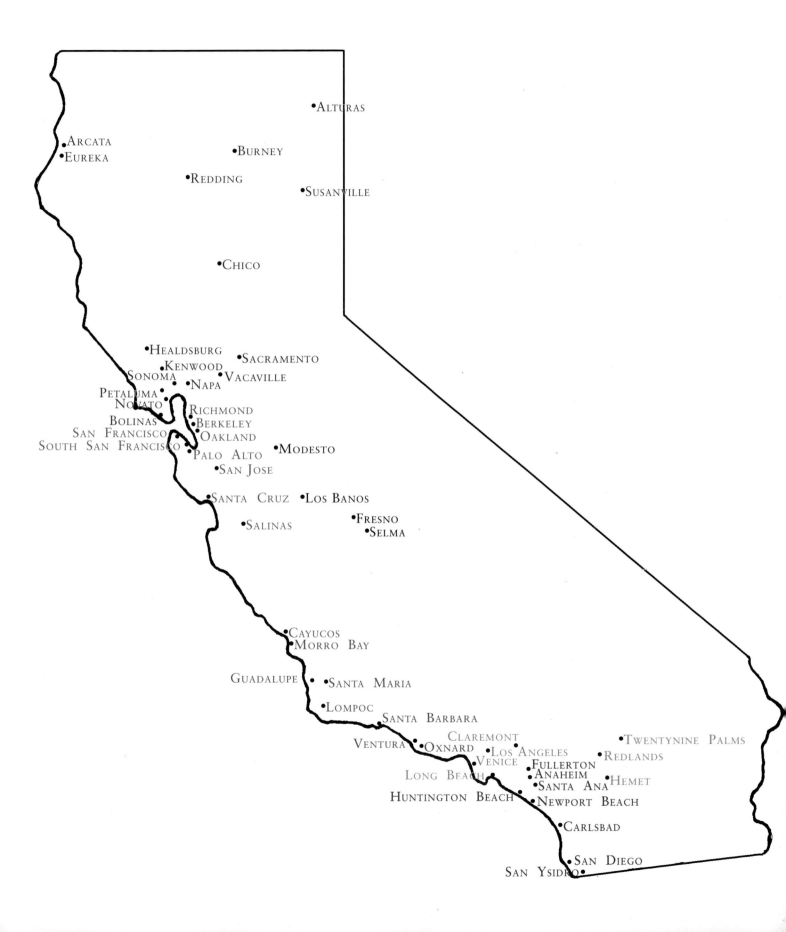

- Alturas
- Arcata
- Eureka
- Burney
- Redding
- Susanville
- Chico
- Healdsburg
- Sacramento
- Kenwood
- Sonoma
- Vacaville
- Napa
- Petaluma
- Novato
- Richmond
- Bolinas
- Berkeley
- San Francisco
- Oakland
- South San Francisco
- Palo Alto
- Modesto
- San Jose
- Santa Cruz
- Los Banos
- Salinas
- Fresno
- Selma
- Cayucos
- Morro Bay
- Guadalupe
- Santa Maria
- Lompoc
- Santa Barbara
- Claremont
- Twentynine Palms
- Ventura
- Oxnard
- Los Angeles
- Redlands
- Venice
- Fullerton
- Long Beach
- Anaheim
- Hemet
- Santa Ana
- Huntington Beach
- Newport Beach
- Carlsbad
- San Diego
- San Ysidro

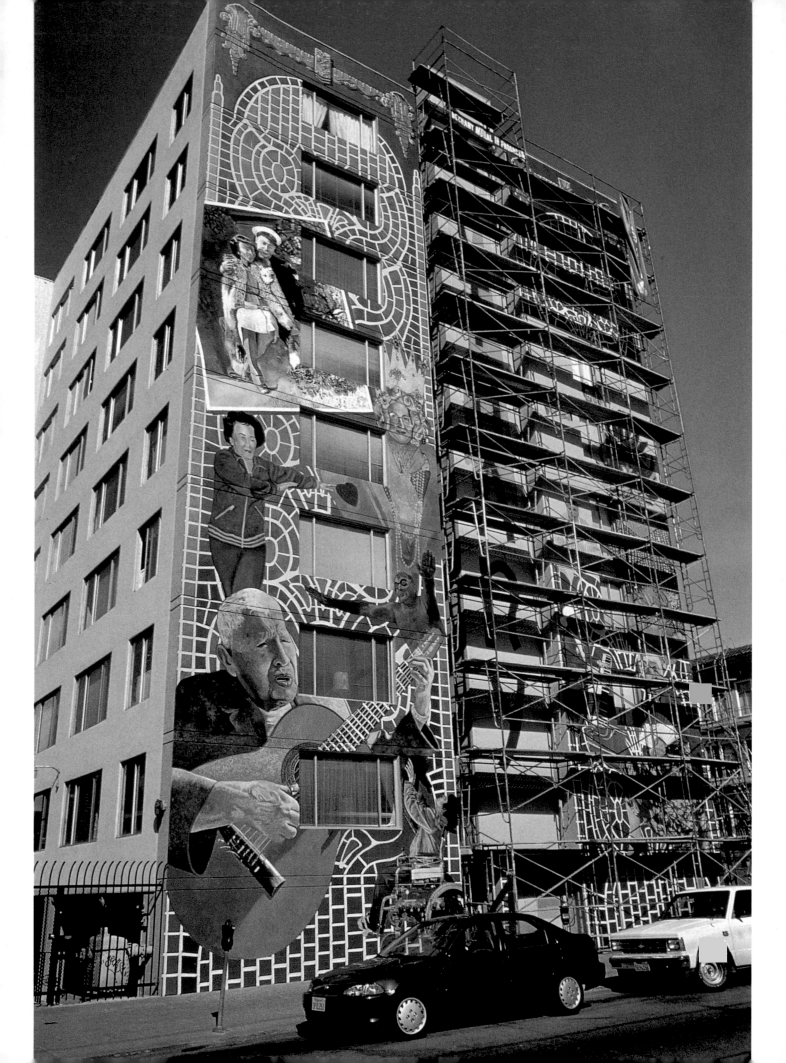

Salud! (in progress), 1997,
by Dan Fontes (assisted by Isabel Graeser),
Bethany Senior Center,
21st Street and Capp Street,
Mission District, San Francisco.

California's mural tradition dates back hundreds of years, before Europeans first landed on its shores, back to a time when native peoples, such as the Chumash and Yokuts, used cave walls and other rock surfaces as giant canvases for their rituals and beliefs. Later, when the Spanish began building missions along California's coast, artists painted decorative designs and religious murals on many of the adobe walls.

The Mexican Influence

In 1920, after the revolutionary overthrow of dictator Porfiro Diaz, the progressive Mexican government under Alvaro Obregón, through the efforts of Dr. Atl, initiated a mural program to promote a new national identity centered around the peasants, Indians and working class. Diego Rivera, David Alfaro Siqueiros, José Clemente Orozco (*Los Tres Grandes*) and others were hired to cover public walls in Mexico City and elsewhere with powerful panoramas capturing the revolutionary spirit. These murals became a focal point of national pride and an important tool for educating the Mexican people. Many U.S. artists, including Californians Bernard Zakheim, Henrietta Shore and Victor Arnautoff, spent time in Mexico studying mural techniques and/or assisting on mural projects. Charles White, who moved to southern California in 1956, lived for almost a year (1947-48) in the home of Siqueiros while working at the famous Taller de Gráfica Popular and studying at the Esmeralda School of Painting. Dewey Crumpler, Judy Baca and Ray Patlán studied in Mexico in the 1970s.

During the 1930s, Rivera, Siqueiros and Orozco all came to California to paint murals. Siqueiros taught at Chouinard Art School in Los Angeles while painting his Olvera Street mural (**América Tropical**) in 1932. Among his students/assistants were Millard Sheets, Paul Sample and Barse Miller. **América Tropical** was censored and whitewashed shortly after it was painted and has remained covered for 65 years.

Maxine Albro, Clifford Wight and Marion Simpson worked with Rivera on his San Francisco murals. Lucienne Bloch and Stephen Dimitroff assisted him on his mural projects in Detroit (Detroit Institute of Arts) and New York City (Rockefeller Center—censored and destroyed). While in the United States, Orozco also painted murals at Dartmouth College in New Hampshire and in New York City at the New School for Social Research.

When the Great Depression hit the United States in the early 1930s, artists were among those most affected. George Biddle, artist and former classmate of President Franklin Roosevelt, wrote a letter to FDR suggesting the U.S. government employ artists to create art for public buildings nationwide. Biddle's inspiration came from his experience as a mural apprentice in Mexico. As quoted in Francis O'Connor's book on the New Deal art projects, **Federal Art Patronage, 1933-1943**, Biddle wrote to FDR in early 1933:

The Mexican artists have produced the greatest national school of mural painting since the Renaissance. Diego Rivera tells me that it was only possible because Obregón allowed Mexican artists to work at plumber's wages in order to express on the walls of the government buildings the social ideals of the Mexican Revolution. The younger artists of America are conscious as they never have been of the social revolution that our country and civilization are going through; and they would be very eager to express these ideals in permanent art form if they were given the government's cooperation.

The New Deal Art Programs

Although inspired by the Mexican government's mural program, the New Deal artists seldom painted with the revolutionary spirit of their counterparts across the border. Except for a handful of Social Realist exceptions–such as a few of the Coit Tower murals in San Francisco, other work by Coit Tower artist Bernard Zakheim, and Charles Kassler's Beverly Hills Post Office murals–the vast majority of California's New Deal wall art gave little hint of the hard times facing so many people during the Depression, nor did they address the issues raised by this unprecedented disaster. The Regionalist trend promoted by the Roosevelt administration exerted a much stronger influence on the state's artists. As a result most federally sponsored murals from this era feature bucolic landscapes, idealized images of local history and scenes of white middle-class Americans enjoying their fun in the sun.

In December 1933, the Public Works of Art Project (PWAP), the first of five federally funded art projects, was launched. The PWAP sponsored 400 murals during its brief seven-month existence. San Francisco's Coit Tower murals were done under the PWAP's auspices. Probably the PWAP's most significant contribution was in demonstrating the viability of a government-sponsored art program that paid impoverished artists craft workers' wages to decorate public buildings. It became a model for the projects that followed.

In Fall 1934, Treasury Secretary Henry Morganthau created the Section of Painting and Sculpture within his department. It was later renamed the Section of Fine Arts. Most of the post office murals painted between 1933 and 1943 were done under the auspices of the "Section," including more than 60 throughout California. Of the five federal art projects created during the 1930s, only the Section chose artists based on artistic merit, often through anonymous competitions. The others were primarily relief programs, set up to provide jobs.

In May 1935, Congress created the Works Progress Administration, which then set up several other agencies to employ the unemployed. Among these were the Federal Art Project (FAP), largest of the New Deal art programs, and the Treasury Relief Art Project (TRAP). Under the FAP alone, 2,500 murals were produced for schools, libraries, city halls and other public sites.

All the federal art projects came to a sudden end in 1943, after the United States entered World War II. Quite simply, arts funding was diverted to build a war machine. Although the Treasury's Section on Fine Arts was intended to be a permanent program, it too closed down.

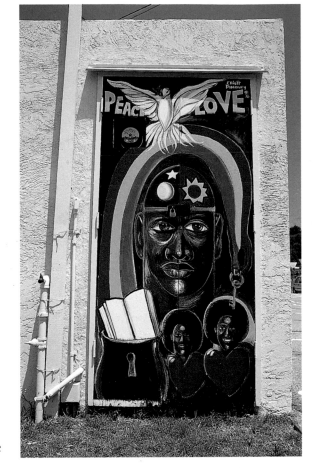

Opposite page: **The Story of Venice** (detail), 1941, by Edward Biberman, Venice Post Office, 1601 Main Street, Venice (Los Angeles).

Right: **Peace and Love**, 1976, by Elliott Pinkney, Watts Towers Arts Center, 1727 East 107th Street, Watts (Los Angeles).

The Birth of the Community Mural Movement

Between 1943 and 1967, relatively few artists continued to paint murals in the United States. Probably the vast majority of those who painted were sponsored by colleges or private businesses. Beginning in the early 1950s, John Biggers developed an entire curriculum teaching mural painting at Texas Southern University. In 1952, Millard Sheets began designing the architecture and murals (painted and mosaic) for Home Savings and Loan Association. During his 30-year career, Sheets, often in collaboration with Susan Hertel and Denis O'Connor, created close to 80 murals for Home Savings offices in California, primarily around themes of regional history.

In 1967, murals hit the inner city streets with Chicago's **Wall of Respect** and **Wall of Truth**. Their message of Black pride wasn't new, as African-American colleges in the southern United States had been sponsoring powerful wall art (primarily inside buildings) since the early 1930s. But during the late 1960s and early 1970s, artists inspired by the political and social struggles shaking the country turned urban walls into canvases.

The 1960s and 1970s in California

It was on the United Farmworkers' Teatro Campesino Center in Del Rey, California, about 13 miles southeast of Fresno, that one of the earliest Chicano murals was painted by social worker Antonio Bernal in 1968. A procession of pre-Columbian rulers headed by a woman was painted on the first of two panels. The second panel showed admired leaders from the Mexican Revolution to the 1960s. La Adelita, a revolutionary woman soldier, was in front, followed by Pancho Villa, Emiliano Zapata, Joaquin Murieta (an outlaw-hero on the U.S. side of the border), César Chavez, López Tijerina of the New Mexico land grant movement, a Black Panther (sometimes labeled Malcolm X) and Martin Luther King, Jr.

Beginning in the late 1960s, artists and community activists all over California organized grassroots arts organizations and collectives to contribute to the movement for social change.

In 1969, in the San Francisco Bay area, Manuel Hernández-Trujillo, Malaquias Montoya,

Esteban Villa and René Yanez founded the Mexican-American Liberation Art Front (MALAF).

That same year Esteban Villa and José Montoya (brother of Malaquias) joined together with their students at Sacramento State University to form the Rebel Chicano Art Front (RCAF). Later the group became more popularly known as the Royal Chicano Air Force.

The RCAF painted many murals in Sacramento, funded in part by CETA (a job training program under the Carter Administration).

Untitled (detail), 1977,
by the Royal Chicano Air Force,
Southside Park, Sacramento.

In 1975, three RCAF women, Rosalinda Palacios, Antonia Mendoza and Celia Rodriguez, did a mural at Chicano Park in San Diego after their return from the First International Women's Conference in Mexico City.

In 1971, René Yanez, of Galéria de la Raza in San Francisco, brought together a team of artists, through a grant from the STEP employment program, to paint the first community mural in the Mission District for Horizons Unlimited. For the next two years Yanez coordinated several other mural projects in the Mission with the staff of the city-funded Neighborhood Arts Program.

In 1973, Patricia Rodríguez, Irene Pérez and Graciela Carrillo, all former classmates at the San Francisco Art Institute, painted a mural in Balmy Alley in the Mission District, near the home of Rodríguez. Then, in 1974, Consuelo Méndez, a Venezuelan-born artist, was commissioned to do a large mural (**Latinoamérica**) in the parking lot of the Mission Model Neighborhood Corporation. She invited Rodríguez, Pérez and Carrillo to join her. For the next two years these four women painted several murals together, calling themselves Las Mujeres Muralistas. They were often joined by other artists, including Estér Hernandez, Miriam Olivo, Ruth Rodriguez and Susan Kelk Cervantes. Their murals were at times criticized as 'apolitical,' however they viewed their collaborations as attempts to create a more optimistic image of their culture than the angry militancy they found in the men's work.

At the same time, the Haight Ashbury Muralists (Miranda Bergman, Jane Norling and

Peggy Tucker) were painting shared visions of unity. This group expanded with the addition of Arch Williams, Selma Brown and Thomas Kunz to repaint the powerful community mural, **Rainbow People** in 1974. Many of these artists have continued in the mural movement to the present day.

In 1978, veteran San Francisco muralist Susan Kelk Cervantes organized a multi-racial group of artists called Precita Eyes Muralists, named for the street at the edge of the Mission District where their studio is located. The group's first project was for the facade of China Books, a store that distributes literature from the People's Republic of China. The mural's theme of farming and people working together was painted in the style of Chinese peasant painters.

In the San Joaquin Valley, 150 miles southeast of the Bay Area, in 1970, Ernie Palomino became the first faculty member of the newly won Chicano Studies Department at Fresno State College. At the time the department was created, the school was in the throes of massive protests at the lack of Chicano programs. Half the college's 20,000 students were Mexican-American. Palomino had just returned to Fresno (where he was born and raised) after studying in San Francisco and then spending five years in Colorado, where he worked with the Colorado Migrant Council.

Palomino's first mural, done with Lee Orona, was painted in West Fresno, near a spot where farm laborers congregated in the early morning darkness each day, hoping to be among those bused to work in the fields. The original mural featured a flatbed truck in the center. In the back sat a mother and small child, surrounded by field hands. A UFW flag waved overhead. Along the mural's edge, Orona painted Quetzalcoatl and a calavera.

In 1974, Palomino got a $5,000 grant from the NEA to do a mural in Malaga, a working class community just south of Fresno. The money was administered through the college, and he was given only 30 days to spend it. Shortly after completing the mural, Palomino started a group for artists interested in reaching out to local Chicano youth. He was influenced by Sacramento's Royal Chicano Air Force.

Palomino named the new group *La Brocha del Valle*. *Brocha* is a slang word in Spanish meaning paint brush. For the first year, the group met in his home, turning the 200-square foot living room into a community art center. *La Brocha* was officially incorporated as a nonprofit in 1976 by Palomino, Fernando Hernández, Salvador Garcia and Francisco Barrio. The group was active for about ten years, doing murals and giving lectures. Gilbert 'Magu' Lujan participated in *La Brocha* while teaching at Fresno City College from 1976-81.

In the mid-1970s, a group of Fresno women artists came together to do a mural. Taking their cue from San Francisco women, Helen Gonzáles, Celia Risco, Sylvia Figueroa, Theresa Vásquez and Lupe González called themselves Las Mujeres Muralistas del Valle.

During the mid-1970s, Greg Brown created a series of nine vignettes in downtown Palo Alto. The first one showed a man in a trenchcoat. Among the most popular was a guy in a spacesuit interviewing an alien on the side of a supermarket and a couple of burglars scaling the side of an office building.

Probably the first Chicano mural in Santa Barbara was painted in 1970 by Manuel Unzueta for the Chicano Studies Department at Santa Barbara City College. Called **Chicano Dream**, the small, allegorical mural showed a naked youth holding a key. He was emerging from a disturbing present and reaching for a more hopeful future. 'Orozco was an important influence in my earlier work, when it was really dark and emotional,' Unzueta explained.

In 1971, Unzueta and his assistants began painting the walls of the just-opened Casa de la Raza with bold imagery. For nine years he added murals, until every major wall was covered. The first one, **A Book's Memory**, expressed Unzueta's anti-Vietnam War sentiments. Other

themes addressed in later murals include the Mexican family and the hope for unity among humanity. La Casa de la Raza is still an active force in the community, although struggling. Earthquake damage to the buildings threatens preservation of some of the murals.

Manuel Unzueta received the first MFA in Chicano Art ever awarded by the University of California. In 1972, while still a student there, he coordinated a mural project commemorating the anti-Vietnam War protests of two years earlier. During Isla Vista's famous uprising, the local Bank of America was burned to the ground for its ties to California agribusiness and various war industries. In 1980, the UCSB Administration destroyed the mural without warning. Ironically it is about to sponsor a new mural by Unzueta.

Several arts organizations on the Eastside of Los Angeles started in the late 1960s and early 1970s to showcase the work of local Chicano artists and to promote community-based art.

Goez Studio was founded as a for-profit business venture by brothers José Luis and Juan Gonzalez with their friend David Botello. The group's First Street gallery was a former meat market. Robert Arenivar quit his factory job to become the group's chief mural designer.

In 1971, Mechicano Art Center opened, spending a year in West Los Angeles before moving to Whittier Boulevard, across the street form the East Los Angeles Doctors Hospital, one of its major benefactors. The nonprofit center provided paint and scaffolding, but no money, to artists doing murals. In 1974, Mechicano coordinated the painting of 10 murals at Ramona Gardens, a public, low-income apartment complex. One of the artists involved was Wayne Alaniz Healy (later of East Los Streetscapers). Others included Willie Herrón, Manuel Cruz, Los Four, Judithe Hernandez and Joe Rodriguez.

In 1973, youth counselors at another Eastside housing project, Estrada Courts, invited artist Charles 'Cat' Felix to paint a mural at East Olympic Boulevard and Lorena Street with

some of the local kids. Through the initiative of Cat, that first mural developed into a much larger project, resulting in the creation of more than 40 murals over an eight-year period. Willie Herrón, Gronk, Ernesto de la Loza, David Botello, Daniel Martinez, Robert Chavez, RCAF from Sacramento, and Chicano Park artists from San Diego were some of those who participated along with local residents.

In 1970, Judy Baca, just out of college, was hired by the City of Los Angeles Parks and Recreation Department as an art instructor. She brought together youth from four local gangs to paint murals. For kids with otherwise strong antagonisms, the mural wall became neutral territory and a place to express themselves and explore their identity. From Costello Recreation Center and Hollenbeck Park developed a collaborative mural-painting process that became the model for a much broader program.

In 1974, the Los Angeles City Council agreed to fund a Citywide Mural Project (CMP) that brought together mentor artists with at-risk young people, initially under the leadership of Judy Baca. In 1976, amid increasing censorship attempts on CMP murals from local politicians, Baca, painter Christina Schlesinger and filmmaker Donna Deitch founded the Social and Public Art Resource Center (SPARC), a non-profit, multicultural art center (see statement by SPARC on page 25). SPARC started its monumental 'History of California'

mural project (now known as **The Great Wall of Los Angeles**) in the Tujunga Wash in 1976 with over 80 teenagers, all of whom had records as juvenile offenders.

The Compton Communicative Arts Academy was a neigbhorhood center started by artist Noah Purifoy in the late 1960s. John Outterbridge became director in 1970, and his series of assemblage murals of human figures and a cityscape decorated the building's facade for several years. The interior walls of the former warehouse were covered with murals by various artists, including Elliott Pinkney. The academy closed in 1975 when the buildings were demolished for 'urban renewal.'

Murals are only one aspect of the creative juices always flowing at St. Elmo Village. Artist Roderick Sykes and his uncle Rozzell started the arts community in the early 1970s with a collection of five families living in 10 cottages three blocks southeast of Venice Boulevard and La Brea Avenue. The grounds are decorated with sculptures made from junk, a pond, lots of cactus, and murals and other paintings, not only on the walls but on the sidewalks too. Children from local schools come for workshops during the week, and on weekends visitors from many parts of the city (and beyond) drop by for festivals, classes or just to experience the place.

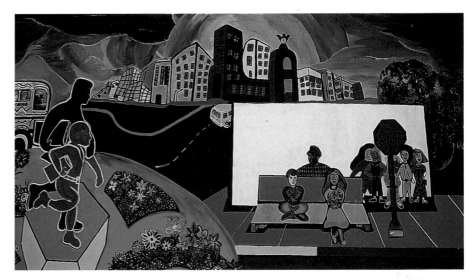

Opposite: **In Memory of a Homeboy**, 1973, by Daniel Martinez, 3328 Hunter Street, Estrada Courts, East Los Angeles.

Right: **Bus Stop**, 1991 (destroyed), by St. Elmo Village artists, Pico and San Vicente Boulevards, Mid-city Los Angeles.

Over the years St. Elmo artists (of all ages) have done many vibrant murals at schools, parks, supermarkets, health clinics and elsewhere. Rozzell died recently, but Roderick and his wife, Jacqueline Alexander (a photographer and muralist), carry on, currently overseeing a major renovation that, over the past three years, has replaced plumbing, wiring and leaky roofs, and brought fresh carpet and paint.

The Los Angeles Fine Arts Squad was founded in 1969 by Terry Schoonhoven and Victor Henderson, two academically trained artists influenced by the rebelliousness and anti-elitism of those times. Murals became a way for them to get out of the studio, cut out the middlemen and take their art directly to the community. Their collaborations, from 1969 to 1974, were characterized by a photo-realist style and the use of illusion, as well as by humor and irony. All of the L.A. Fine Art Squad murals are either gone or badly faded.

During the early and mid-1970s, other major mural creation projects were funded by the Cultural Affairs Department in their Inner City Mural Program. Brockman Galleries, under the direction of Alonzo Davis, created a series of murals, the most important grouping covering a multi-block retaining wall on Crenshaw Boulevard. Among the participating artists were Varnette Honeywood, Mark Greenfield (currently the director of the Watts Towers Arts Center) and James Borders.

13

Emigdio Vasquez, Orange County's best-known muralist, was first introduced to the Mexican muralists in a 1970 class on the Art of Mexico taught by Shifra Goldman at Rancho Santiago College in Santa Ana. The students also went on a field trip to see the murals of East L.A. From 1977-1985, Vasquez worked for the city of Anaheim as a muralist. While artist-in-residence at the Bowers Museum in Santa Ana from 1985-88, he brought in Ben Valenzuela as a guest artist, and together they painted four or five murals.

In 1970, at the same time that Chicano activists in San Diego were occupying land under the Coronado Bridge at what became known as Chicano Park, they also took over a city-owned exhibition hall in Balboa Park and turned it into an art center. After unsuccessfully trying to evict them, the city finally agreed to provide an alternative space—an abandoned water tank—as well as money to renovate it. Forty artists, calling themselves Los Toltecas en Aztlan, created El Centro Cultural de la Raza. Murals were painted on both the inside and outside during the 1970s, including the famous portrait of Apache chief Geronimo by Victor Ochoa.

The pylons holding up the Coronado Bridge became a mural museum with dozens of murals in Chicano Park celebrating Chicano heritage. Victor Ochoa, Mario Torero and Salvador 'Queso' Torres were among the park's early leaders and muralists. The RCAF came from Sacramento to join in the artistic explosion.

1980s and 1990s

During much of the 1970s, government funding through the CETA job training program helped create hundreds of murals, and gave artistic youth a chance to learn from mentors as well as to establish their own skills. As CETA money disappeared at the end of the 70s (enter the Reagan administration), in San Francisco funds from the city's Office of Community Development (OCD), and administered by the newly established Mural Resource Center, helped bridge the gap. Balmy Alley and the **ILWU Mural-Sculpture** were two significant examples of projects financed through artist ingenuity. **Maestrapeace** on the Women's Building in San Francisco was a culmination of the collective skills of seven outstanding women muralists and their many helpers.

Throughout the years, the Precita Eyes Muralists have created dozens of important murals, including many with youth at public schools. They also have conducted mural tours and, more recently, organized a Mural Awareness Month for San Francisco.

The Sacramento Metropolitan Arts Council established a mural program involving youth from many of the local high schools working under the guidance of muralists Joe Lott, Juanishi Orozco and Richard Herrera. Special seminars have been held and guest artists and speakers invited to provide information and inspiration to these young artists.

Arts in Corrections is a program to facilitate art classes within the correctional institutions. Muralists and teachers like Juan Fuentes have worked caringly

with these programs. A survey of murals painted within the federal system in California documented 175 murals. Although most were of the landscape variety, a few dealt with the feelings of incarceration.

In 1987, Long Beach arts activist Dixie Swift initiated a youth-centered mural program with public artist Keith Williams. Funded by the city's Community Development Department, the first, a block-long mural on Santa Fe Avenue in West Long Beach, involved 150 Stevens Junior High School students (with support from art teacher Susan Sirls) over an eight-month period. From this first successful effort developed the Mural Mentor Program. For the past several years it has been directed by artist Heather Green.

In Los Angeles, through its own fundraising projects, SPARC continued updating period sections of **The Great Wall**, employing hundreds of youth trained by professional artists.

In 1988, SPARC initiated Great Walls Unlimited: Neighborhood Pride, a mural program in which artists were competitively selected, then connected with youth apprentices to paint murals in communities all over the city. Between 1988 and 1995, when the funding was abruptly cut off, 72 murals were completed. These are images of strong ethnic identity and pride, emotionally charged visions of pain and hope. For the first time, Asian artists began painting murals in L.A.'s Koreatown, Chinatown and Little Tokyo.

Always ambitious, Judy Baca as SPARC's artistic director launched **The World Wall** in the early 1990s, with panels exhibited in Leningrad, Helsinki and at the Smithsonian Institution in Washington, D.C. The idea was to invite a local artist to add a mural at each site and to gather people to talk about the major issues of our times, such as peace and the environment.

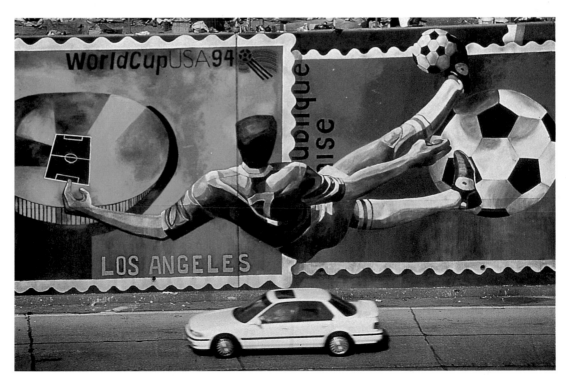

Opposite: **Untitled**, Juvenile Detention Center, Fresno.

Right: **Stamps of Victory** (detail), 1994, by Johanna Poethig, Harbor Freeway (110) between 7th and 8th Streets, Downtown Los Angeles.

Major events in Los Angeles helped shape public visibility for the mural movement. The 1984 Olympics saw the funding of a series of murals along the 101 and 110 freeways in downtown L.A. Ten years later, in anticipation of the final match at the Rose Bowl, World Cup Soccer contracted with SPARC for five major murals–at Los Angeles International Airport and on downtown freeways. Artists from Chicago, San Francisco and San Diego joined with local artists for this project.

15

In San Diego, Chicano Park continued to be the center for on-going mural production. With the 1989 Loma Prieta earthquake, serious questons about retrofitting the pylons threatened the very existence of these art treasures. Only the strong organizing efforts of the people of Logan Park saved the murals by pressuring CalTrans to develop an alternative plan.

Elsewhere in the state, superrealist portraits of photographic clarity dazzled passersby—by Kent Twitchell and Richard Wyatt in Los Angeles, Daniel Galvez in the Bay Area. Other murals of monumental size were painted by Keith Sklar, Dewey Crumpler and the Maestrapeace artists in San Francisco. Visitors to many parts of the state have also been entertained by trompe l'oeil gems, most notably in Chico and Los Gatos by John Pugh.

Some artists began working in ceramic tile, such as Horace Washington in San Francisco, Juanishi Orozco in Sacramento and Los Angeles artists East Los Streetscapers, Eva Cockcroft, Terry Schoonhoven, Francisco Letelier and Richard Wyatt.

Beginning in the 1970s and increasing since then, artists normally associated with a particular city were beckoned by mural commissions to places far from home. Kent Twitchell painted basketball great Julius Erving on a four-story wall in Philadelphia. Daniel Galvez created murals in Cambridge, Worcester and Pittsfield, Massachusetts. In 1996 he completed the life of Malcolm X for the Audubon Auditorium in Harlem. Johanna Poethig of San Francisco made major contributions in the Los Angeles area. Miranda Bergman, Juana Alicia, Roberto Delgado and Eva Cockcroft traveled to revolutionary Nicaragua to paint with local artists. Bergman later organized the Break the Silence Project to paint murals on the West Bank with Palestinian artists and fellow Americans Susan Greene, Marlene Tobias and Ina Redmond. Susan and Luis Cervantes painted with Russian artists in Leningrad, while Paul Botello, Eva Cockcroft and Toons went to Berlin.

Public art support appears broader in recent years. In Los Angeles County, with new construction accelerating during this period, several cities have instituted '1% for Art' assessments of large commercial real estate developers. Frank Stella's **Dusk** and Kent Twitchell's **Harbor Freeway Overture** in downtown L.A., as well as Richard Haas's Landmark Square mural in Long Beach, are just a few of the murals created under this program.

The MetroRail public transit project is another major vehicle bringing murals to the L.A. area. Every station includes a public art component. Many veteran local muralists are winning commissions, including East Los Streetscapers, Richard Wyatt, Eva Cockcroft, Elliott Pinkney, Frank Romero, Roderick Sykes, Terry Schoonhoven, Francisco Letelier and Margaret Garcia. Public libraries and community police stations are also sites for new murals.

Beginning in the mid-1980s, a highly controversial aspect of public decoration burst on the scene as graffiti taggers and spraycan artists took to the walls in California. Some were able to transform blank space into strong, highly sophisticated murals, whereas others neither tried nor were capable of success.

California's New Mural Towns

In a category all by themselves are several small towns that are turning to murals as a tourist attraction to revitalize their sagging economies. Lompoc, Susanville, El Segundo and Twentynine Palms are the most visible examples of this phenomenon, a trend that is taking place in other states as well. In general, these small-town murals are attractive, well-painted and harmonious. Most present an historical view similar to many of those produced under the New Deal in the 1930s, a perspective that leaves out struggles, problems or any major confrontations—often the actual driving forces of social change and progress.

The inspiration for these efforts derives from the experience of Chemainus, a former logging town in British Columbia, Canada. In the summer of 1982, five murals were painted as part of a downtown revitalization project. The following year the local mill shut down after 120 years in operation. Almost immediately the business community and the municipal government came together to create the Festival of Murals Association. Since then more than $250,000 has been spent and 33 murals completed. Chemainus has become an international tourist destination.

Community leaders in several California towns made a pilgrimage to Chemainus before initiating their own projects. Lompoc, Twentynine Palms and El Segundo in Los Angeles County all began their programs with a mural by Chemainus artist Dan Sawatzky.

Other similar programs are just getting off the ground in Palm Desert, Napa and Santa Rosa.

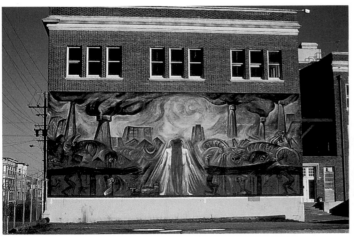 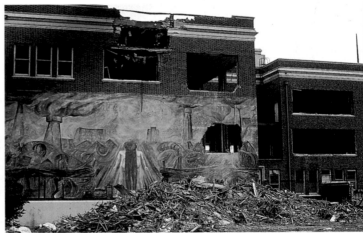

Opposite: **Untitled** (detail)
Martin Luther King Swimming Pool,
1984, by Horace Washington,
3rd and Carroll Streets, Hunter's Point–Bayview,
San Francisco.

Above: **LULAC Mural**, 1975 (destroyed in 1984),
by Gilberto Ramirez,
League for United Latin American Citizens,
26th Street and Folsom Street,
Mission District, San Francisco.

Looking Ahead

A number of trends can be identified. As murals weather, disappear with inner-city demolition, or are endangered by changing wall ownership, preservation is now recognized to be an important aspect of mural creation. In the past it was almost totally disregarded. Some artists are turning to more durable materials, such as ceramic tile or enamel paint on metal. Others are painting outdoor murals on removable fiberglass canvas. In Los Angeles, the Mural Conservancy has begun a Mural Rescue Program designed to identify historically significant and/or aesthetically notable murals requiring cleaning or conservation. So far the

program has "rescued" 21 murals. SPARC also is involved in a city-sponsored mural maintenance program.

Cities, large and small, are devoting more attention to developing their downtown public spaces in hopes of reversing the flight of businesses and consumers to the suburbs. Larger mural commissions are one positive result. At the same time, many traditional funding sources are no longer available, challenging the ingenuity of mural centers and muralists to find money elsewhere.

Mural making has become more of a formal process with less spontaneous energy spent on creativity in behalf of personal, political and social beliefs. During the 1960s and 1970s, many Chicanos and African Americans painted murals on neighborhood walls, at least in part because they were denied access to mainstream art venues. Today, some of these veteran artists are being received in a variety of other venues, including major mural commissions in prominent public places.

To some degree the spontaneous aspect of public art has become the domain of today's youth, many of them part of the Hip Hop Generation that has chosen the spraycan as its brush.

While it is true that mural art is achieving broader recognition and acceptance, those murals that include self-expression and self-definition by artists in impoverished neighborhoods, whose work seldom has been valued by the formal art community, are the heart of the mural movement. Murals are certainly no panacea for cities rife with decay or youth otherwise abandoned by government, schools, the job market and families. But community murals can be an empowering force, giving visibility to community issues and serving as a means of communication between peoples and cultures.

This book is dedicated to those artists, communities and individuals who continue to create and sponsor murals that awaken our conscience and stir our hearts.

Robin Dunitz
Jim Prigoff

Capturing Our Identity,
1997, by ManOne,
Avenue 56 near Baltimore St.,
Highland Park (Los Angeles).

18

Hearts of America (detail), 1996, by Eliseo Art Silva, Immanuel Presbyterian Church Parish Hall, Catalina Street and Wilshire Boulevard, Koreatown (Los Angeles). Photo courtesy of the artist.

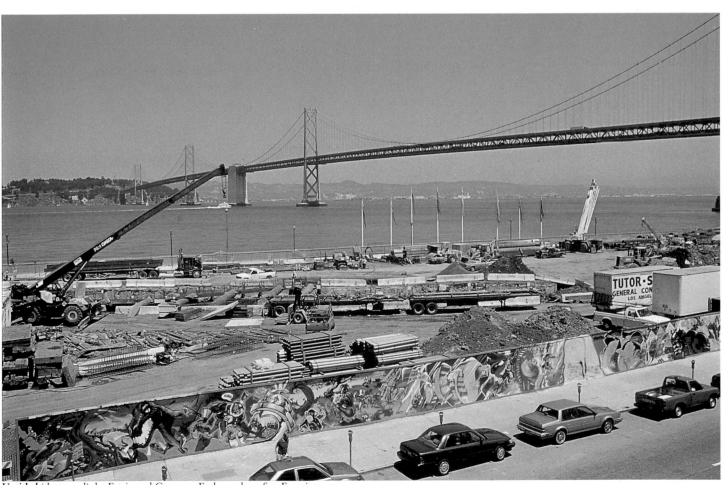

Untitled (destroyed), by Estria and Crayone, Embarcadero, San Francisco.

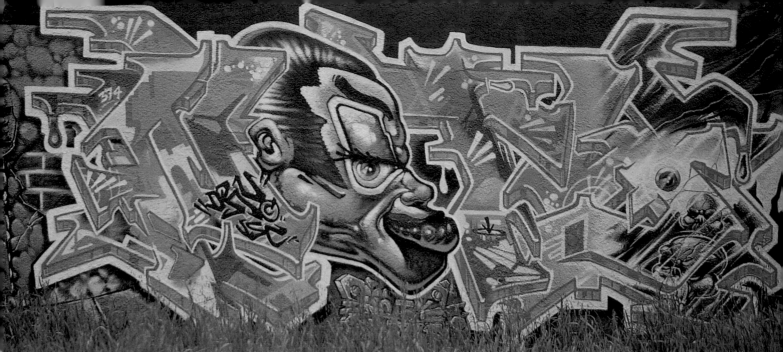

Above: **Untitled** (detail), by Dru, Laurel Canyon Boulevard., Pacoima (Los Angeles).

Above: **Untitled**, 1997, by Cycle, Albany tracks, San Francisco Bay Area.

Below: **A Couple of Immigrantes**, 1997, by ManOne, Figueroa Street (northside alley) between Avenue 51 and 52, Highland Park (Los Angeles).

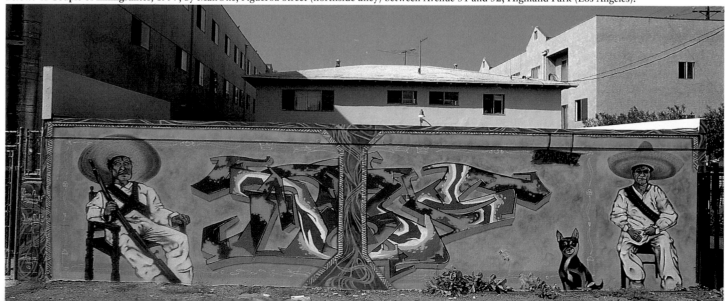

SPRAYCAN ART MURALS

California muralists paint with a variety of techniques using brushes, air brush, as well as spraycans. Mostly, youth muralists (writers) use spray cans almost exclusively to create their murals, also called 'pieces.' Some spraycan art is commissioned and supported with a budget for artistic rendering, painting and paint supplies. Other walls are considered 'permission' walls where artists first contact the owners for the right to paint their pieces. In addition, a vast number of walls are painted on a 'non-permission' basis. Some locations become local 'Halls of Fame,' where the walls get repainted on an almost weekly basis. In recent years many of these locations throughout the state have been 'buffed' and are no longer accessible to youth. Another favorite location is along the Amtrak lines. Fame and exposure for their artistic renderings are often attributed as the reason youth paint in very visible locations, but there are a surprising number of murals that are painted behind buildings, in out of the way places and in many cases in spots known only to other writers.

Although a limited number of major walls may be visible over a period of many years, it is more than likely that most of the spraycan art shown in this book already has disappeared. Countless other pieces will have replaced them, or solid color walls may bear mute testimony to that which lies beneath their coatings.

During the past 14 years a remarkable number of street-trained artists have created an exciting body of high-energy images, bursting from the walls in exuberant color. Although mainly centered in urban areas, the images can be viewed in almost all parts of California. Bordering this page is a selective (but by no means definitive) list of names of practitioners who have withstood the test of time, style, contribution and devotion to an art form that grew out of the current U.S. graffiti youth culture. As they have grown older, a few artists have left the public walls to paint mural-sized canvases which now hang in private collections and in at least one major California museum.

Jim Prigoff

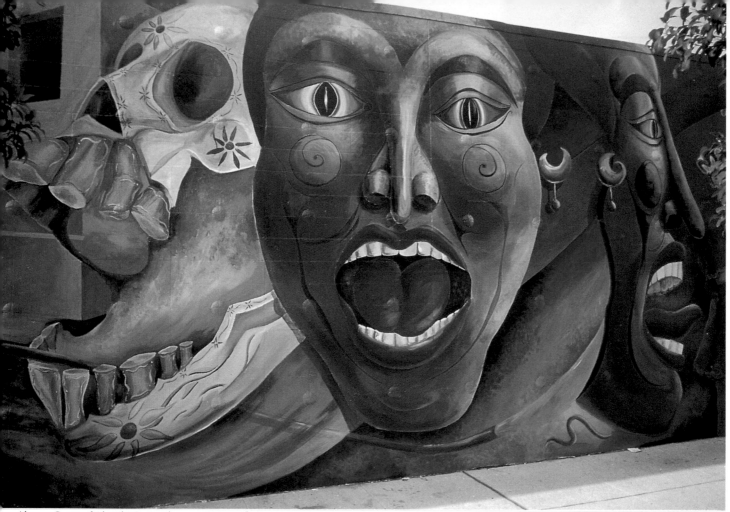

Above: **Carnaval** (detail), © 1995 by Precia Eyes Muralists Joshua Sarantitis and Emmanuel Montoya, Harrison Street between 18th and 19th Streets, San Francisco. All rights reserved. Photo courtesy of Joshua Sarantitis.

Below: **Si Se Puede** (detail), ©1995, designed and directed by Susan Kelk Cervantes. Contributing artists Juana Alicia, Margo Consuelo Bors, Gabriella Lujan, Olivia Quevedo and Elba Rivera, Cesar Chavez Elementary School, 825 Shotwell Street between 22nd and 23rd Streets, San Francisco. All rights reserved. Photo by Eric Melder and courtesy of Precita Eyes Muralists.

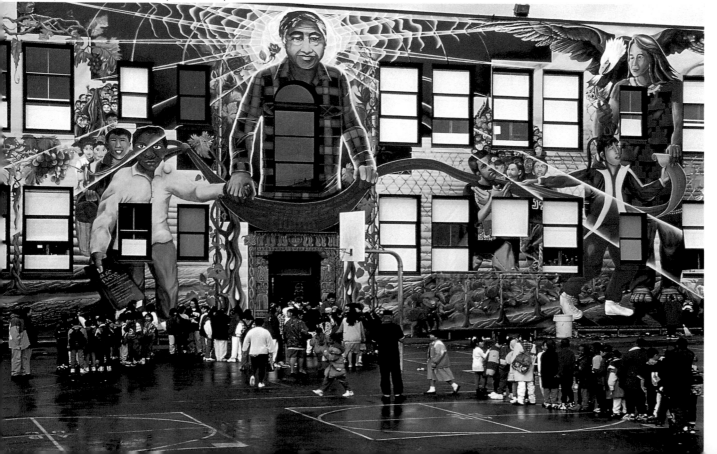

San Francisco

The Precita Eyes Mural Arts Center is a multipurpose community-based arts organization. The center is a project of Precita Eyes Muralists Association, Inc., a nonprofit, tax-exempt association of artists/muralists and supporters, which evolved from a community mural workshop organized in 1977 by current director Susan Cervantes. The seeds for the beginning of Precita Eyes were planted by the vision of Latinos/Latinas from the Mission District community trying to reclaim their cultural identities through a people's art form.

The center sponsors and implements on-going mural projects throughout the Bay Area and internationally. In addition, it has a direct impact on arts education in the San Francisco Mission District by offering seven weekly art classes for children and youth (18 months through 19 years) and adults. These classes and community mural projects enable participants to develop their individuality and confidence through creative activities and to experience unifying, positive social interaction through collaboration.

Walking into the center during almost any day of the week, one could find children engaged in arts and crafts, artists drawing from the figure, professional muralists collaborating on a portable mural, a slide presentation to a group of educators or public school students, or an intense planning session for a new monumental mural project for the Mission District community. More than 20,000 students and tourists have walked from Precita Eyes as the starting point for mural tours encompassing more than 80 murals in an eight-block walk. Precita Eyes is alive with purpose and ideas, and it is continually evolving to meet the needs of the individuals, young and old, who pass through its doors.

Los Angeles

The Social and Public Art Resource Center (SPARC) is a gift from the neighborhoods of Los Angeles to each other and the world. No other arts organization in this city serves the artistic and social function, day in and day out, of bringing diverse peoples together to express themselves in a public and positive manner.

The seed of SPARC's vision is the Mexican social mural movement, especially as expressed by David Alfaro Siqueiros: 'We repudiate so-called easel art and all such art which springs from ultra-intellectual circles, for it is essentially aristocratic. We hail the monumental expression of art because such art is public property.' But SPARC has transcended this maxim and created a new standard for what is public art. Art is not just official party lines, but a record of everyone's story, (i.e., **The Great Wall of Los Angeles**). Art is not just the finished work visible to all, but the creative process is itself a community collaboration (i.e., Great Walls Unlimited: Neighborhood Pride). No longer is the mural static, but it moves around the world allowing other peoples to see and to add their own vision to it (i.e., World Wall). And instead of raising money just from public agencies or private foundations and corporations, public art funding comes from the very communities that seek to make their monuments a part of the collective history of a diverse city (i.e., Cultural Explainers).

SPARC has achieved all of this and much more. For it is in the process of community collaboration that SPARC's greatest contribution is made. That cannot be quantified, but the finished work is secondary to the coming together of peoples who have heretofore had no voice, no images, no monuments. Through this process they express their history, their frustrations and their dreams.

The artistic vision that is SPARC belongs to one woman, Judith F. Baca. For all of SPARC's 20 years, Baca has served as its artistic director, guiding the organization through adversity and triumph. Political and cultural elites have continually questioned SPARC's work – the former for not being politically right, the latter for not following the 'art for art's sake' dogma. Yet the neighborhoods SPARC has served have stood by SPARC and Baca, and have made her distant dream an ever-present reality.

The fruits of the struggle belong to the neighborhoods that have invited us in to help tell their stories, to the artists and their neighborhood assistants, and to the employees of SPARC through these 20 years. Together they have made the hundreds of public art works that SPARC has produced their legacy for all time.

ARMANDO DURON
President, SPARC Board of Directors

The Party at Lan-T'ing,
1991, by Shiyan Zhang,
Los Angeles Public Library,
850 Yale Street,
Downtown Los Angeles.

San Diego

Rock art, pre-Columbian frescoes and *Los Tres Grandes* genetically precede our Chicano *Mestizo-vizion*. *Murales* tentatively brought focus on our Living Culture and historical transmutations with a voice of empowerment. The Centro was energized by multidisciplinary artists who collaborated with themselves and the community actively, becoming the essence of Barriology.

Calamity reunifies humanity and for Raza we seem to have had a Big One every 10-year cycle since 1492. At this time we have won a victory! against Caltrans and the retrofit scheme for Chicano Park murals. Not only did artists come forth in preservation of this local historical site, but our community with its organizations, i.e., the Centro, Barrio Station, MEChA and the Chicano Park Steering Committee (CPSC). The Chicano Park Artists Task Force, 'Fuerza', was formed in early 1996 by the CPSC and the community. Several *Marchas* demonstrated our unity and paraded again Chicano issues that continue to persist.

The Centro's Art Advisory Committee and the Board are strategizing the future arts programming in response to the budget cuts. In Fall 1997 we are collaborating

Geronimo, 1980-81, by Victor Ochoa, El Centro Cultural de la Raza, Balboa Park, San Diego.

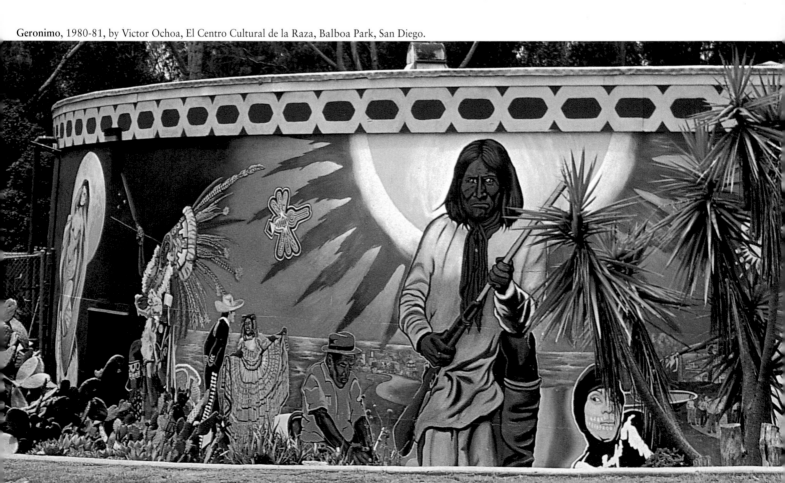

with Insite '97 and focusing on Public Art in site specific areas, with Chicano Park and *Fuerza* as well as our presence in Balboa Park and our historical influences in the development of Border Art.

Archival collections in slides have been produced with the library at the University of California, Santa Barbara. Negotiations for other materials continue. Paul and Joaquin Jaquez are implementing our mural information through the Internet (http://www.solar studio.org) and will be creating a new multimedia information booth at Chicano Park linked with the Centro's gallery.

We want to thank all the *gente* who made the efforts for our survival: the artists, the documentors– the historians and photographers, the youth who worked on murals and grew up to protect them and appreciate them, and especially the founders and the people for the past 30 years who brought us to the brink of the next millennium.

Que vivan los murales! Que viva nuestra comunidad.

Una esquina de Aztlán. A corner of Aztlan.

VICTOR OCHOA
Co-Founder of The Centro, Chicano Public Artist and Educator

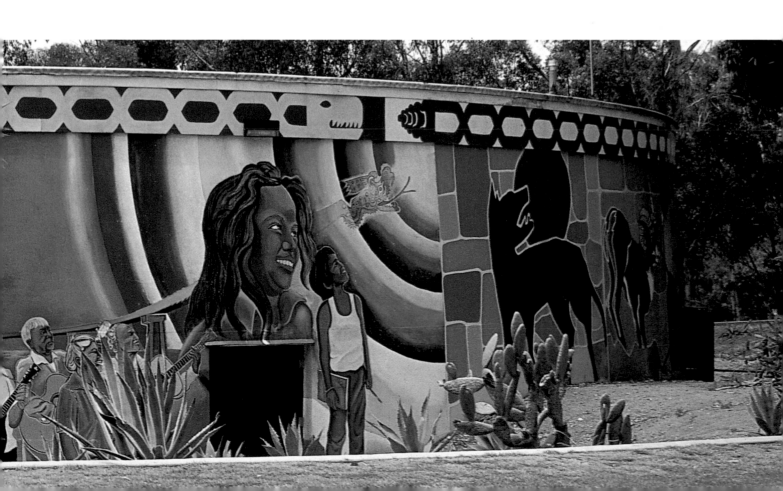

This project developed from a proposal by the Indian Action Council (IAC), and accepted by the Private Industry Council (PIC) of Humboldt for one of its summer youth work experience programs. I was approached by PIC to design a mural, and so I met with representatives from IAC to discuss its content. They requested that certain images important to their culture be included, such as an eagle and basket-making, because the local Yurok are famous for their baskets. They also wanted to show respect for elders. IAC's Center has a children's day care and a library, so they suggested an elder reading to a multi-racial group of children.

They allowed me to choose the colors, the overall layout and design, which incorporated their images. They also gave me the opportunity to include many of the elements unique to my style of painting. I produced an original watercolor scaled down one inch to the foot, and color copies of this were used on site as a guide by the painters. I painted with a crew of young men and women and their instructor, Matt Durham.

Upon completion of the mural, IAC held a salmon barbecue open to the community to celebrate. This was my first mural, and it was so much fun that I am looking forward to doing more.

NANCY NORMAN

Untitled, 1996, designed by Nancy Norman, Indian Action Council, 2725 Myrtle Street, Eureka.

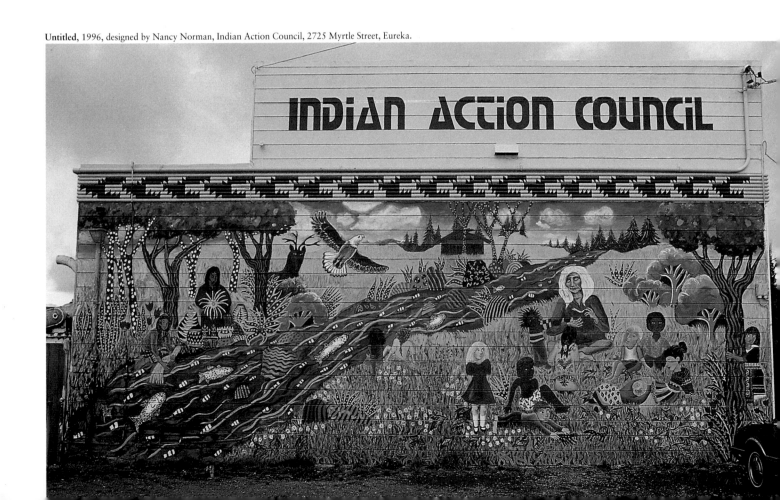

Multicultural Mural, 1985, by Duane Flatmo, Los Bagels Company and Wildwood Music, I Street between 10th and 11th Streets, Arcata.

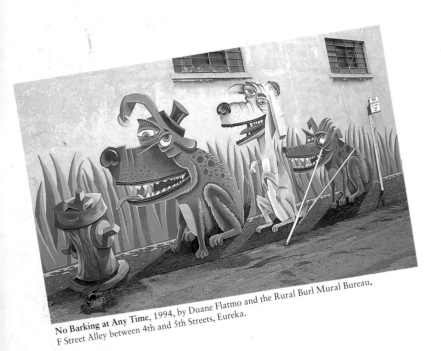

No Barking at Any Time, 1994, by Duane Flatmo and the Rural Burl Mural Bureau, F Street Alley between 4th and 5th Streets, Eureka.

I like to paint in a style that I call 'whimsical cubism.' You show one side of the face, but somehow you're looking at two nostrils, and you're looking at the mouth on the side of the face, and you're seeing the chin on the opposite side. It's skewing things.

No Barking At Any Time was painted by a group of mostly at-risk high school kids who were funded as an artist-in-residence program by the California Arts Council, the City of Eureka and Ink People Gallery in Eureka.

DUANE FLATMO

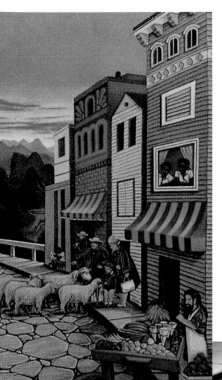

Duane Flatmo has created quite a niche for himself in Humboldt County. More than 20 of his murals embellish local walls. His cartoonish images are also popular with area brewers. His boundless creativity refuses to be contained in two dimensions. Since 1982, he has found time every year to bring to life a Rube Goldberg-like contraption that he races in the annual Kinetic Race. He moved to Humboldt County in 1977 to go to college after growing up in Southern California. Both of his parents were artists.

Untitled, 1994, by Duane Flatmo, Yakima Roof Racks (interior), Arcata.

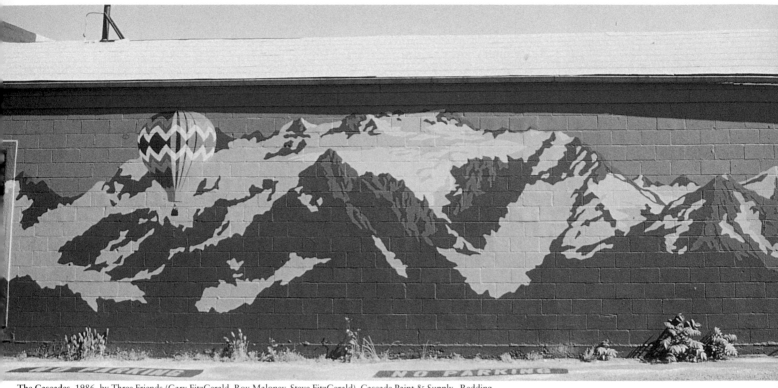

The Cascades, 1986, by Three Friends (Gary FitzGerald, Roy Maloney, Steve FitzGerald), Cascade Paint & Supply., Redding.

Antelope, c.1990, by Three Friends, Total Hardware, Alturas.

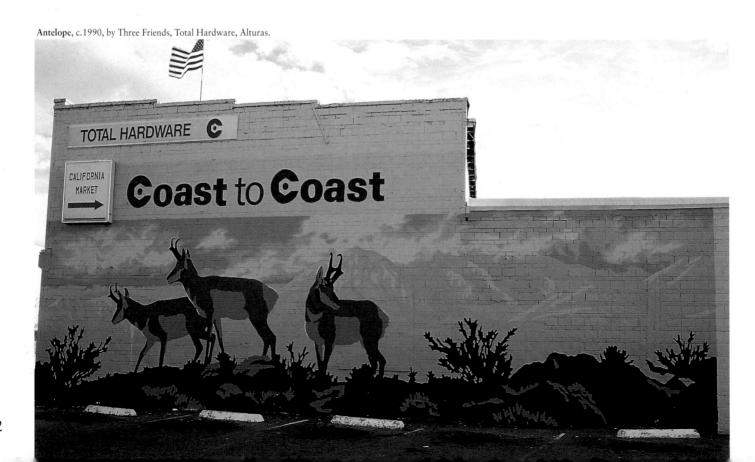

W e ("Three Friends") have created nearly 100 indoor and outdoor murals around the north state since about 1980. The outdoor murals are designed extremely simply, like a silkscreen. Five to 12 colors, that's about it. I lay the mural out so it can be executed in about two days. It's not unlike a paint by number painting. We get volunteers of all sorts. It's the Tom Sawyer syndrome. People see it's fun so they lend a hand, but Three Friends paint the important contours. The towns up here are losing the lumber industry, so they're trying to pull in the tourists.

GARY FITZGERALD

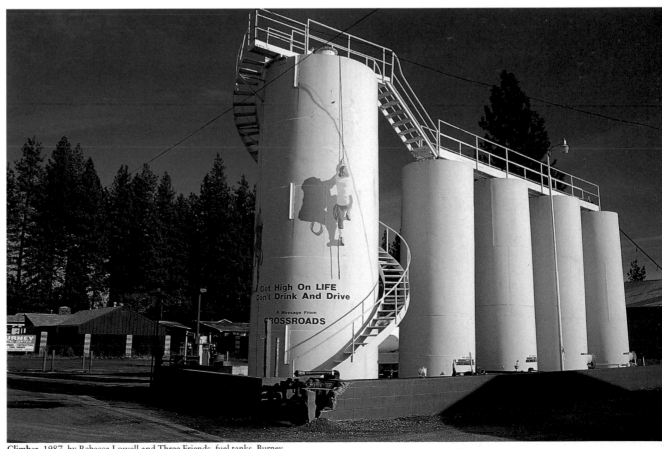

Climber, 1987, by Rebecca Lowell and Three Friends, fuel tanks, Burney.

Dad Popcorn was a local character named William Vellenoweth with a fancy popcorn wagon in Susanville from 1918-31. The thing finally blew up and nearly killed him. The kids are the Weir kids who lived in town. The girl in the blue coat used to come down and visit me while I was painting, only she was 86 years old. She's about 13 in the mural.

BEN BARKER

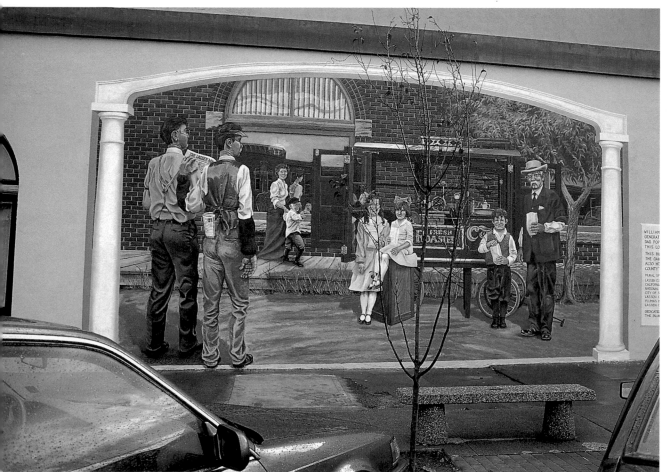

Dad Popcorn, 1993, by Ben Barker, Lassen County Times Building, Main Street and Gay.

History of Cattle Ranching in Lassen County (detail).

My mural was sponsored by the Lassen County Arts Council as part of a project to make the old part of town more attractive to tourists and other people passing through. It's a combination of old historical photographs and contemporary photos. The image on the far left is a cowboy I met who works on a ranch and showed me around. He was thrilled that his portrait wound up on the wall.

ARTHUR MORTIMER

History of Cattle Ranching in Lassen County, 1992, by Arthur Mortimer, Roop and Main Streets.

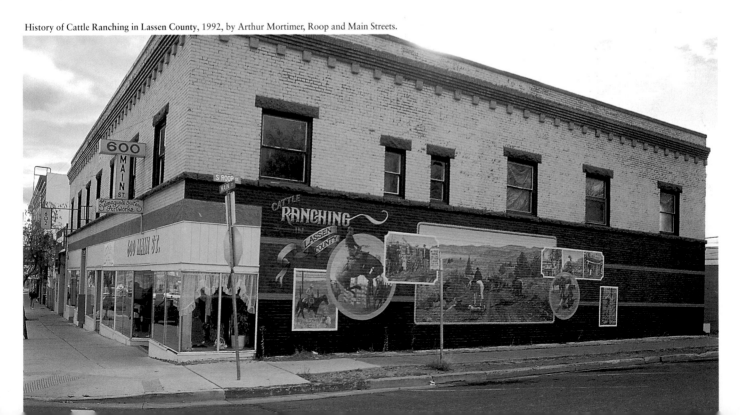

Creating Her History: A Tribute to the Women of Lassen County, 1993, by Judith Lowry, 611 Main Street, Susanville.

When I was asked to paint a mural for my hometown of Susanville, I noticed that there were several murals devoted to the accomplishments of men–loggers, ranchers and local businessmen. I decided to create a mural specifically to honor the women of the area. My family–a mix of Native American-Mountain Maidu Pit River and Paiute–has lived in Lassen County since before the European settlers came. My grandmothers and great-grandmothers are all very powerful influences to me. I decided to pay tribute to them and the pioneer women who came later.

I divided the mural into two sides. The figures on each side have their counterpart on the opposite side. Mrs. Potter (left side) the town's midwife for many years, is balanced by the native woman of the Bear Dance, an annual spring ceremony. Together they symbolize the idea of new birth and regeneration. The old storyteller on the right represents the education of the young and has her counterpart in Miss Heavner (age 92 at the time the mural was painted), who taught for many years in Susanville. Painting her with her 1926 kindergarten class also gave me an opportunity to pay tribute to the town's people of color, since she had children in her class who were Asian, Mexican, Indian and African American.

This was my first mural. Arthur Mortimer, a visiting L.A. muralist, gave me encouragement and lots of good advice on how to use the grid system to help erect my image onto the wall. However, I had to give up that method since I am more of an intuitive primitive painter. In the end, I went out and bought those big fat chalks that kids use to draw on the sidewalks, and just climbed up there and drew it all freehand. Then I had to paint in the outlines very quickly before the rain came.

JUDITH LOWRY

Sponsored by the Plumas County Art Commission, this mural shows some of the area's history, focusing on ranching, logging and the lifestyle of the local Native Americans. The building on which it was painted was the town's original stagecoach stop, built in 1860.

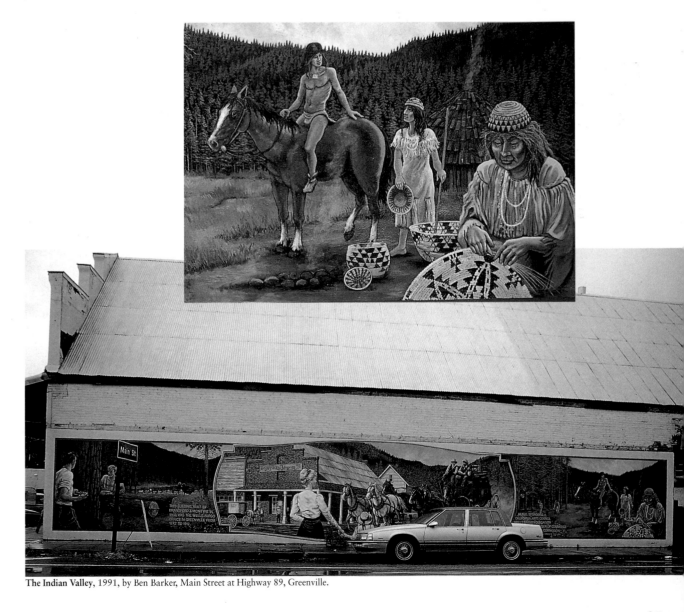

The Indian Valley, 1991, by Ben Barker, Main Street at Highway 89, Greenville.

The Bear Dance is an ancient Maidu ceremony performed each spring to honor the creation, the World Maker and the earth. A wand is made of the bark from a willow tree. It makes a rattlesnake sound when shaken. The Maidu use it during the ceremony to get through the summer without being bitten by a rattlesnake or eaten by a grizzly.

ROBERT PFENNING

Bear Dance, 1989, by Robert Pfenning, Bradley and Main Streets.

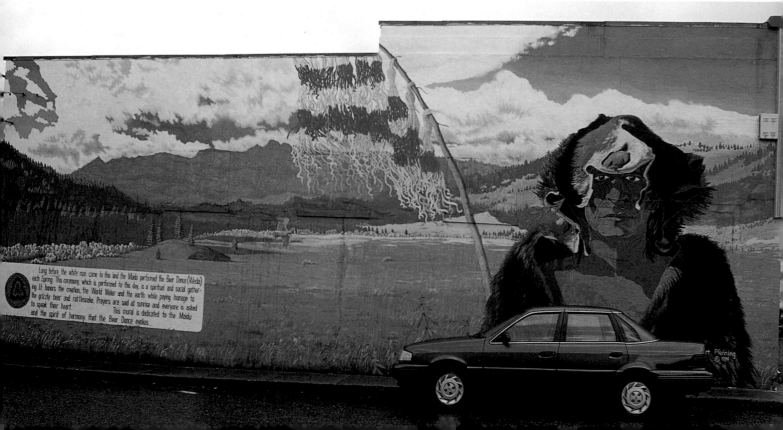

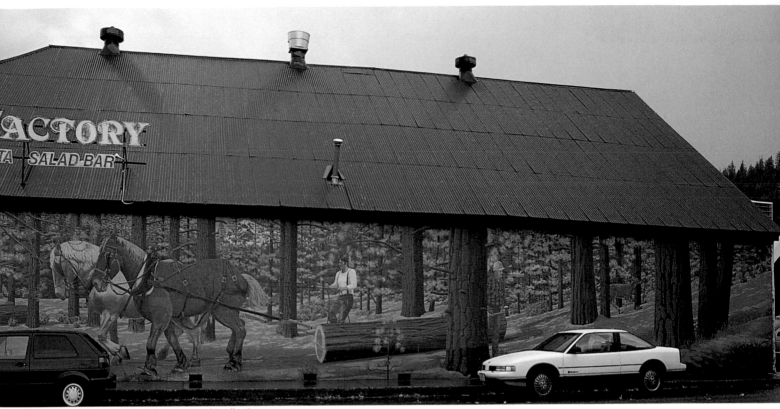

Annie and Toby, 1987, by John Wehrle, Main and Bradley Streets.

Annie and Toby *was a joint venture of the Quincy Chamber of Commerce and the Plumas County Art Commission. Although the painting has an historical look, the models were drawn from a contemporary horse-drawn logger, Dennis Miller. Many landowners in the area hire Dennis because horses cause less ecological damage to the land than mechanized logging. Quincy was a great place to spend a summer painting. I wish they hadn't put the pizza sign back up, though.*

JOHN WEHRLE

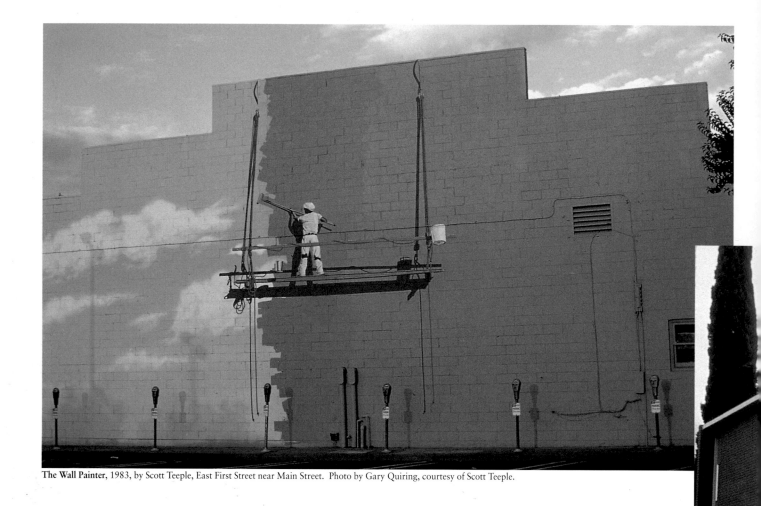

The Wall Painter, 1983, by Scott Teeple, East First Street near Main Street. Photo by Gary Quiring, courtesy of Scott Teeple.

Scott Teeple has been painting murals since the late-1970s. After studying painting at Chico State, he found himself initially doing artwork and signage for local restaurants and bars. Several of his Downtown murals are trompe-l'oeil, a whimsical style he particularly enjoys.

I also enjoy the fact that my Downtown murals have become a part of the fabric of our community here in Chico.

SCOTT TEEPLE

*P*eeling away the modern educational facade and flaunting the ancient Greek Academe–the foundation of our educational system.

JOHN PUGH

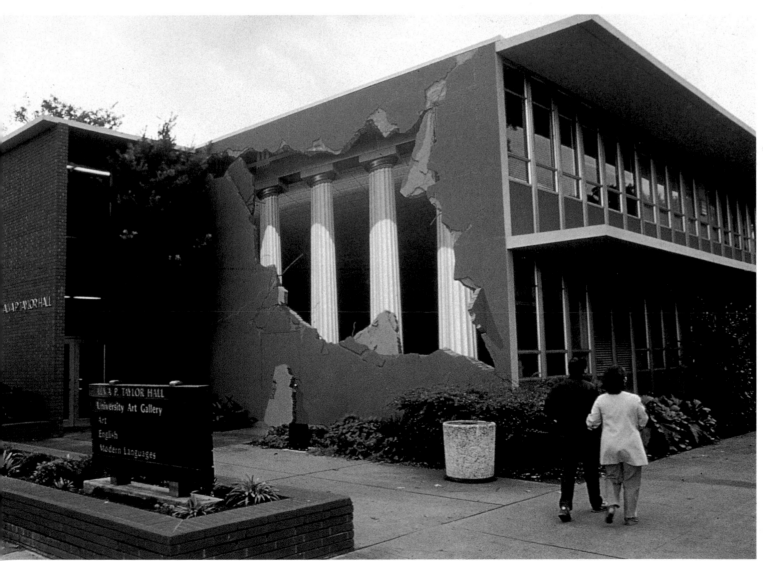

Taylor Hall Mural, 1981, by John Pugh, California State University, West First and Salem Streets.

I got this job while going to school. I was studying graphic design. My teacher hooked me up with one of the main guys at Bill Graham Presents. She showed him some of my work. I was first hired to do a close-up portrait of Bill Graham for a Christmas party–25 Years of Rock & Roll.

He liked it so much that he said they needed me to do Sacramento. It's a temporary building. They showed me the wall and pictures of the murals that had been on there before and said, 'Do your thing.' At that time I was painting a lot of women's faces. These are from photos out of different magazines. There are two other faces around the side of the building.

I've been doing graffiti for 11 years–but I never really called my stuff murals. This piece was done freehand with aerosol spray paint on plywood. It measures 15' x 60.'

VOGUE

Untitled (destroyed), 1991, by Vogue, Cal-Expo Amphitheater.

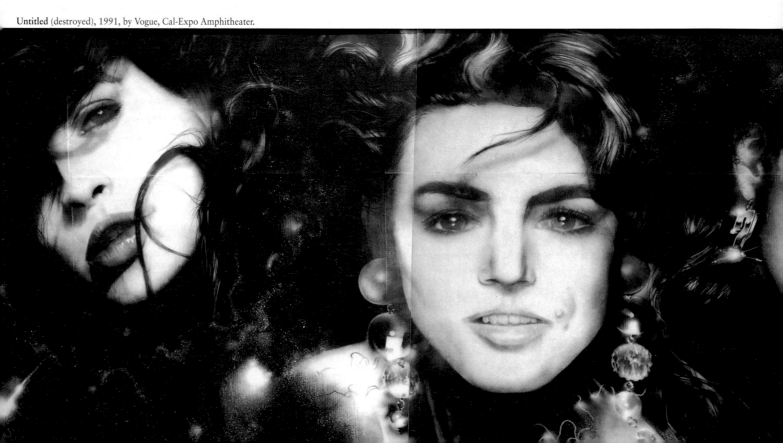

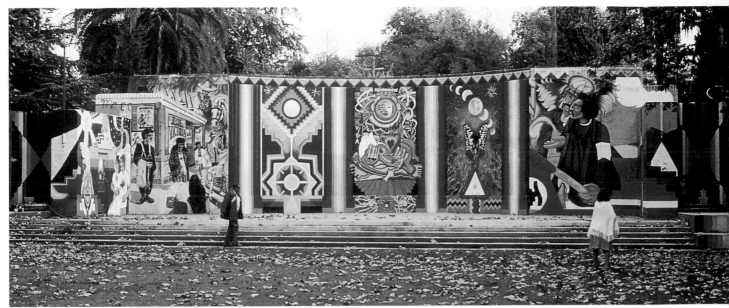

Untitled, 1977, by the Royal Chicano Air Force (aka Rebel Chicano Art Front), Southside Park.

It is a very unusual Chicano mural because with the RCAF group, there was so much diversity in backgrounds and still we were all Chicano. It's been underrated, too, because it doesn't only have the clenched fists and the 'venceremos' thing, although it's all there. Flores Magon is there. Zapata is in there, and Cuahtemoc is there.

Each panel had a maestro to head it up and who took on apprentices. Juanishi decided to incorporate a lot of southwestern indigenous symbolism—motifs and ceremonial kinds of things. Juan Cervantez has an old Aztec or Mayan sage talking to a contemporary farmworker holding a UFW flag. The middle panel is Esteban Villa's with a very cosmic earth mother done in his abstract style. You sense a soft spirituality in Stan Padilla's piece, which is a torso that becomes a butterfly and goes up into the cosmos.

I combined three epochs that have shaped my life: the Mexican Revolution because that's what my grandparents came out of, the pachuco era and World War II, and the young low-rider today. I grew up shining shoes for the pachucos in the '40s, so I've always done work with the pachuco—not to glamorize or romanticize that image, just to remind people that there was a group of young Chicanos treated worse than the chollos ever were.

This mural has survived, not unscathed completely, but still very powerful. The reason people respect the images is because it doesn't leave anybody out.

José Montoya

43

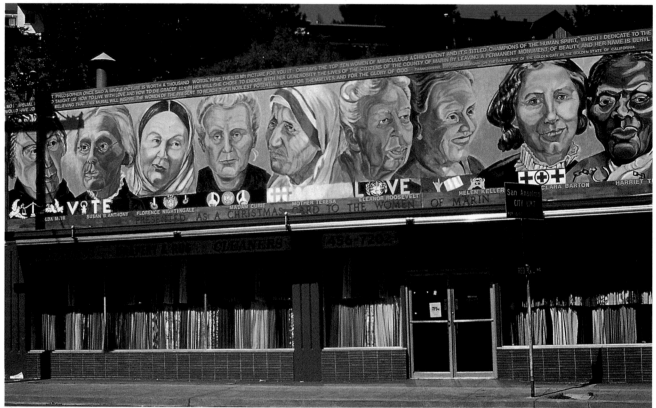

Famous Women of History (destroyed), 1982, by Claire Josephson and Monica Armstrong (Clarity Productions), San Anselmo.

Untitled, c.early 1980s, artist unknown, Bolinas.

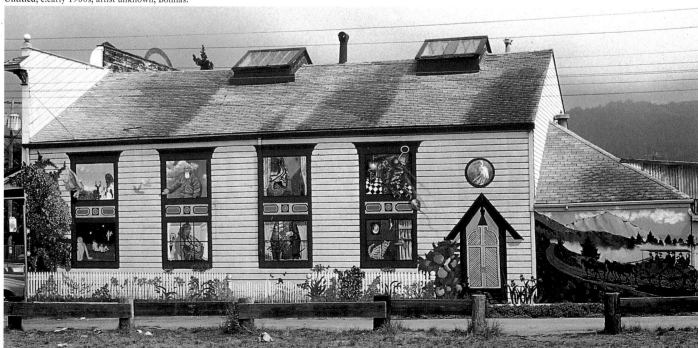

Dutch painter Vincent Van Gogh was obviously the stylistic inspiration for these portraits of Lincoln, Jefferson, Franklin and Washington. A seascape and a landscape reminiscent of *A Starry Night* grace two other walls.

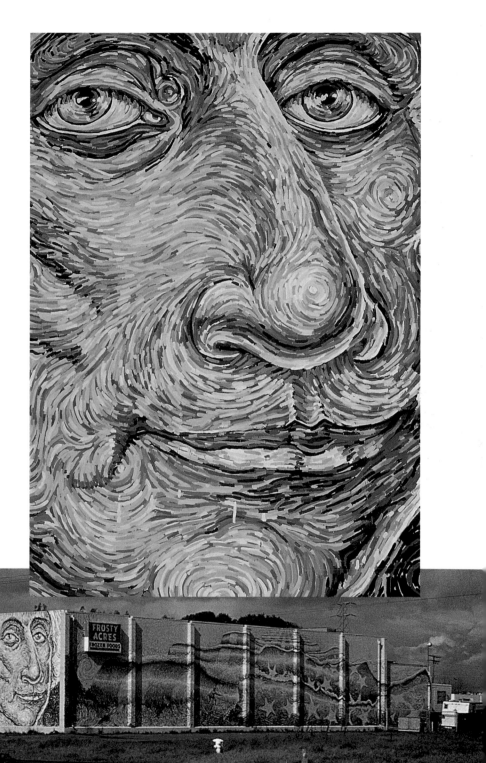

Bicentennial Murals, 1976, by Sam Frankel, Frosty Acres Frozen Foods.

The students wanted the imagery to deal with people who have struggled for peace in the 20th century. We have, from right to left: Joan Baez, Nelson Mandela, a Salvadoran farmworker, César Chavez, Yoko Ono, John Lennon, Katherine Smith (from the Big Mountain Movement), Dr. Martin Luther King, Jr., Sadako Sazaki (the girl from Hiroshima who folded almost 1000 paper cranes and died of radiation poisoning), Lame Deer, Sandino, Alice Walker, a marcher from Selma, Alabama, Frida Kahlo, a refugee from Honduras with a child on her back, Mo Eich (a student who worked with me at Stanford), and Brian Willson (who lost his legs at the Concord Naval Weapons Station protest). A grandmother of the Disappeared from Guatemala and farmworker children from Nepal and Mexico are in the foreground.

The college president's wife was very upset over the design because she said there were no 'American' heroes in it. But all the people were selected by the students of the college.

JUANA ALICIA

Puente de la Paz (Bridge of Peace), 1988, by Juana Alicia with students, World College West, Commons Building, 101 S. San Antonio Road, Petaluma. Photo courtesy of the artist.

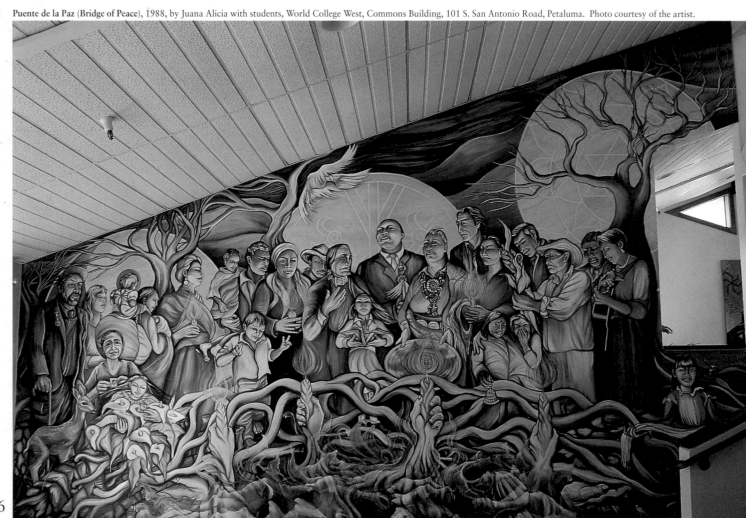

They actually built a wall for us to do the mural on! It's about the contributions of Latin-American workers to California agri-business, primarily the wine industry. It's an unusual winery. The workers put on gigantic barbecues at the end of each harvest. What we did was reflect what we felt, and what we saw in this particular winery. It is not one of the typical farmworking situations in California.

RAY PATLÁN

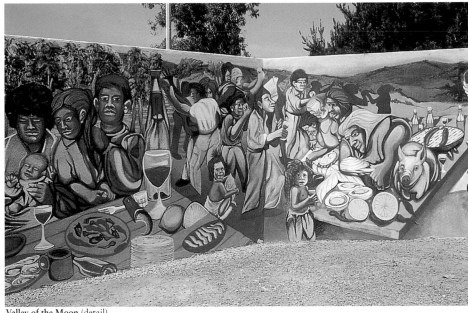

Valley of the Moon (detail).

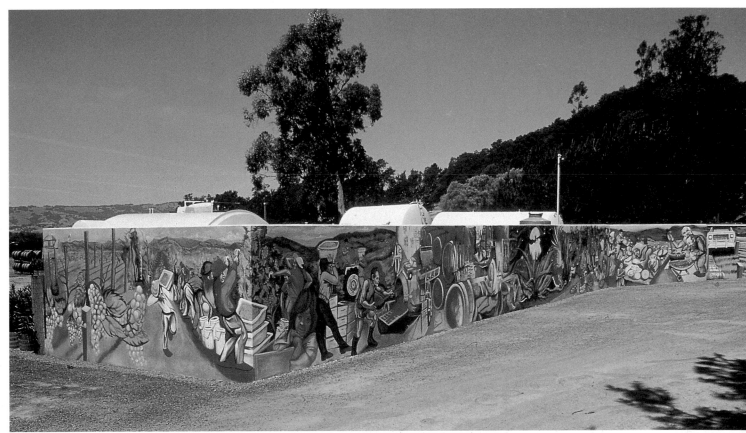

La Valle de la Luna (Valley of the Moon), by Eduardo Pineda and Ray Patlán, Gundlach Bundschu Winery, 2000 Denmark Street, Sonoma.

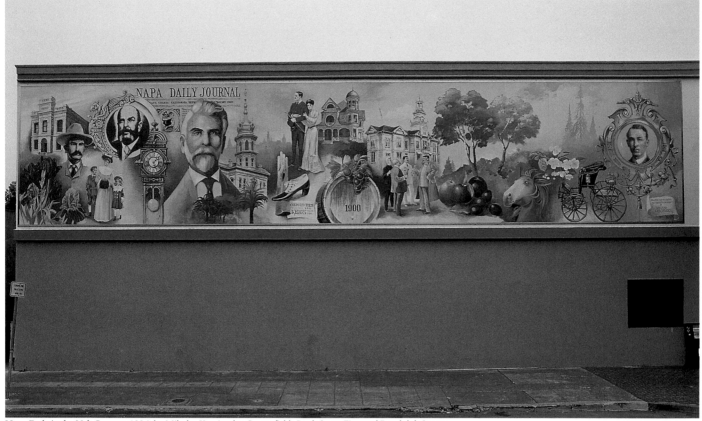

Napa Early in the 20th Century, 1996, by Mikulas Kravjansky, Copperfields Book Store, First and Randolph Streets.

Napa at the beginning of the 20th century, featuring (from left to right) Napa County Sheriff D.A. Dunlap, Napa Mayor D.S. Kyser, School Superintendent Lena A. Jackson, Superior Court Judge H.C. Gesford, and Justice of the Peace (and later state senator) Nathan Coombs.

T*his wall is like a time capsule. Once about a century ago, there was a nice little city located in the valley. It was so beautiful that the Gods wanted to live here. But this was not polically correct for their holinesses, and they had to choose Mt. Olympus. I am a Napan since 1988. My wife and I came from central Europe. Our western experience started in Toronto, Canada, for 10 years, then Florida for another 10 years, and finally we chose Napa. When I came to this city, I discovered what the Gods had planted here. This mural is my magical mirror. I hope we will stay here forever.* (Excerpt from a speech at the mural's unveiling)

MIKULAS KRAVJANSKY

The Napa River circa 1900 is viewed from the Third Street Bridge looking south.

Featured in the water are the schooner *Emma* and the stern wheeler *Zinfandel*.

I t all started in 1993 when I met artist Susan Clifford at a Business for Artists class. She was looking for a bass player to play with her and her husband on a CD project. I ended up doing that with them. She saw an ad in the paper about the mural project and said she'd do the paperwork if I'd go in with her on it. This was the first public mural I ever did. It was sponsored by the Napa Leadership Group, an independent organization of local business people that gets together to do things for the city. They had done some research and had a stack of favorite pictures, images that were to be included in the mural. I came up with the original design and Susan helped me paint on it for a couple of weeks. I ended up painting most of it myself, but I probably wouldn't have done it without her. I wouldn't have had the gumption to attempt it.

The left bank scene is from the 1890s and the right bank scene is from 1915. I widened the river two to three times what it should be so that it would fit on the space better. Other than that it's quite accurate.

STEVE DELLA MAGGIORA

Untitled, 1994, Steve Della Maggiora and Susan Clifford, Main Street.

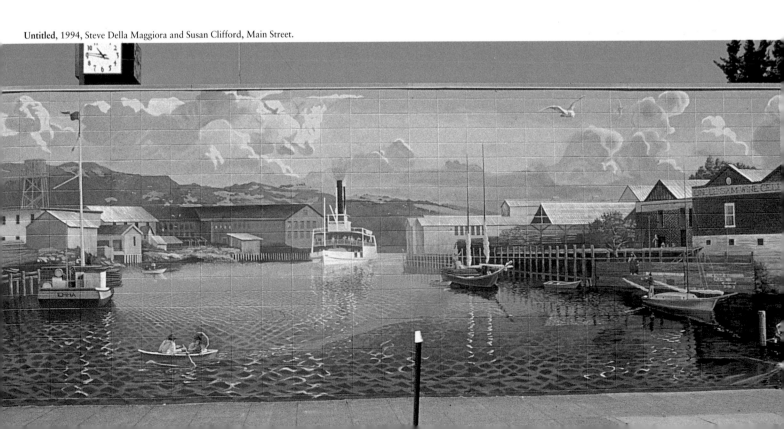

I make murals which are basically big paintings that just happen to be outside or in a public space. I don't like propaganda in my work. I am more interested in taking large spaces and creating walk-in worlds with subtle thematic statements.

DAVID GORDON

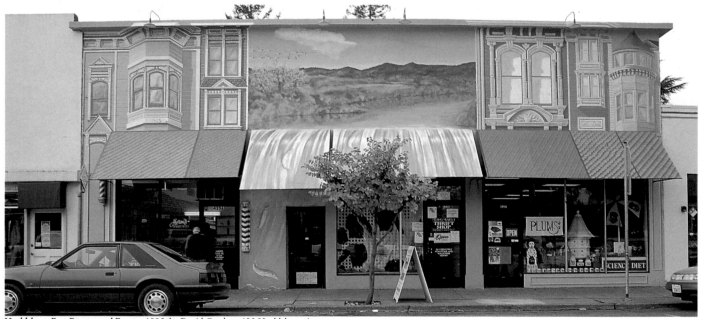

Healdsburg Past Present and Future, 1995, by David Gordon, 433 Healdsburg Avenue.

I love the way the light shines through the leaves of the vineyards. It causes the leaves to sparkle in a way that watercolor captures so well.

<div align="right">CLAUDIA WAGAR</div>

The artist first did a small watercolor painting of chardonnay grapes, the only grapes used by Landmark Vineyards to produce its wine. She used an airbrush for the mural in order to convey the subtle colors and the translucency of the grapes. In 1992 Wagar received the Artist Achievement Award from *American Artist Magazine* for this mural.

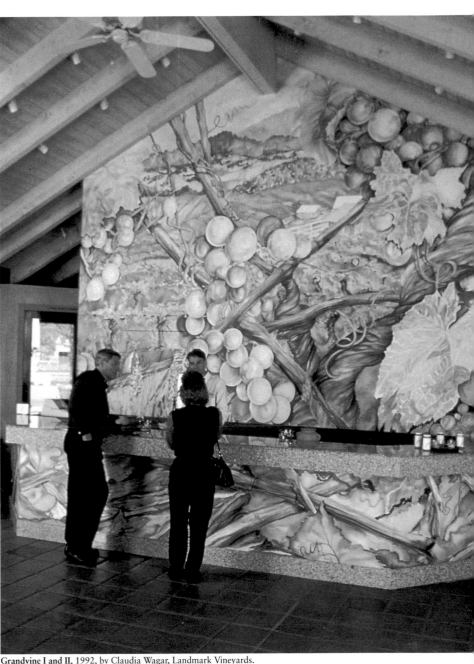

Grandvine I and II, 1992, by Claudia Wagar, Landmark Vineyards.

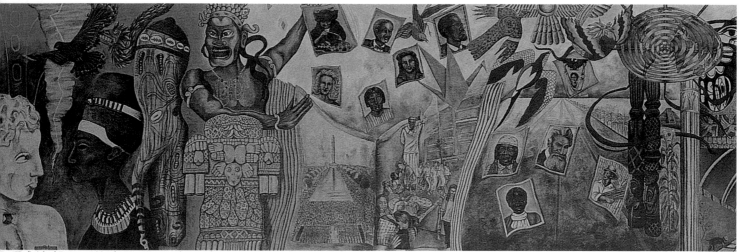

Unfinished Dream, 1991, by Kim Anno and Miranda Bergman, University of California, Memorial Union.

The mural was the result of a student struggle at Davis. They had a number of demands about more visibility for the students of color. They had a hunger strike, and ended up gaining a lot of their demands. One demand was for a mural that included the vital contributions of many nationalities, shifting the focus from the centrality of Europeans in history and culture, creating a more inclusive picture.

MIRANDA BERGMAN

We have the crumbling and cracking image of a Greco/Roman statue facing off with cultural icons, such as Quetzalcoatl (the Toltec and Aztec feathered serpent god), a mask from New Guinea, Egyptian Queen Nefertiti, etc. There is a central part that represents the struggle (the campus hunger strike), and the mural ends in the construction of a world house made of architectural details of many cultures.

KIM ANNO

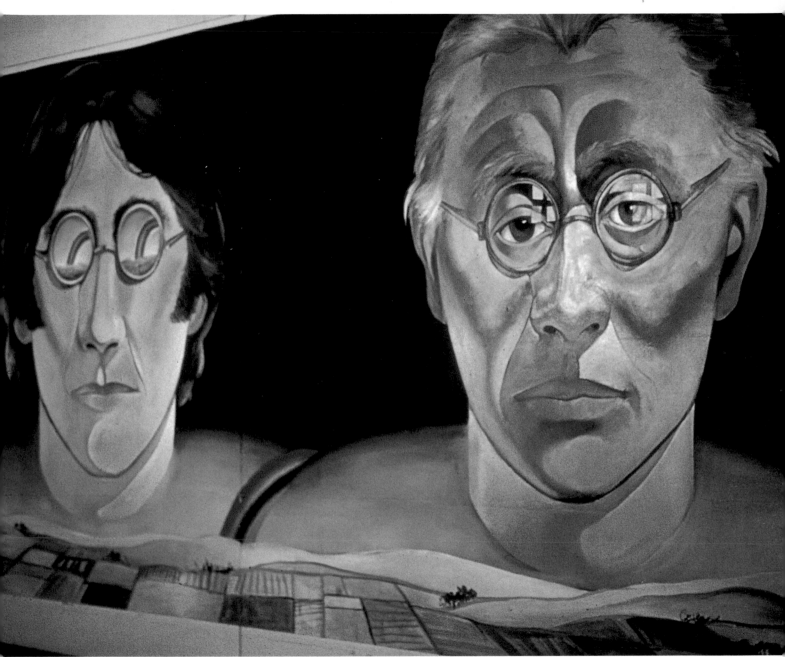

Untitled, c.1985, California Medical Facility, Vacaville State Prison.

Painted in a sally port, this mural shows two faces, those of a young man and an old man. Close inspection reveals that they are the same person. In the eyes of the young man are rainbows. In the eyes of the old man . . . prison bars.

I was very much a part of the Chicano art movement in the '60s. We used public art as a way of organizing. I started to see a big change in the late '70s. Murals became almost trendy. Oftentimes I saw them as more decorative—very pretty, very cultural. I saw culture with no politics at all as dangerous.

I decided to leave the actual painting of murals and go into teaching. I taught at the California College of Arts and Crafts (in Oakland) from 1977 to 1989. I taught a class called Mexican and Chicano Public Art.

I transferred to UC Davis, and I've been teaching the same mural class there since 1989. It's a nice way to bring the university out into the community.

MALAQUIAS MONTOYA

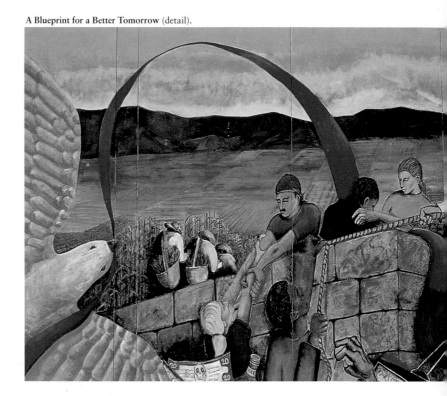

A Blueprint for a Better Tomorrow (detail).

A Blueprint for a Better Tomorrow, 1994, by Malaquias Montoya with students, Will C. Wood High School.

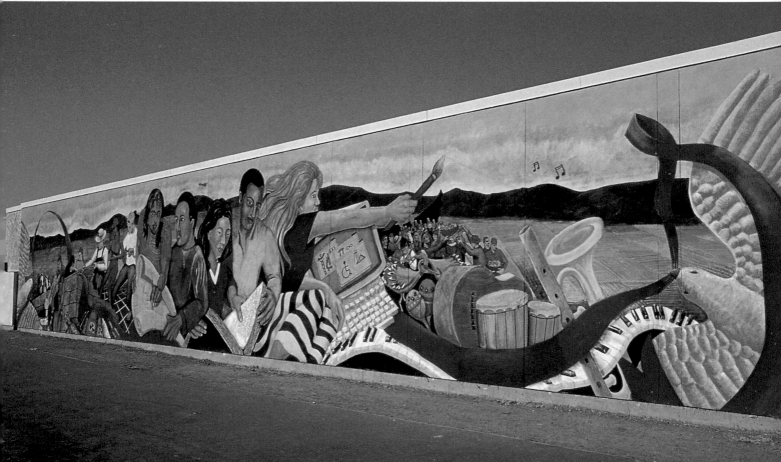

Untitled, 1966, by Lucienne Bloch (assisted by Stephen Pope Dimitroff), St. Mary the Virgin Episcopal Church, Steiner and Union Streets.

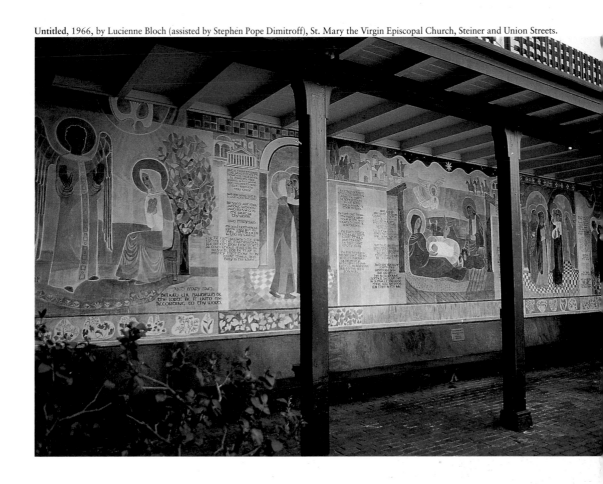

The inspiration for the fresco above originated with a dream Father Hill experienced back in 1965. Father Hill was the priest at that time. He was extremely moved by the visions he saw in his dream and decided to have an artist bring them to life so that they could be shared by all.

My grandmother had seen many paintings of Mary the Virgin. The ones she thought most beautiful were the simplest ones. This is how she has always felt about art. My grandmother's spiritual side can be felt and seen through nature's beauty and reflected in her warm earth tones and the different flora found along the bottom of the mural.

LUCIENNE ALLEN
Lucienne Bloch's granddaughter

Lucienne Bloch was born in Geneva, Switzerland, in 1909, the youngest child of internationally famous composer and photographer Ernest Bloch. In 1932, she worked as an apprentice to Diego Rivera on his frescoes in Detroit and New York. She met her husband Stephen Pope Dimitroff at that time. He was always her technical assistant until his death in 1996.

55

In 1934, 25 artists were brought together to paint murals in the newly completed Coit Tower. They were commissioned by the Public Works of Art Project (PWAP), the first of four federal New Deal art programs developed primarily to provide work to unemployed artists.

The overall theme of the Coit Tower murals is 'Aspects of California Life.' The first-floor frescoes relate to the state's industry and agriculture, as well as city life. Five murals on the second floor depict outdoor recreation. Lucien Labaudt painted depictions of both sides of upscale Powell Street along the staircase connecting the two floors.

At the time this project began, the city was in turmoil–first with the Pacific Maritime Strike and shortly thereafter with the San Francisco General Strike. However, only four of the Coit Tower artists (Clifford Wight, Bernard Zakheim, Victor Arnautoff and John Langley Howard) chose to acknowledge the social unrest of the time, adding details to their murals such as left-wing newspapers, slogans and symbols. Their work generated significant controversy.

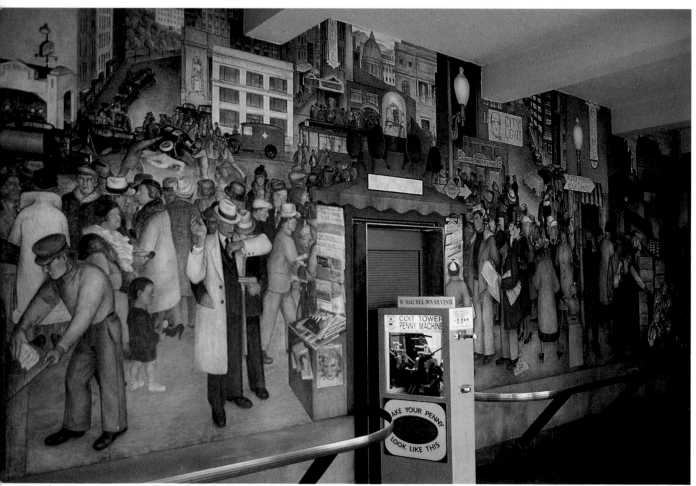

City Life, 1934, by Victor Arnautoff, Coit Tower (first floor), Telegraph Hill.

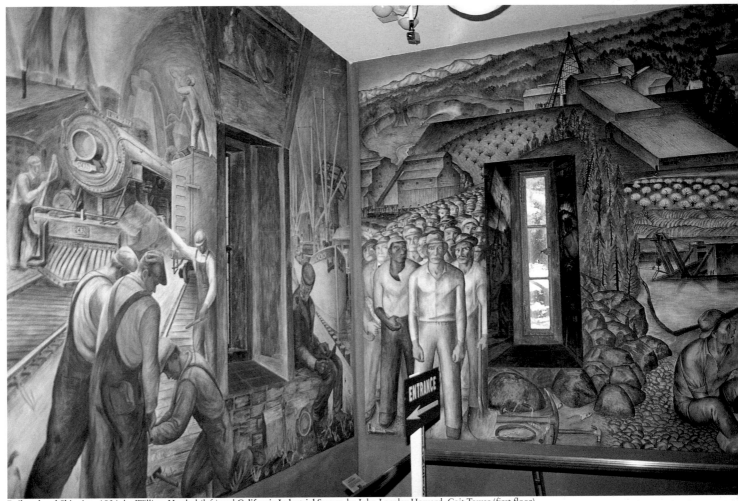

Railroad and Shipping, 1934, by William Hesthal (left) and **California Industrial Scenes**, by John Langley Howard, Coit Tower (first floor).

California, 1934, by Maxine Albro, Coit Tower (first floor).

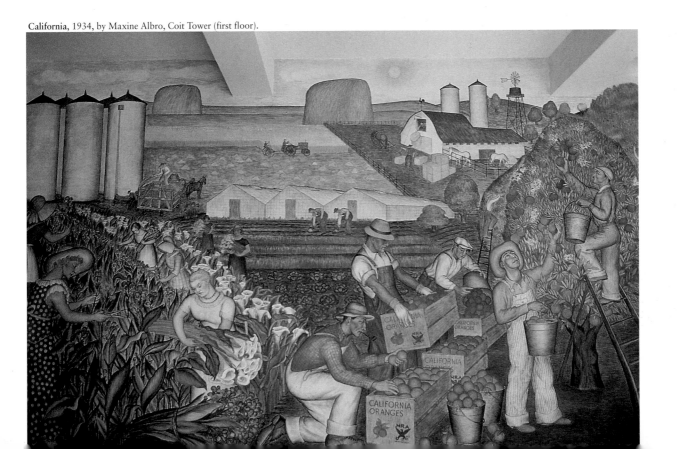

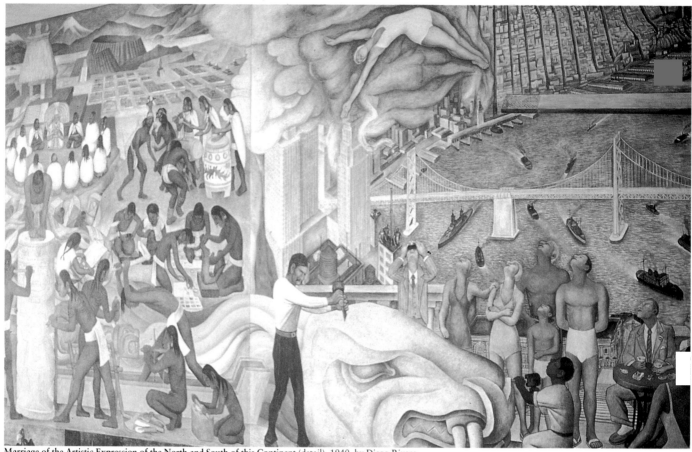

Marriage of the Artistic Expression of the North and South of this Continent (detail), 1940, by Diego Rivera, City College of San Francisco, Little Theater (lobby), Ocean Boulevard and Phelan Avenue.

I completed the mural three months after the Golden Gate Exposition closed. A special day was set aside to present the work to the people. 32,000 automobiles crossed the span of the Bay Bridge to Treasure Island that day. The mural measured no less than 1800 square feet. It was spatially my biggest work.

In this mural I projected the idea of the fusion of the genius of the South (Mexico), with its religious ardor and its gift for plastic expression, and the genius of the North (the United States), with its gift for creative mechanical expression. Symbolizing this union–and the focal point of the whole composition–was a colossal Goddess of Life, half Indian, half machine. She would be to the American civilization of my vision what Quetzalcóatl, the great mother of Mexico, was to the Aztecs.

DIEGO RIVERA
from **My Art, My Life, An Autobiography**

This portable fresco on movable steel frames was painted during the Golden Gate International Exposition in 1938-40, held on Treasure Island to celebrate the completion of the Golden Gate and Oakland Bay Bridges. After the Exposition the mural was crated and stored until 1961, when it was placed at its current location.

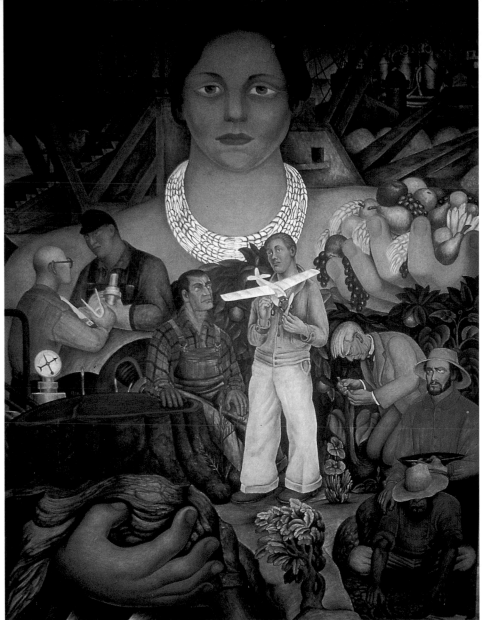

Allegory of California, 1931, by Diego Rivera, City Club (10th floor), 155 Sansome Street, Financial District.

The wall I was to cover flanked an interior staircase connecting the two stories of the Exchange's Luncheon Club. It was 30 feet high. In the central portion of the mural, I painted a colossal figure of a woman representing California. The almost classically beautiful tennis champion Helen Wills Moody served as my model. In portraying her, I made no attempt to formalize her features but left them recognizably hers.

I painted around her figure the rich and varied resources of the state: on her left, the lush agriculture, its workers and heroes; on her right, industry, its buildings and machines, and representative working men and women.

As a symbol of the future I showed a young California boy facing the sky with a model airplane in his hands.

On the ceiling above the wall, I painted a female nude in billowing clouds, symbolizing the fertility of the earth as well as the natural interconnection of agriculture and industry.

I worked on this mural with such complete absorption that when I was finished I was literally exhausted.

DIEGO RIVERA
from My Life, My Art, An Autobiography

SAN FRANCISCO

This was the last government-sponsored mural of the New Deal era. Anton Refregier won the commission in 1941 to paint 27 panels (later changed to 29 to include the war) in an open competition conducted by the Treasury Department's Section of Fine Arts. Although most of the sketches were approved before World War II, the actual work on the walls didn't begin until 1946.

Refregier's history is based on conflict more than achievements, portrayed by groups of people representing classes rather than individual heroes. His radical perspective was approved before the war, but afterwards the changed political climate made these murals much more controversial. In 1953, a local congressman was pressured to introduce a resolution in the House of Representatives to have them removed. According to a handful of organizations, some panels were communist-inspired and cast aspersions on California's history. However, due to strong support from local museums, other art organizations and labor, the resolution never made it out of the Subcommittee on Public Buildings and Grounds.

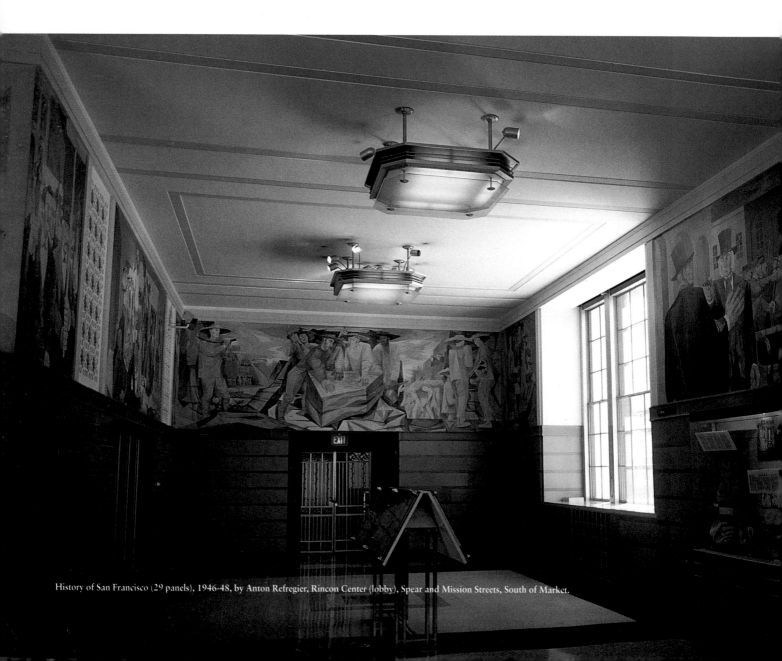

History of San Francisco (29 panels), 1946-48, by Anton Refregier, Rincon Center (lobby), Spear and Mission Streets, South of Market.

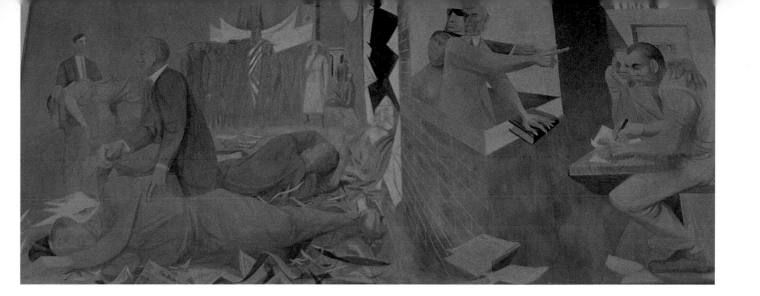

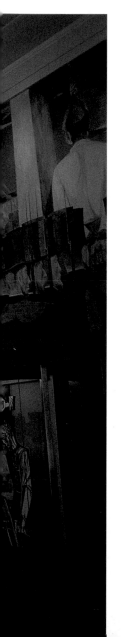

The series of panels begins in the northeast corner of the Mission Street lobby with scenes of Native American life before the coming of the Europeans.

Panel #25 above, **1916--Preparedness Day**, depicts the aftermath of the bombing of the local Preparedness Day Parade, and the trial of Tom Mooney and Warren Billings. Tom Mooney was a labor activist whose trial and conviction aroused international support, due to widespread belief in his innocence. He was sentenced to death, but in 1918 his sentence was commuted to life imprsonment. Then, in 1939, he was pardoned.

Panel #26 below, **Maritime and General Strike**, is about the labor strife on San Francisco's waterfront in 1934. A 'straw boss' is shown on the left side, pointing at a job seeker with one hand and accepting a bribe with the other hand. In the center of the painting, a labor organizer addresses a group of workers.

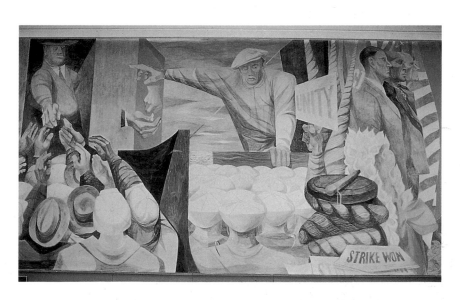

The Galería de la Raza is a community arts organization founded in 1970 by a group of local Chicano/Latino artists in San Francisco's Mission District. The mission of the Galería is to promote public knowledge and appreciation of Chicano/Latino art and the indigenous cultures from which they arise. Galería fulfills this mission through visual arts exhibitions, education programs, multi-media presentations and publications.

One of the unique aspects of the Galería has been its exhibition billboard. When the organization moved to its present site in 1972, the founding artists inherited a commercial billboard on the outside of the corner gallery. The space was used by advertisers to promote products such as cigarettes, junk food and other propaganda not necessarily endorsed by Galería. The artists began to write and paint over the advertisements to include positive images relating to the Chicano community in the Mission District. Eventually, the owners of the billboard site decided to donate the space to the Galería artists.

In 1978, Galería used the billboard site to advertise an exhibition, 'Day of the Dead: Homenaje a Frida Kahlo.' Since then, Galería has continued the tradition of advertising our exhibitions and related programs with this unique mural format. The site is still used by artists, however, to express political or social messages. Examples include a special mural series protesting the Gulf War and the recent immigration backlash in California.

OLIVIA Y. ARMAS
Galería archivist

Recuerdos de Frida (**Memories of Frida**)(temporary billboard), 1987, designed by Michael Rios (standing in the photo), painted and lettering designed by Eva 'Venus' Garcia, Galería de la Raza, 2857-24th Street, Mission District.

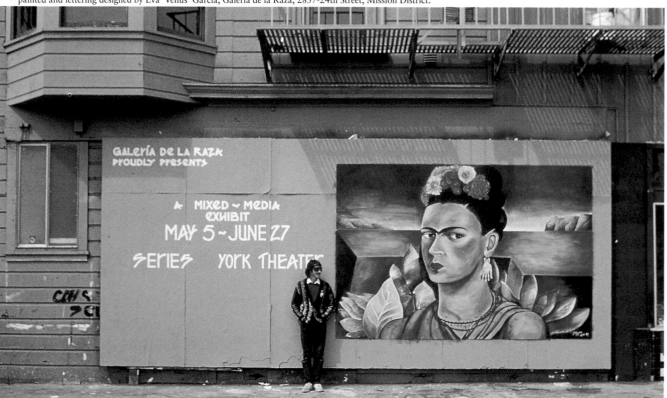

Cruisin' with Magu (temporary billboard), 1991, designed by Gilbert 'Magu' Lujan, painted and lettering designed by Eva 'Venus' Garcia, Galería de la Raza, 2857-24th Street, Mission District.

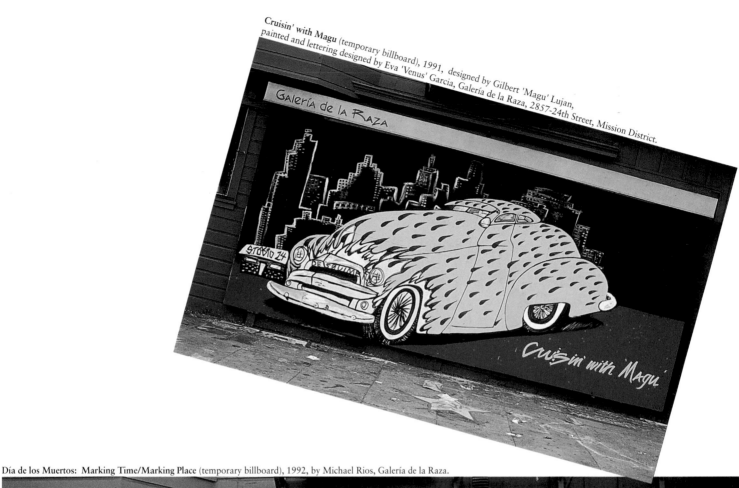

Día de los Muertos: **Marking Time/Marking Place** (temporary billboard), 1992, by Michael Rios, Galería de la Raza.

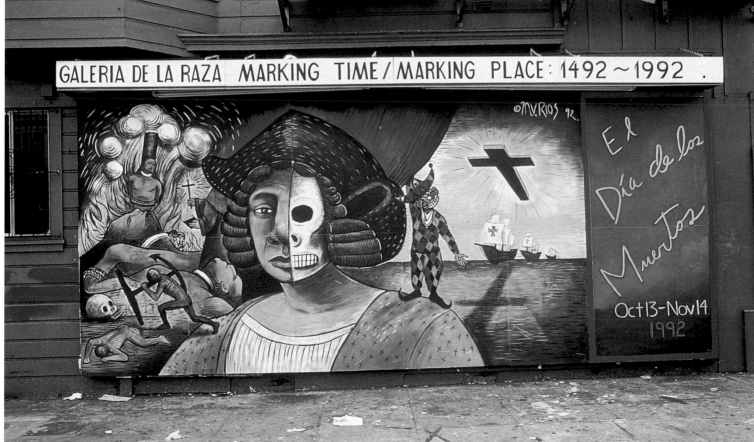

Balmy Alley (near 24th and Harrison Streets in the Mission District) was an early site for murals in the 1970s. In 1973, Patricia Rodríguez, Irene Pérez and Graciela Carrillo painted one of the first murals. The following year, these three former San Francisco Art Institute classmates joined with Venezuelan-born Consuelo Méndez to become the Mujeres Muralistas.

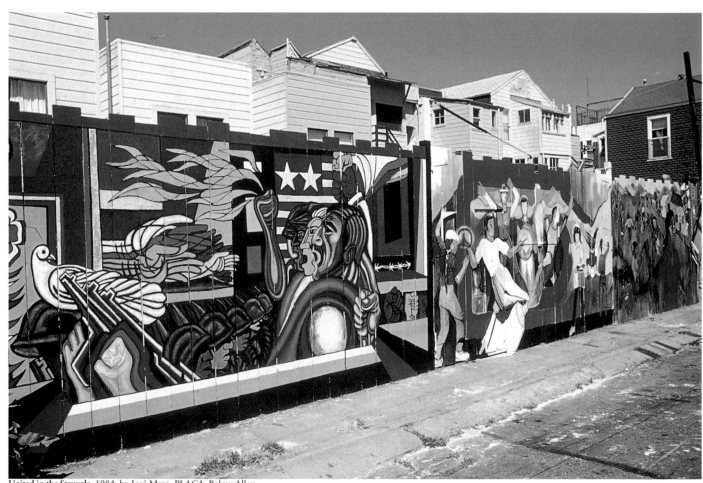

United in the Struggle, 1984, by José Mesa, PLACA, Balmy Alley.

Patricia Rodríguez and I were very good friends since I moved into the area. During nine months in 1984, we organized 36 artists, some working collaboratively and some working as individuals, to do 25 murals on Balmy Street. We called ourselves PLACA, which means the mark the kids make on the walls. Our thrust was peace in Central America. Newer murals more reflect the immediate community.

RAY PATLÁN

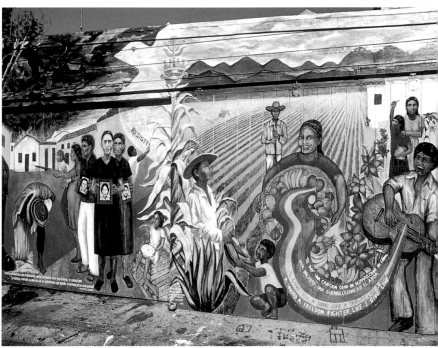

La Cultura contiene la semilla de la resistencia que retona en la flor de la liberacion, 1984, by Miranda Bergman and O'Brien Thiele, PLACA, Balmy Alley.

Give them arms and also teach them how to read, 1984, by Jane Norling, PLACA, Balmy Alley.

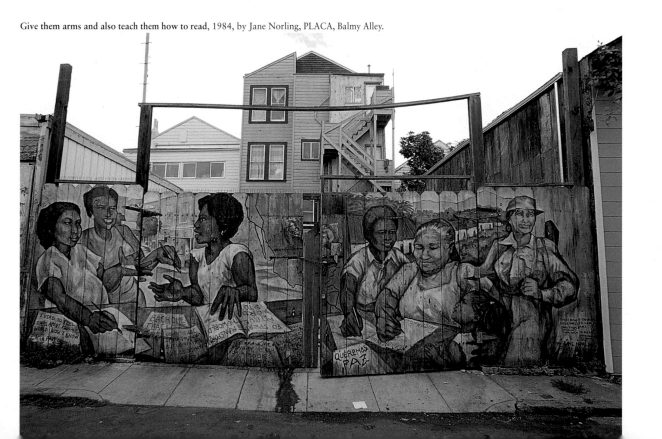

I was one of the founders of the Clarion Alley Mural Project. There were six in the core group: Aaron Noble (we lived in the same place in the alley, and he still lives there; I moved in August 1996); Sebasiana Pastor, a single mom and a teacher; Michael O'Connor; Mary Gail Snyder; and Ara Celli Soriano. We started meeting in the Fall of '92, and started painting in '93. We were very inspired by Balmy Alley.

Clarion Alley was very unkempt. It was mostly used for a shooting gallery and a bathroom. It was a dark alley that people would definitely avoid. It was mostly the backs of houses with a lot of garage doors and a lot of fences. Our idea was to use the walls of the alley to speak of the great diversity in the neighborhood in terms of people and interests and cultures.

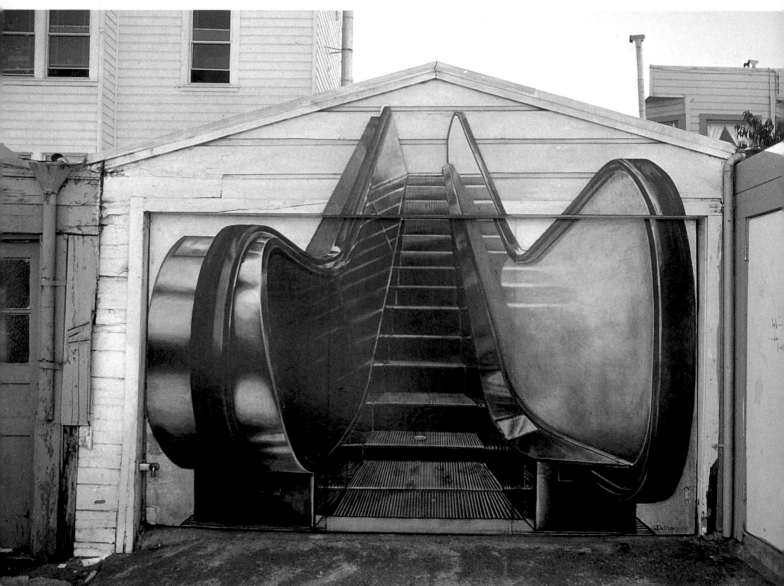

Untitled, 1995, by Julie Murray, Clarion Alley, Mission District.

Untitled, 1993, by Twist, Clarion Alley, Mission District.

The artists who have worked in the alley either live or have a professional life or a community life that involves that neighborhood. Also, we wanted to contribute to the mural tradition. For some of the people who did murals in the alley, it was their first mural, but they had either done a lot of comics or a lot of paintings. People even came from a film background. Also, a lot of people did spraycan work. In several murals we paired an artist with an organization and had them collaborate. We have the American Indian Movement Youth Council, Homes Not Jails, Casa de las Madres (a center for battered women), Horizons Unlimited (a youth organization in the Mission), Galería de la Raza, Precita Eyes and Walden House. We have now close to 30 murals in the alley.

RIGO

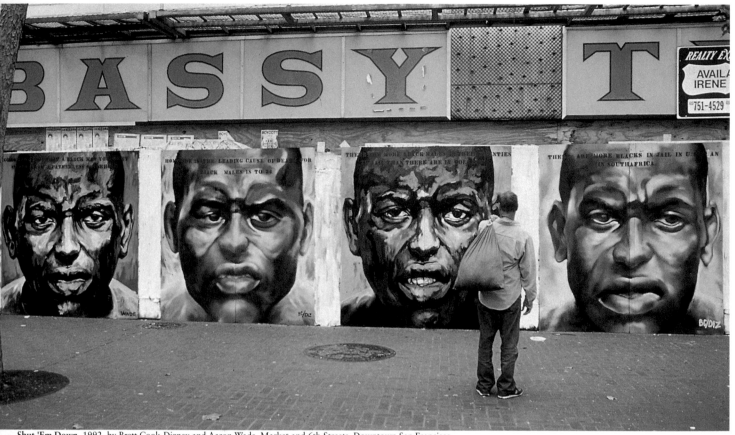

Shut 'Em Down, 1992, by Brett Cook-Dizney and Aaron Wade, Market and 6th Streets, Downtown San Francisco.

The faces were constructed from one image, then we slightly changed the image four times. Two of the portraits were in spray, two in acrylic–that's usually the way we collaborate. That was our fourth collaboration. These paintings were made in our studio and then we went and drilled them up. At the time it was soon after the statistics about Black males had come out in Newsweek. We were really moved by those statistics, and so we put them in red text over the foreheads of those portraits.

I definitely believe that art is something all people can experience, even if they haven't been educated necessarily in the jargon of the art establishment. Public works catalyze something in people that is really significant. I always had the gift of making marks, so I want to share that with people. If that means I'll have to pay for my own materials, do it for free and put it outside where it may not last a long time, I do that. I have a show and 600 people will come. That's nothing to when I do something outside and 600,000 people see it.

DIZNEY

I look at billboards quite a bit. They are a very authoritarian and effective way of communicating. How can I use the same packaging but replace the content? So I use bright, very simple images with a message that asks people to think about what they just saw. This piece is a reminder that something has been lost, or that something is about to be lost for good. The yellow and black stripes signal a warning. I'm playing a litle bit with advertising that always glorifies the winner. So this is sort of a large billboard glorifying the loser.

Personally, I was also taking into account the fact that it was going to be behind a Shell gas station, which is a corporation that has a very nebulous environmental track record. I think issues of fossil fuel, environmental impact of the oil industry and all of that can come into play.

RIGO

Extinct, 1995, by Rigo, 5th and Folsom Streets, south of Market area.

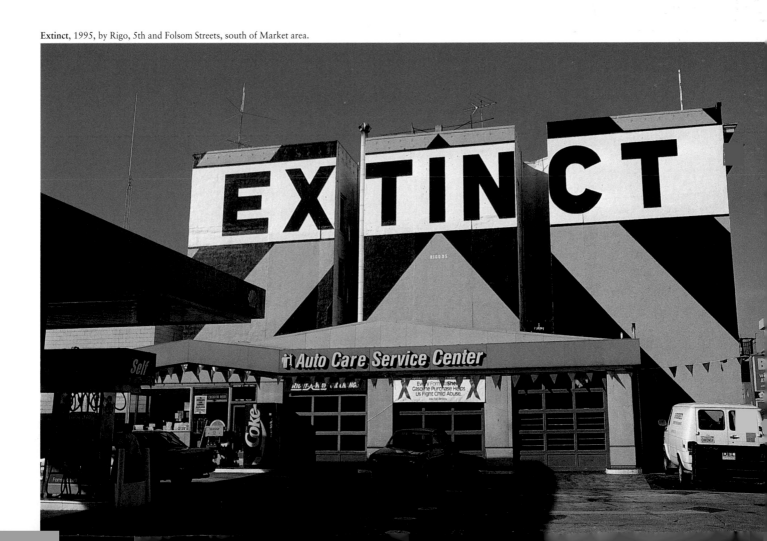

Learning Wall, 1989, by Keith Sklar, Franklin and Hayes Streets, Civic Center.

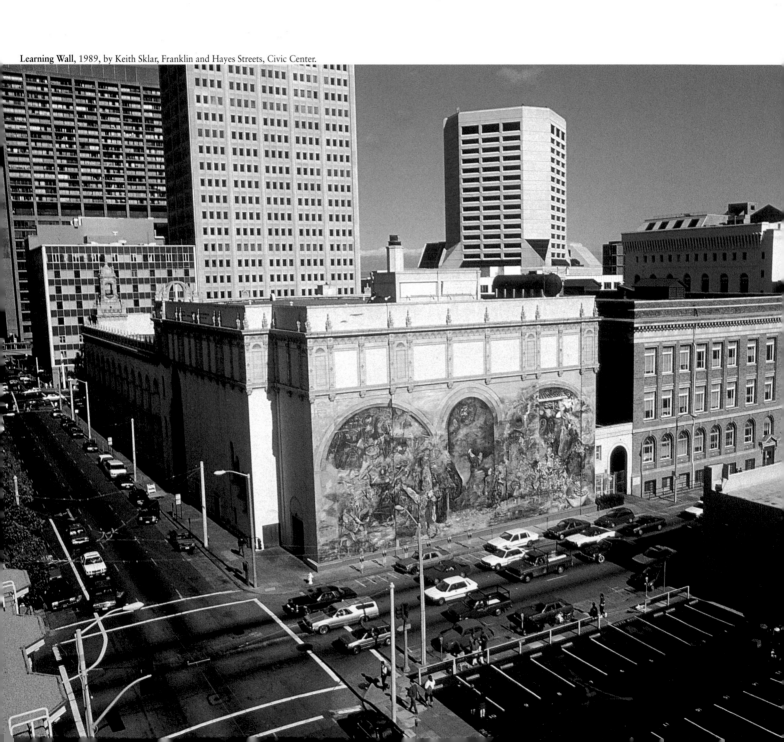

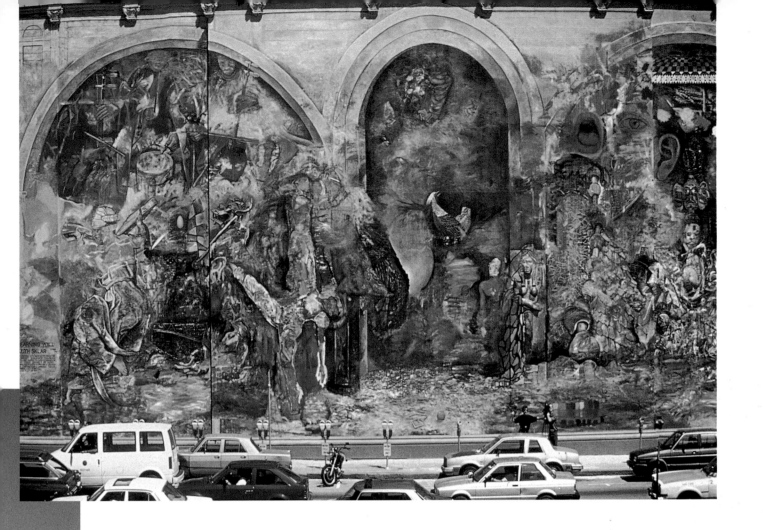

I wanted to paint using studio technique, but on a public scale. So the mural is improvised on the site with the broadly accessible theme of celebrating the diversity of the arts. References to American folk quilts, masks from Ghana, stained glass and Chinese musicians are all merged in this abstract, kind of chaotic-looking composition. It does not look like a mural as much as it looks like a painting. It's about breaking boundaries. Abstract painting is 100 years old already. I didn't feel I needed to pretend it doesn't exist. Typically murals are made by doing a bigger version of something that has been figured out on a smaller scale, which is not an intuitive process for me in the studio. I don't sketch, although parts of my work are extremely tight. The mural is 45 feet by 100 feet.

KEITH SKLAR

We painted the mural for everybody—the bank personnel, the people on the other side of the teller counter and the people walking outside the bank windows. We wanted to represent the many nationalities and mixtures of the Mission.

CHUY CAMPUSANO

Untitled, 1974, by Chuy Campusano with Luis Cortazar, Mike Rios and others, Bank of America, 22nd and Mission Sts. Photo by Sheila Sherry, courtesy of Chuy Campusino.

The artist's first job as a teenager was pattern-cutter for Lilli Ann Corporation, a manufacturer of women's clothes. He worked there for five years.

I want everyone to use their own imagination when they see the mural. It's okay for different people to see different things from the shapes and colors and what they see will change too–and that's all right too. There's no heavy message here, only that these abstract shapes with colors are all around us every day, and everyone sees them differently anyway.

CHUY CAMPUSANO

Lilli Ann, 1986, by Chuy Campusano, Elias Rocha, Samuel Duentas, Roger Rocha, Carlos Anaya and members of Signpainters Local 510, Lilli Ann Building, 17th and Harrison Streets, Mission District. Photo by Sheila Sherry, courtesy of Chuy Campusino.

Our Roots Are Still Alive: Everyone Has a Right to a Homeland, 1995, by Miranda Bergman, Susan Greene, Ina Redmond and Marlene Tobias with community volunteers, Mission and 21st Streets, Mission District.

This mural is a product of a trip I took with three other Jewish women artists. It was during the time of the Intifada (Palestinian civil disobedience in the Occupied Territories of Israel), a very interesting time in history. That struggle was getting a lot of world attention. I just had this flash one day, 'Why not go there and paint a mural as a Jewish woman in support of a Palestinian State.'

We lived in a refugee camp with a Palestinian family for three months. We were welcomed as women, as artists and as Jewish people reaching out in friendship and peace. We had an amazing time. We painted five murals and worked with Palestinians on all of them.

MIRANDA BERGMAN

There are many pieces of the San Francisco mural that are from the murals we painted in the West Bank. We added some portraits of people we met there. The woman in black was part of a group that protested against the occupation every Friday afternoon at many sites around Israel. This woman in particular lost her whole family at Auschwitz. She believes that 'never again' means never again for anybody anywhere.

The dancers are from the Al Fanoon Dance Troupe. They were based at the Cultural Center where we were painting, and we spent a lot of time with them. The little cartoon character is Handela, in a sense the Bart Simpson of the West Bank. His creator was a popular political cartoonist who was exiled and then assassinated. He drew Hondela with his back to the viewer in the corner of his cartoons instead of signing his name.

The image of a weathered old man with Jerusalem on his back is from a painting by a well-known Palestinian painter named Suliman Mansour. Another image from a Palestinian artist is the woman holding an army helmut filled with seeds. A dove is eating out of the helmut.

SUSAN GREENE

I had never worked on a mural. In fact, I'm not a painter. I'm a graphic artist. I was interested in the team effort of going to another country, and bringing a gift of painting a mural to leave behind. Also, the Middle East spoke to me because I'm a Jewish American woman. I had group experience going into hot spots–I had been to El Salvador a couple of times, so I was somewhat tested in that way. The trip was extremely transformative and profound on so many levels for me personally. We made such good friends with the people we painted with. I was the apprentice on the trip. There was no history of muralism in Palestine. I think at first people thought we were ruining their walls by putting marks all over them. Once they saw the paint going on–the vibrancy of the colors and the images really coming alive on the wall–they got excited and, as Miranda calls it, mural magic happened. People wanted to participate, which is exactly what we had hoped.

We made a promise that we would take their story back. Besides putting together a slide show and doing presentations around the United States, we wanted to paint a mural that would depict the incredible colorfulness, strength, humility and love of the people of Palestine that we had experienced. It was really a wonderful vehicle to talk to people about the Palestinian struggle from our experience.

MARLENE TOBIAS

ILWU Mural-Sculpture, © 1986, by the Mural Environmentalists Together in Art Labor (Miranda Bergman, Tim Drescher, Nicole Emanuel, Lari Kilolani, James Morgan, Ray Patlán, Eduardo Pineda, James Prigoff, O'Brien Thiele and Horace Washington), Mission and Steuart Streets, South of Market St. area.

In late 1983 the idea occurred to me that a mural celebrating the 50th anniversary of the 1934 Maritime and General Strikes painted near the local site of the approaching 1984 Democratic National Convention might catch the attention of the many hundreds of reporters and cameramen who would be roaming the area. Those momentous strikes had changed working conditions on the West Coast waterfronts and strengthened organizing for the ILWU.

Muralist Mike Mosher and mural historian Tim Drescher became early collaborators. We successfully enlisted the enthusiastic support and aid of the ILWU's leadership. A group of 13 outstanding muralists, graphic artists and painters were drawn to the project, although by the 1986 dedication the particpants numbered 10.

During the collective design process, the idea of a mural gave way to a freestanding painted mural-sculpture to be placed next to a plaque commemorating Bloody Thursday (July 5, 1934, when two union men were shot and killed) at the corner of Mission and Steuart Streets. A very large waterfront warehouse became the 'studio' for the 3/8-inch metal sculpture that was painted with highly toxic airplane paint. Nights and weekends brought together this group dressed in protective garments, goggles and breathers. At the finish, a crane was hired to carry the six-ton mural-sculpture, painted on both sides of three attached sections, to its final location.

The panels depict working conditions before, during and after the strikes. Months were spent incorporating the many concepts derived from interviews with strike veterans, archival photos and other historical material.

JIM PRIGOFF

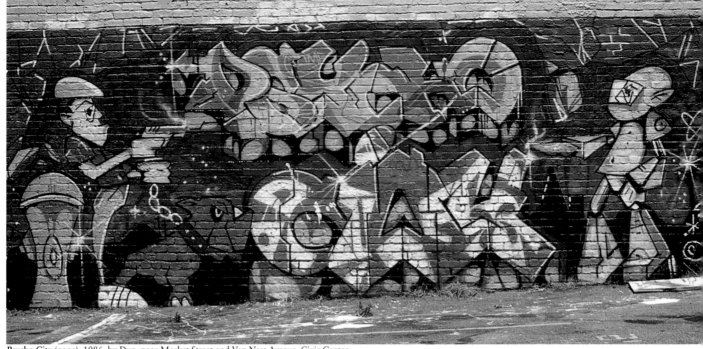

Psycho City (gone), 1986, by Dug, near Market Street and Van Ness Avenue, Civic Center.

Psycho City used to be a parking lot. It was a great yard because it was open and everybody knew about it. It had a centralized location. It wasn't a permission location, but nobody really hassled us. You could say it was kind of a safe haven. It lasted about 10 years. It started with tagging in '84. It was officially named in '86 when Dug did a piece (above) called **Psycho City**.

We had a big party in there back in '92. I mean barbecue pits and breakdancing. There were about 200 people there. A cop came in on Saturday around 4:00 in the afternoon. While he was leaning on his driver side talking to some kids, there were some 20-30 other kids that went ape shit on his car. So he drove off with everyone's tags on his car. The next day, on Sunday, about 15 paddy wagons showed up with a few squad cars and started busting people. That's why it got fenced up.

This (image below) was my first attempt at a 'double vision' piece. It's my 'peace piece'–two words **peace** and **piece** superimposed upon one another. It was a reaction to the San Francisco paint ban in 1991. This picture shows it in its still unfinished state.

<div align="right">NEON</div>

Peace Piece (destroyed), 1991, by Neon, Psycho City, near Market Street and Van Ness Avenue, Civic Center.

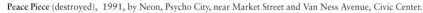

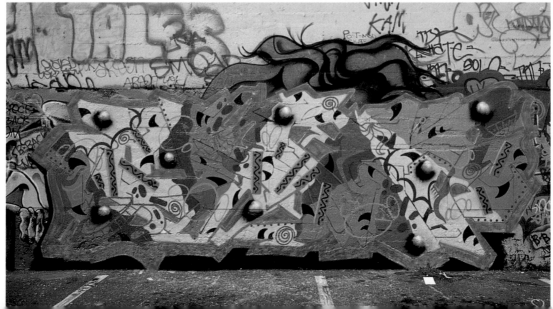

SAN FRANCISCO

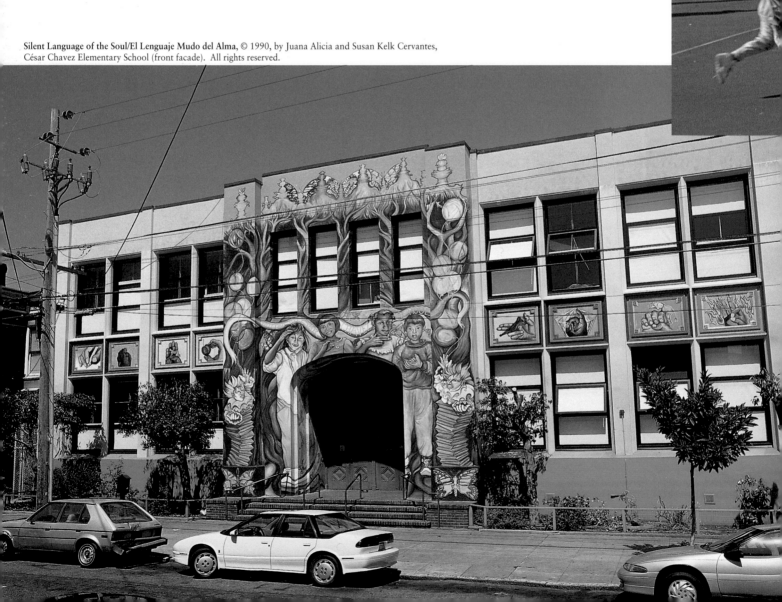

Hawthorne School was one of the most rundown schools in San Francisco. More than 18 ethnic groups attend the school with 10-15 different languages being spoken there. What struck Susan and me most was how a high respect for the diversity of language was everywhere, particularly the deaf program at the school. All the children at the school learn some level of sign.

We did two large columnar vignettes using language and sound and alphabets as the source of our iconography. Each square has a symbol that begins with the same letter in Spanish and English. In the upper right and lower left are the Phoenician and Greek roots of each of the letters.

We wanted to make it a very celebratory mood, and a feeling of a big storybook of language and cultural diversity opening to all the children, making them feel really welcome.

JUANA ALICIA

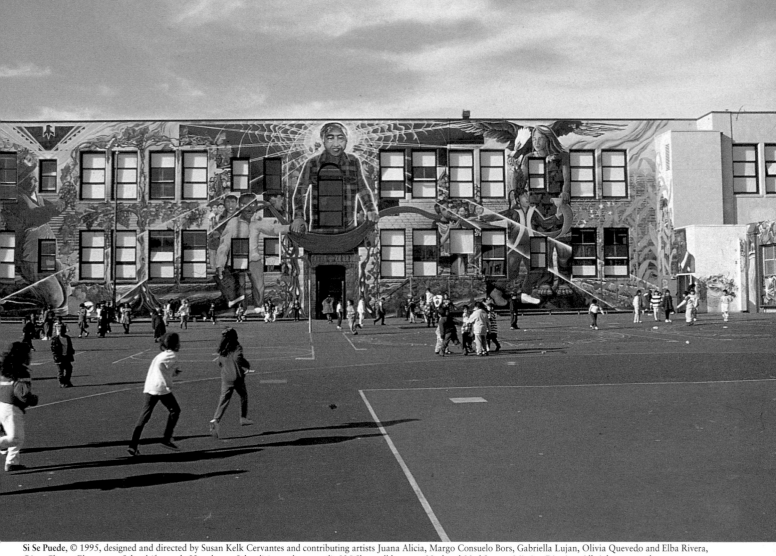

Si Se Puede, © 1995, designed and directed by Susan Kelk Cervantes and contributing artists Juana Alicia, Margo Consuelo Bors, Gabriella Lujan, Olivia Quevedo and Elba Rivera, César Chavez Elementary School (formerly Hawthorne School) (rear playground), 825 Shotwell between 22nd and 23rd Streets, Mission District. All rights reserved.

Si Se Puede pays homage to the vision of the deceased founder of the United Farmworkers Union. He was a labor leader, civil rights champion and educator who served as a role model for children of all ethnic origins. Grape arbors weave between the school's windows, representing the life, work and struggle of the people who have created the agricultural wealth of California. The red grapes symbolize the blood of the workers, and the water their tears.

F*or myself and all the artists who contributed to this work, we were honored to have the opportunity to create a work that ties the histories of all Californians through the example of the life of César Chavez. This mural was created as an important aspect of the educational process at César Chavez School, where art and culture are being integrated as a natural part of the curriculum and by design continues to support the cause for social justice.*

Susan Kelk Cervantes

I was in New York and I looked at the Statue of Liberty. I said that's it!. So I took the statue and I put her on her side like she's homeless, and painted the text, 'Give me your tired, your poor. . . .' The mural is on a homeless shelter. I knew there were objections from the neighborhood about having a homeless shelter in their midst. It kind of pissed me off. I wanted to represent in the mural not only the agony of homelessness, but also the responsibility of our society.

JOHANNA POETHIG

To Cause to Remember, 1992, by Johanna Poethig, Welsh Street off 5th Street, South of Market.

People's Power/**Lakas Sambayanan**, 1986, by Johanna Poethig, Vic Clemente and Presco Tabios, 300 Alemany Boulevard, Bernal Heights.

*W*e were able to paint this mural within a month of the People Power event, right at the moment of kicking Marcos out of the Philippines. It talks a lot about that particular moment in time and the history leading up to it, going way back to colonial times. There are strong images of Marcos' head breaking apart, people in front of military tanks manned by skeletons in fatigues, Cory Aquino holding her assassinated husband, and victims of poverty and repression contrasted by beautiful scenes of a proud past. The symbols in it transcend its actual historical reference, so that it also talks in general about breaking away for political freedom.

Having grown up in the Philippines, I wanted to paint murals about its culture, politics, history and heritage. Filipinos comprise the second-largest Asian community in the United States. I searched for two Filipino artists to work with and assist me in the process and met Vicente Clemente and Presco Tabios. Vic is an ex-political prisoner held in detention for two years by the Marcos regime. Presco is a poet and playwright. We completed our first collaboration, **Ang Lipi ni Lapu Lapu**, in 1984.

JOHANNA POETHIG

81

Black and Tan Jam, 1984, by Dewey Crumpler (assisted by Kermit Amenophis, Bonnie Long and Sandra Roberts), Western Addition Cultural Center, 726 Fulton Street.

This mural is really a celebration of African American culture. The arts for me is what makes my blood circulate. I took the images which were central to the highest achievement in cultural formation, like the Ife head–the Ife queen mother. Then I went to music and added Louis Armstrong and Billie Holiday, two polarities that deal with the highest level of African American expression. I juxtaposed Charlie Parker and Mahalia Jackson. I continued to do this up around this structure in a way that made these figures move through space and time. And to have Duke Ellington orchestrating this whole process is equivalent to Beethoven putting together the whole Europoean high cultural thing.

DEWEY CRUMPLER

The Mime Troupe provided the wall, but it was a neighborhood committee of people who worked with me, giving me direction in terms of what they wanted in the design. They wanted a history of the neighborhood, a history of the building itself–which used to belong to Fantasy Records, now a multimillion-dollar corporation in Berkeley. Mongo Santa Maria, Paul Desmond, Cal Tjader, Lenny Bruce, Eddie Duran–lots of really great artists recorded their music there in the '50s.

It used to be a rehearsal space for Mongo and all of his homies, and is currently the offices of the Mime Troupe, so the Mime Troupe wanted their history on the wall too. There are five different plays going on simultaneously on stage. Frida Kahlo is in the audience. Lenny Bruce is a harlequin sitting on the edge of the stage.

JUANA ALICIA

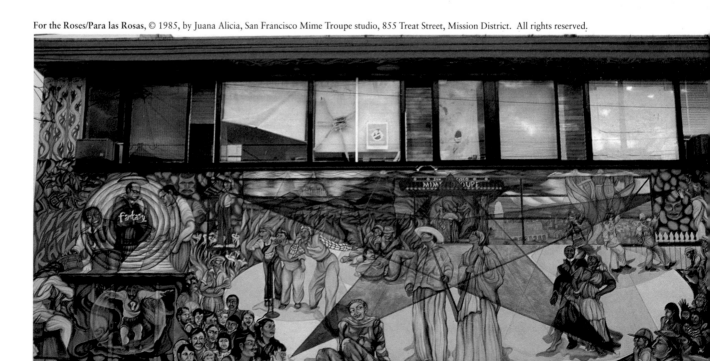

SAN FRANCISCO

Funded by San Francisco's Office of Community Development and the Bank of America–whose building is the canvas–**Reflections** was an attempt to create a mirror image of the Marin headlands reflected in the painted architectural image. I feel the result was only partially successful. This project went through five different locations before it was realized. Notice the painted window mullions were designed to fit the one real window in the wall. The building is currently occupied by Bill Graham Productions.

JOHN WEHRLE

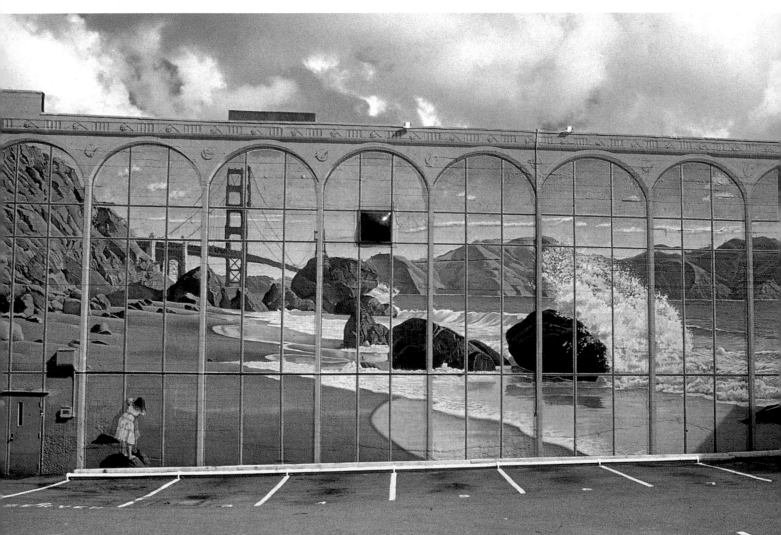

Reflections, 1985, by John Wehrle (assisted by Dan Fontes and Jim Petrillo), 260 Fifth Street.

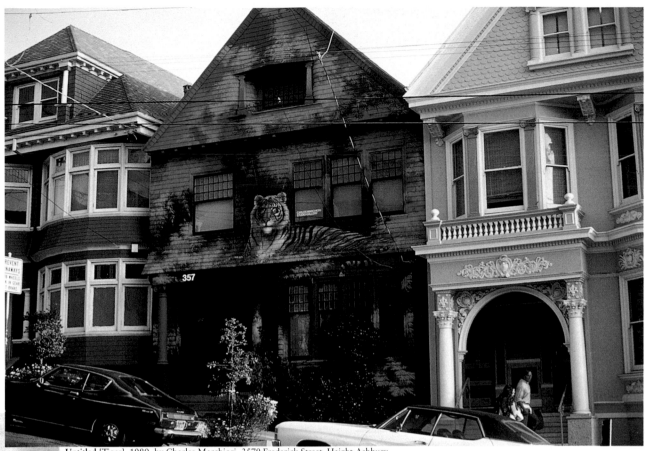

Untitled [Tiger], 1980, by Charles Marchiori, 3579 Frederick Street, Haight-Ashbury.

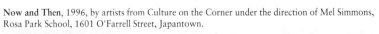

Now and Then, 1996, by artists from Culture on the Corner under the direction of Mel Simmons, Rosa Park School, 1601 O'Farrell Street, Japantown.

Maestrapeace is a history of women of the world over time on a monumental scale. Four heads, each two stories tall and representing mythic females of African, Native American, Asian and European ancestry, gaze at each other from the building's corners.

The mural was commissioned by the Women's Building to celebrate its 15th anniversary and the paying off of its mortgage. It is the nation's only women-owned and operated advocacy, service, cultural and social action center dedicated to the empowerment of women and girls.

I feel we made love to the walls of the building. The way we expressed our message was like composing a song–in color. I'd never done a collaboration before, and the beauty in seven people being of one mind was intensely powerful. I wouldn't have believed it if I hadn't taken part in it.

I kept focusing on the young girls who were going to pass by these walls and see themselves. As a child, I was often discouraged from doing art because it was not a _woman_'s career, especially for a woman of color. Part of my reason for doing the mural was to destroy that myth. I wanted women and girls to know they are empowered, that they can do anything.

I almost didn't do the mural. I had never climbed a scaffold, nor did I know a great deal about blending colors on such a large scale. My background is more in graphic arts and design. I remember the first day. Surveying San Francisco's skyline and feeling the wind at my back, I reached the top of the scaffold and prepared to begin painting. I was starting with the Native American (Olone tribeswoman), a two-and-a-half-story head in the top right corner. I had mixed my colors and held the brush in my hand. I suddenly realized I couldn't touch the building! I was terrified that I might mess it up. It was like stage fright. All my insecurities came rushing at me as I sat there looking out over the city. Gratefully one of my sister artists climbed up to where I was. She dipped the brush in paint and, with a few strokes and some gentle nudging, jump-started me into a year's painting frenzy. I really appreciated Juana for doing that.

YVONNE LITTLETON

The mural is a fabulously colored, deeply detailed tribute to the often-hidden history of women's contributions to societies worldwide. It honors both famous and unsung women, highlights political activism, artistic and scientific achievements, and proclaims the healing power of women's wisdom for the ills facing today's communities. The figuration spans centuries, through the combination of ancient spiritual icons and modern portraiture of women in all stages of life. Carefully rendered fabric patterns weave across the four-and-a-half story walls, and nearly 500 calligraphed names of women convey a depth of cultural diversity and inclusion. Among the many women and cultural icons celebrated are 1993 Nobel Peace Laureate Rigoberta Menchu, Georgia O'Keeffe, Audre Lorde, Coyolxauhqui, Yemeyah, Guanyin, Hanan Ashrawi, Lillian Ngoya, Joycelyn Elders, Lolita Lebron and Niuta Teitelboim.

MIRANDA BERGMAN

Maestrapeace, © 1994, by Juana Alicia, Miranda Bergman, Edythe Boone, Susan Cervantes, Meera Desai, Yvonne Littleton and Irene Pérez, Women's Building, 18th Street and Lapidge Street, Mission District. Photo by Cesar Rubio and designed by Josh Sarantitis.

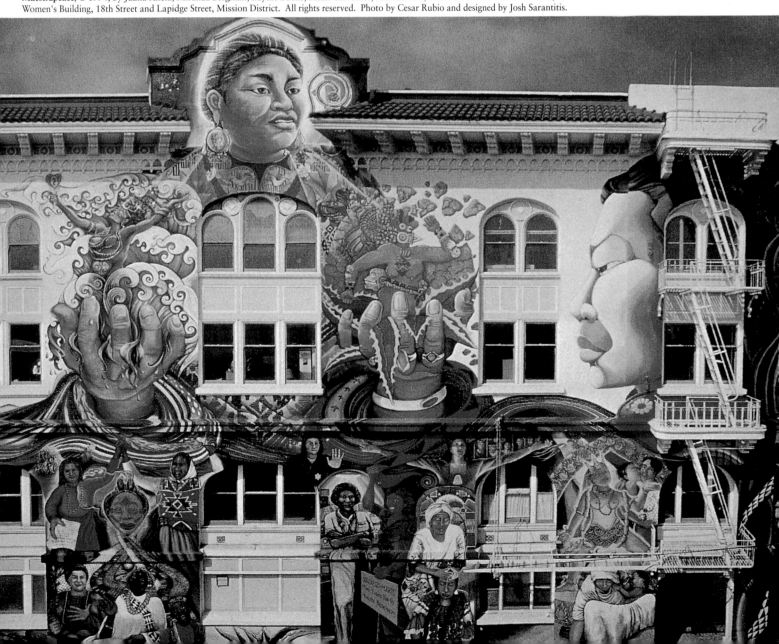

One Tree, 1995, by Rigo, 10th and Bryant Streets at the 101 Freeway, south of Market Street area.

I got permission to use the wall, but there was this tree that seemed to be in the way. The tree started as an obstacle to painting a mural, and then I decided to approach it differently and incorporate the tree in the mural.

I wanted to call attention to this natural element in a part of the city where there's very little of that. It's mostly a light industrial area--warehouses, concrete, cars. Colliding organic, natural life with city, human stuff.

It works on a humorous level as well. The sign either makes no sense or too much sense, it's so obvious. I see that, so what? People go by so fast that they don't have time to sit with the work and resolve it. You have to deal with it from memory.

RIGO

T he whole idea was to capture the movement and the color and the music of the Carnaval festival. The mural depicts images from throughout the world, including Brazil, Mexico, the Caribbean, Bolivia, Peru and Europe. The subject was selected because the parade of the Carnaval festival in San Francisco ends just a few blocks from the site. It's a two-day festival celebrated in May, and both days there are booths set up in front of this wall.

JOSHUA SARANTITIS

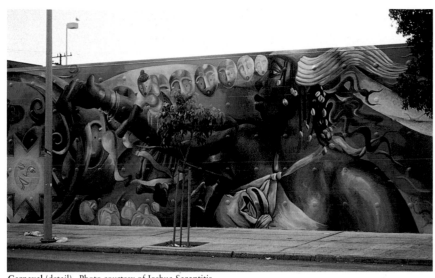

Carnaval (detail). Photo courtesy of Joshua Sarantitis.

Carnaval, © 1995, by Precita Eyes Muralists (Joshua Sarantitis and Emmanuel Montoya) and assisted by Carlos Loarca and about 25 volunteers, Harrison Street between 18th and 19th Streets, Mission District. All rights reserved.

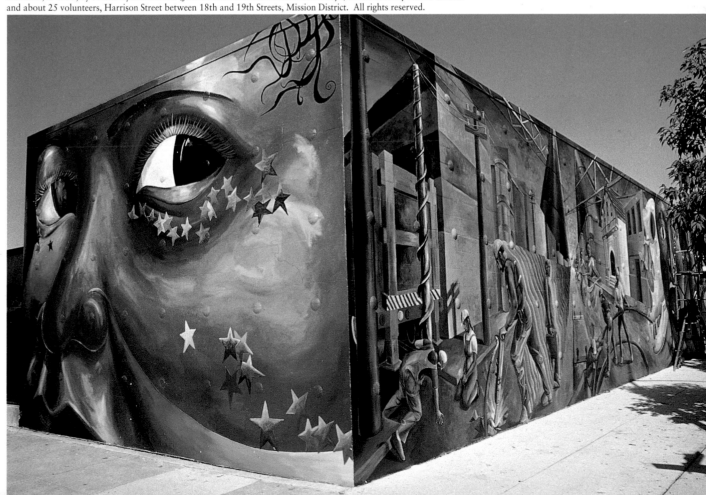

This was a real community project. We had a lot of meetings with residents who lived across the street, and did many workshops. There are monumental portraits of five endangered species: a bald eagle, an American crocodile, an ocelot, a buffalo and a rainbow trout. The backdrop is a bizarre urban landscape that's being overtaken by natural forms. Along the base are ceramic objects embedded in concrete. made by local schoolchildren.

JOSHUA SARANTITIS

Frisco's Wild Side (detail), © 1995, by Precita Eyes Muralists (Joshua Sarantitis, Dierdre Weinberg, Clair Bain, Chris Kirby, Peter Collins, Estria, Spie), plus about 25 adult volunteers, and students from Bessie Carmichael School, Maltby Electric, Langton Street between 7th and 8th Streets, south of Market area. All rights reserved.

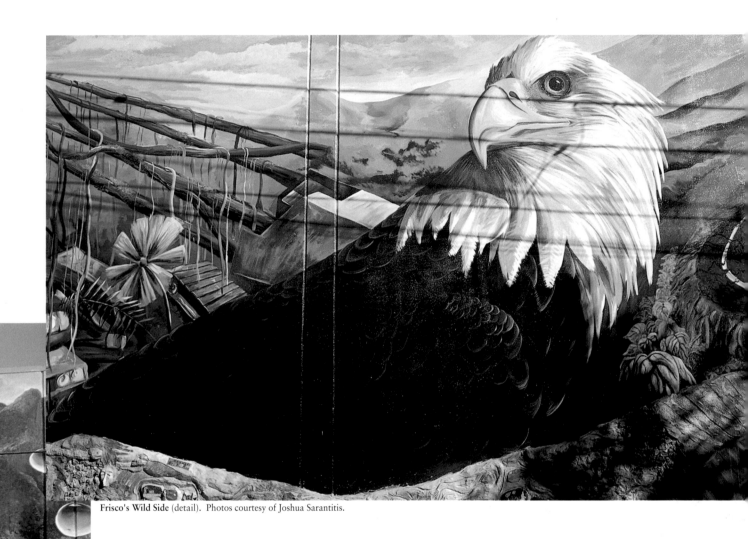

Frisco's Wild Side (detail). Photos courtesy of Joshua Sarantitis.

If you look at all my pieces, everything I've done is different. I never try to have a signature style. I've been doing graffiti since '84. I started in Hawaii. I'm from there. I went out and tried it first with a portable airbrush from model kits after seeing movies like 'Breaking' and 'Beat Street.' That didn't work but I liked the experience.

I came to the Bay Area for college (the San Francisco Academy of Art). In the first week I met Crayone, and he was doing these huge, elaborate constructs. I was like, damn, you really can do anything with just spraycans. That became a goal for me.

Christina (below) was an old girlfriend. She's now getting married to somebody else. That piece is gone now and I've done another piece over it.

The portraits to the right are of my old partner Crayone (upper left portrait) and myself.

When I started out, everyone was making up their names by using the New York ethic of taking a word that was meaningful, like Seen, Risk, Dare–those kinds of names. I knew I was going to be an artist–not just a graffiti artist–and so I should have an original artist's name. So I played around with the letters I like and sequences that I could draw well. After playing around with it for a month or two, I ended up with this.

ESTRIA

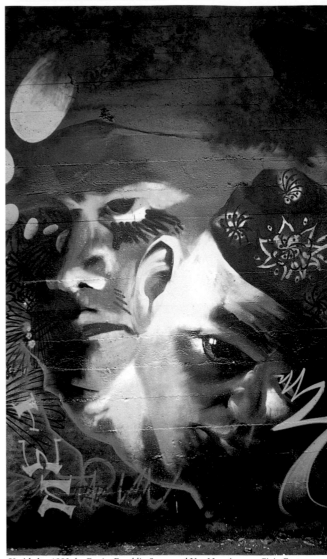

Untitled, c.1992, by Estria, Franklin Street and Van Ness Avenue, Civic Center.

Christina (destroyed),1996, by Estria, Coors Yard.

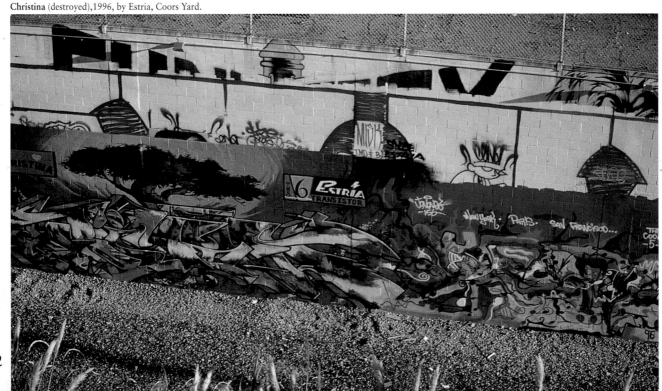

We wanted to do something really huge that no one had done before. When we look at the magazines or the European books, they're just going off with huge murals and backgrounds. San Francisco doesn't really have anything like that going on, so we wanted to show that we can go off on a master scale. We pulled it off. It's about 18 feet tall by about 35 or 40 feet wide. We had a scaffolding for the first half and then we finished it on a ladder. It took us about a month.

The McCune Building is actually the Coors Yard because it used to be the Coors Beverage Company. The original wall belongs to a music studio. I happen to know the guy that owns it, so it's kind of like my yard now. It used to be called Funk City but funk died out by late 1988. My band moved there in '90 and I began to bring people back there. Soon word of mouth caught on and everybody goes there, but the main wall is still respected as the hardcore stylists' wall.

NEON

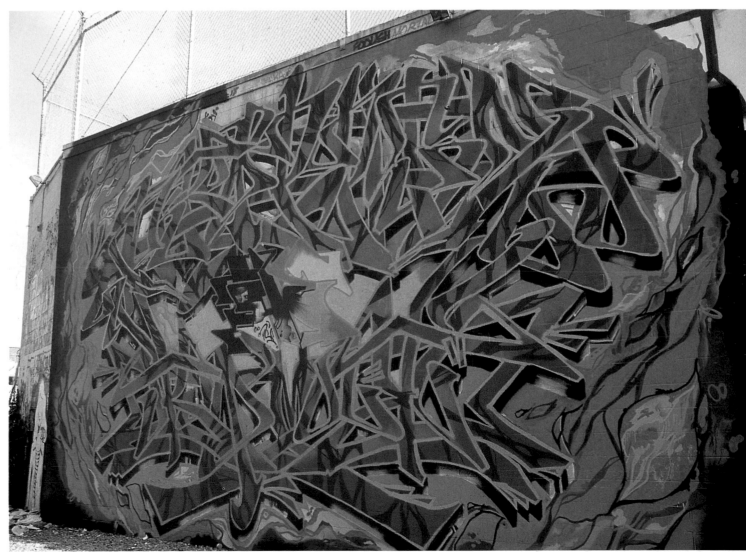

Droppin' the Bomb, 1996, by Misk and Neon, Coors Yard, McCune Building (rear).

T he Evolution sketch was conceived during a three-day period of inspiration. I painted it at the Crossroads Cafe at USF because I thought it looked great there, and I felt it wouldn't last at a yard. It's funny how certain pieces will run for months, even years, and others get hacked in a matter of days. This was my most ultimate wildstyle sketch, so I felt the need to 'protect' it.

I've been doing graffiti for about 10 years. My style is a combination of New Wave and Funk. Funk is a common 'mainstream' style, stuff you'll see coming out of any city now–like train pieces, anything that's pretty much readable. My style is more abstract. It's local to San Francisco. I'm the last current guy who runs it on a regular basis. It's where basic letter formation is more emphasized rather than the overall design of the piece. Each letter should stand on its own, like a font.

NEON

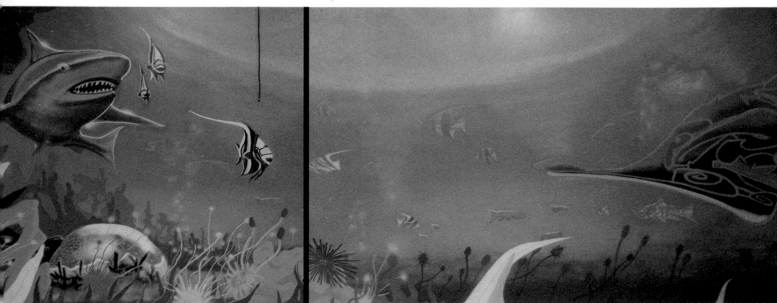

Evolution (joined details), 1996, by Neon, Crossroads Cafe, University of San Francisco, Turk Boulevard between Stanyan Street and Masonic Avenue Photos courtesy of the artist.

Dean, 1988, by Dean, Norfolk Alley.

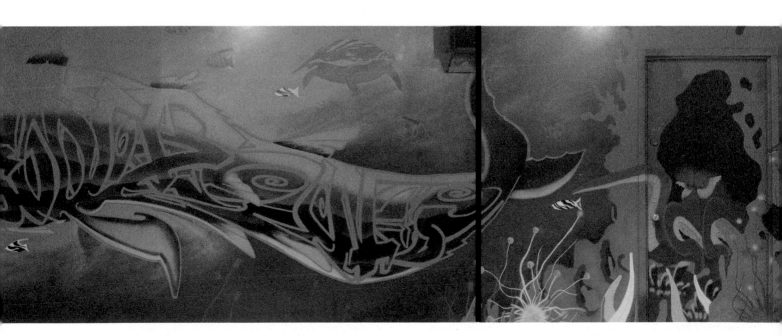

This mural was designed to commemorate the successful lawsuit that resulted in the recent formation of Thurgood Marshall Academic High School. Students attending this school aspire to careers in math and science, and come from areas of the city previously underserved by science-oriented college preparatory schools. Part of the school's philosophy is to integrate community activism with academic curricula. Each year students must do a special project in which they identify problems in the community and develop solutions. Because the community and student populations are ethnically very diverse, facilitating cross-cultural understanding has been an important area of student inquiry.

The **United We Stand** mural began as a project proposed by students of teacher Maggie Harrison's English-social studies class. The students and I met as a mural club for a semester, seeking a theme that would represent values and experiences held in common across the community. We researched local history, interviewed residents, brought in images and stories. The resulting theme is a positive view of immigration and work, a reminder that immigrants and native-born share in a vision of a future life enriched by meaningful work. Along the way, we should not forget the difficult times we overcame. A symbol of this is seen in the highway sign near the center, representing the danger of immigrating without documentation.

JAN COOK

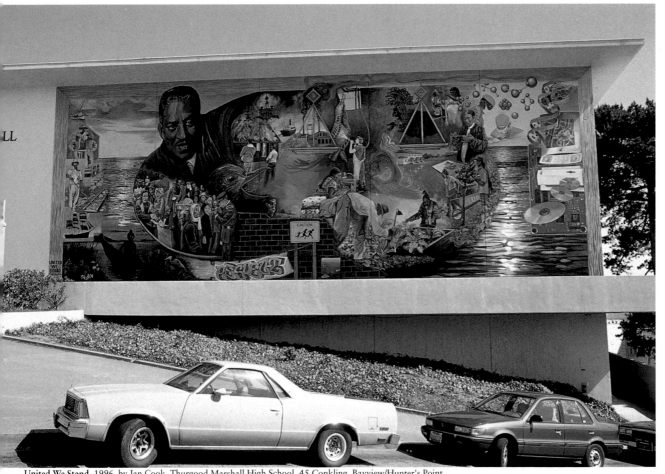

United We Stand, 1996, by Jan Cook, Thurgood Marshall High School, 45 Conkling, Bayview/Hunter's Point.

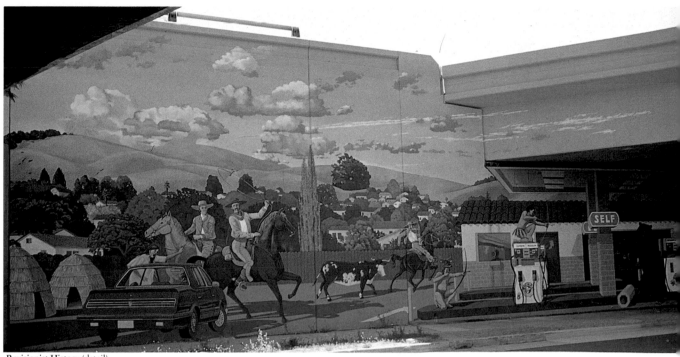

Revisionist History (detail).

Revisionist History, a 265-foot-long mural commissioned by the city of Richmond, juxtaposes the past and present in a whimsical history lesson. The Richmond arches span San Pablo Avenue using the I-80 freeway overcrossing on the north and south ends to frame the mural on the east wall, and creating a natural gateway from the formerly nondescript structure. Californios, Ohlones and the wildlife which previously inhabited the area are seen interacting with present-day residents in a contemporary street scene. Text and signage from the present-day storefronts make reference to historical eras and the area's cultural context.

JOHN WEHRLE

Revisionist History (detail), 1993-96, by John Wehrle, San Pablo Avenue at I-80.

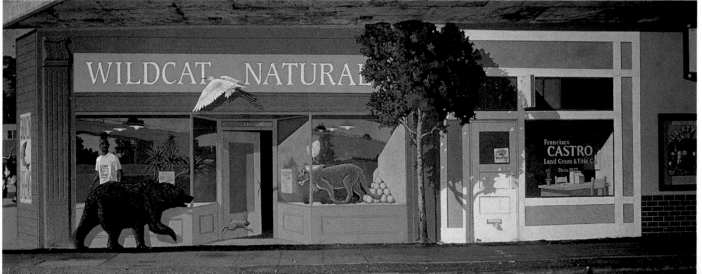

97

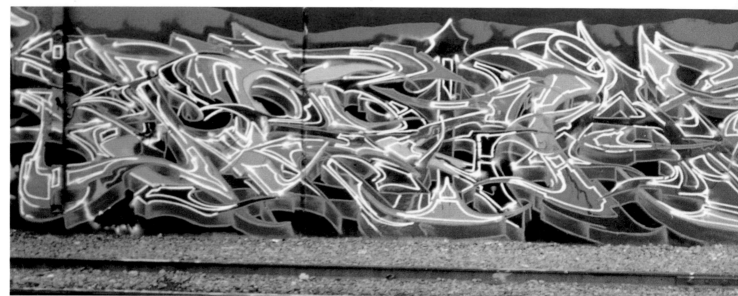

Untitled (detail), 1996, by The West Coast Poem and Poesia, Oakland train tracks. Photo courtesy of Poem.

U p North (in the San Francisco Bay Area) *where we're from, it seems like graffiti has always revolved around letters and flippin' crazy styles. Oakland writers seem to focus more on letters and not so much on characters.*

POEM

Sweet Dreams (destroyed), 1987, by Dream, Oakland train tracks.

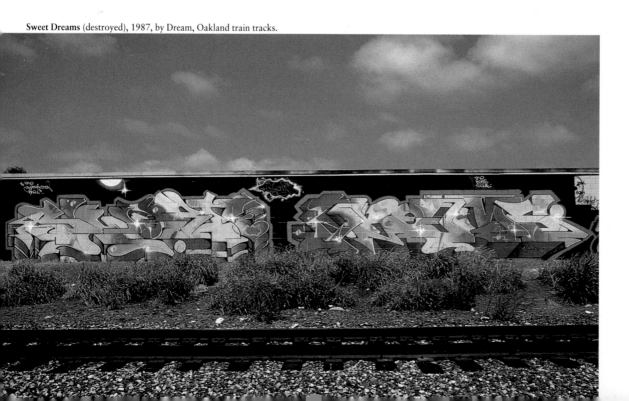

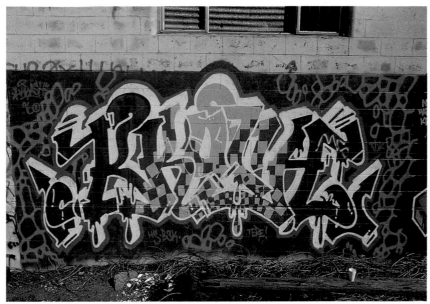

Untitled, 1996, by Krash, Oakland train tracks.

Untitled, 1996, by Giant, Amtrak at 62nd Street.

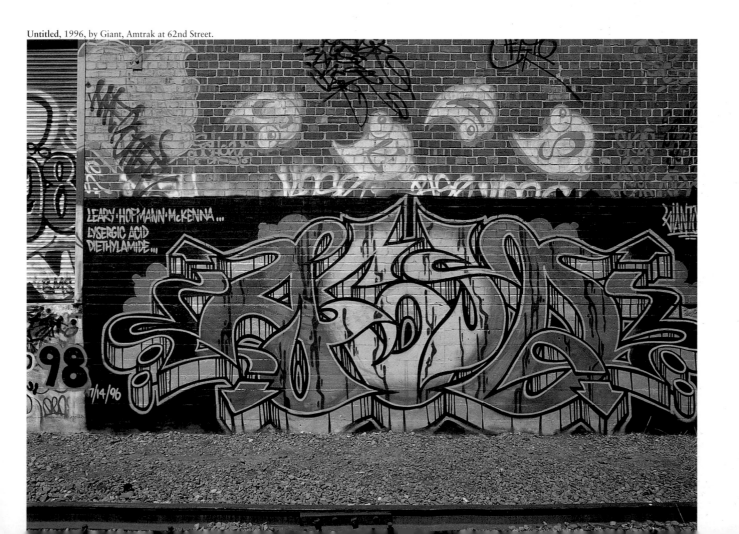

Mitzvah: the Jewish Cultural Experience, 1985, by Keith Sklar (assisted by Brooke Fancher and Dan Fontes), 1404 Franklin, downtown.

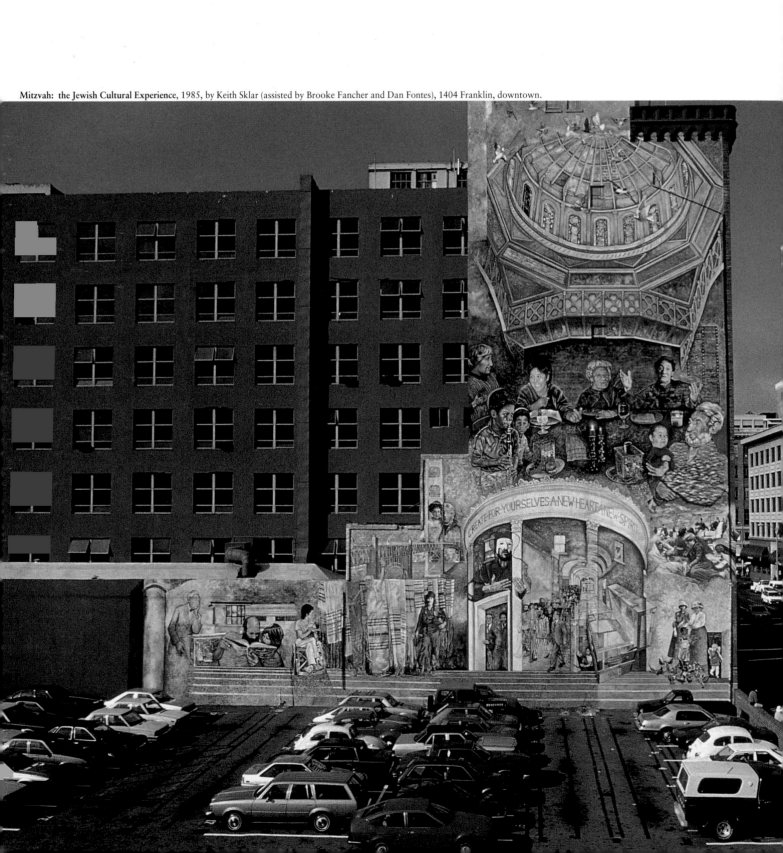

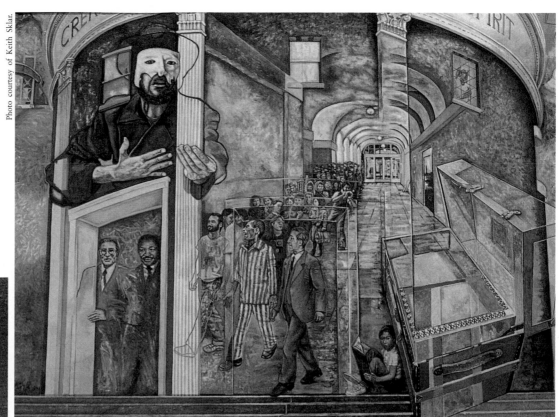

Pe018eople in the mural are local Bay Area people, such as Harvey Milk, Gertrude Stein and Rabbi Heschel–he was a local activist rabbi who for years marched with Martin Luther King, Jr. Then there are local Jews who are Asian, Black and Chicano in the mural. So it breaks apart a stereotype of what it looks like to be Jewish. These are not converted people. These are people who grew up that way.

The top of the mural is the interior dome of the Reform temple in the area. The central bottom architecture is of the nearby Conservative temple fused with the Berkeley Jewish Community Center. The Orthodox temple is on the left side.

The mural is 108 feet tall.

KEITH SKLAR

101

We wanted something showing the diversity of arts in the East Bay, particularly Oakland. So we had people scout around for different groups, anything from the San Francisco Mime Troupe to a Congolese dance company. Jack London is in there. Malvina Reynolds, the folk singer, is in there, and Judy Grahn, a gay poet and author. There's a kid from a nearby elementary school who's doing ceramics.

The structure of the mural is that when you walk along the mural, you get higher up in the air over Oakland. The entire bottom third of the mural is this aerial view of Oakland. It's 132 feet long. The end with Calvin Simmons, the late conductor of the Oakland Symphony, is 28 feet high. It angles down to 16 feet in height at the low end.

KEITH SKLAR

Grand Performance (detail), 1984, by Daniel Galvez and Keith Sklar (assisted by Brooke Fancher, Dan Fontes and Karen Sjoholm), I-580 underpass at Grand Avenue.

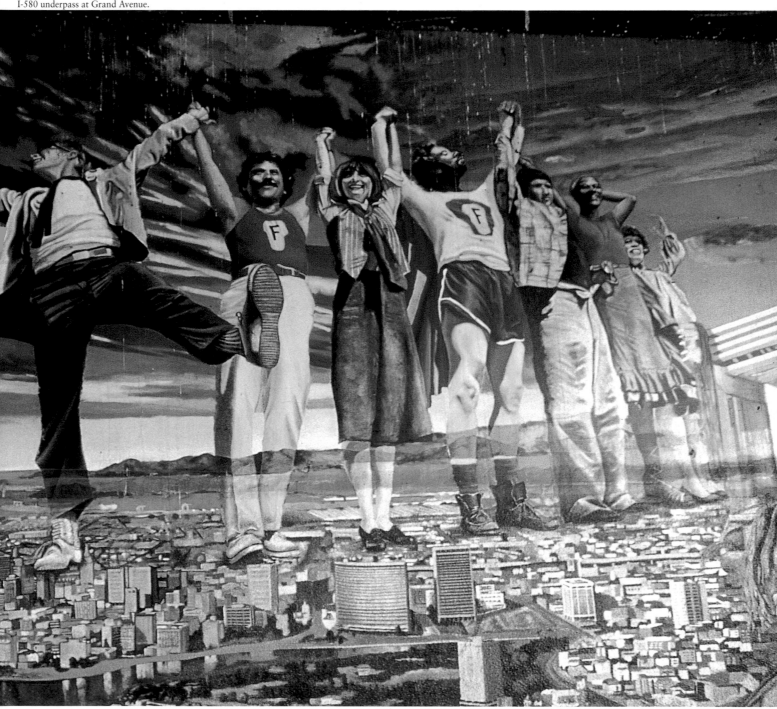

Marilyn, 1990, by Phresh, East 14th Street at East 15th Avenue, Central Oakland.

A t the time I did this, there was a real push in the graffiti scene to innovate the art form. It wasn't really a formal challenge, just a friendly competition between me, Vogue and a few people from San Francisco (TWS, Crayone and Estria). Vogue had always done portraits, but he had never done one in color. We were all trying to push the boundaries at the same time.

I thought I'd try to do a recognizable face. Also, I wanted to integrate some airbrush techniques into aerosol art that hadn't been used before. The big silver thing with the pipes was the part I innovated with airbrush. **Marilyn** was practice in color theory, too.

This piece was probably the best work I've done. Since then I've gone back to simple lettering, easy to read type things–the basics of graffiti–to get back in touch with the roots of it all. I got started in '83 or '84–when **Subway Art** came out. Everybody saw that, plus movies like 'Beat Street' and 'Wildstyle.' That was when the West Coast took off, both L.A. and up here.

PHRESH

I t's a guy when he first started out in the city, trying to do the biggest and the baddest. We were seeing a lot of Mexican murals. They were so colorful. We got influenced subconsciously. Not really trying to take their style. We were saying, "When I do my piece, I'll try to be the most colorful." I want to stand out. In New York, they use what they can, because most of them steal their paint. In the beginning, in the Bay Area, a lot of people were buying paints. So I buy my paint to go from yellow to orange to red to blue to purple.

I went outside San Francisco and started doing murals in Oakland and Berkeley, started getting hooked up with all the writers out there. One of the writers told me that a lot of people were getting up on this school wall in Berkeley. The character in the mural was comic influenced. It came out of comic books. I tried to integrate my letters with the monster in the background.

This piece was never completed. On the second night, cops rolled around the corner. As I saw the lights, I started throwing the cans over the top of the police car into the park. I pretended to be asleep, like I was a bum or something. There was one can of black paint on the ground. The cop said, 'If I go up to the top of the ladder and the black paint is wet, you're busted, buddy.' So she went up there and touched the black paint and it was wet. She came back down, but she didn't have any proof. She told me to go home, actually. She felt like I was an artist and not bothering anybody. It was weird for me because that was when I was first starting out. It was one of those crazy days when you go outside in the Bay Area at night. I had a great time.

CRAYONE

Secura (destroyed), 1986, by Crayone, Berkeley.

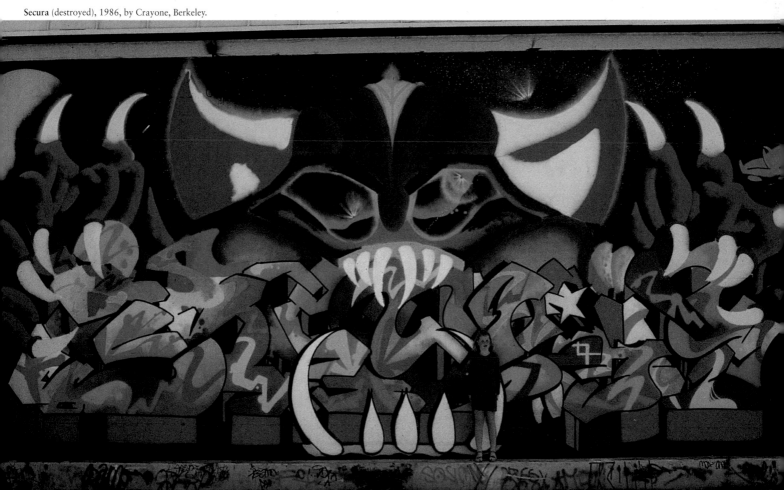

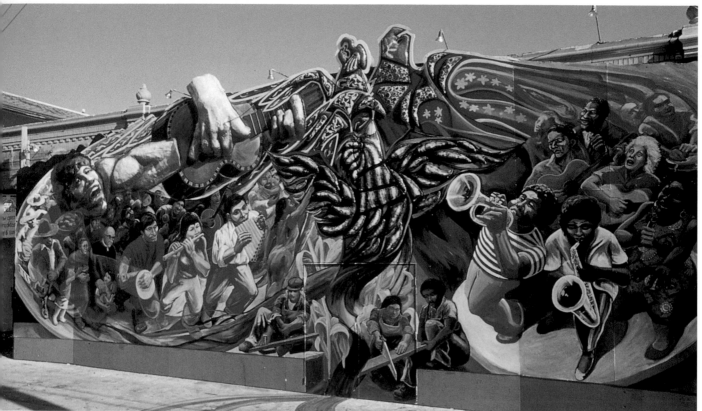

Song of Unity, 1978 (repainted in 1986), by Anna de Leon, Osha Neumann, Ray Patlán and O'Brien Thiele, La Pena Cultural Center, 3105 Shattuck Avenue.

The most important part of the mural to us was the portrait of Victor Jara, and the incident that occurred in the stadium (in Chile after the military seized power from Salvador Allende), where his hands were taken off. So we used that as a model of artists working along with political struggle, and the determination of artists to be part of everyday life. We used his hands playing the guitar by themselves, angelic-like.

This was one of the earliest murals to use experimental sculpture and relief forms. We used ceramic and we also used papier-maché, dipped in polymer medium to plasticize it. The people who worked on it were artists from different approaches to art: myself, a veteran muralist from Chicago; Anna de Leon, who was a baker and a ceramicist; O'Brien Thiele, a self-taught painter who was primarily doing house painting and had some experience with building materials and construction; and Osha Neumann, who had already been doing mural work in Berkeley with a group called Communarts–which we all became part of eventually.

RAY PATLÁN

During the U.S Bicentennial there was a lot of celebrating and fanfare. In the same spirit, I thought it would be appropriate to commemorate a more recent revolutionary period, the Sixties.

The outpouring of community support that followed showed that Berkeley agreed. To this day, Berkeley has no statue, plaque or memorial of any kind–other than the mural itself–to commemorate the events of those years that shook the city and the nation.

OSHA NEUMANN

The **People's Park Mural**, 1976, by Osha Neumann, Daniel Galvez and others, Haste Street and Telegraph Avenue.

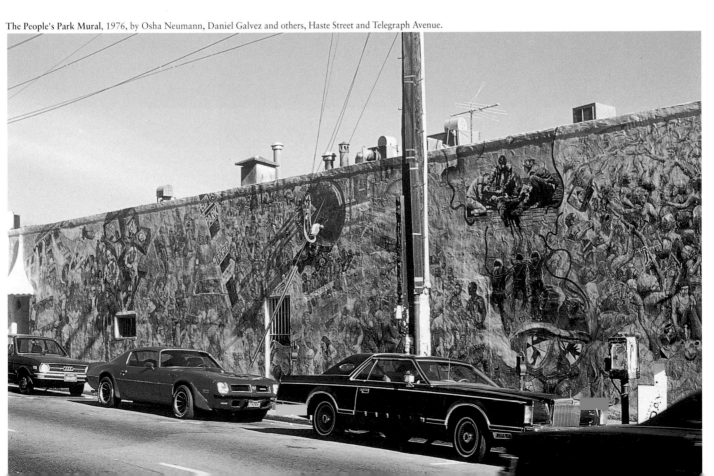

Prometheus Gives Fire to Man, 1996, by Nicolai Larsen (assisted by Catalina Gonzales and Ron Loria), CalTrain Station, East Grand Avenue and Dubuque Avenue (frontage road at 101). Photo courtesy of the artist.

I've lived on the Peninsula all of my life, so I'm really familiar with all of the towns. The train goes from San Jose to San Francisco. I came up with an abstract design based on a dream I had about the Titans and Prometheus. I've studied Greek myths since I was a kid. The project was sponsored by the City of South San Francisco Cultural Arts Commission. The mural starts with the universe and the galaxy, which is the center of creation. Prometheus swooped down from the heavens and stole fire from the sun. That's the comet he's holding. Symbolically he gave fire to man. There's a bonfire in front of a huge worker representing the steel industry, formerly the backbone of South San Francisco, especially in World War II. Now it's been taken over by technology. The pattern of repeated hexagons symbolize DNA and the biotechnical industry. The color spectrum represents the doppler shift (the speed of light) and transportation. Prometheus is wearing an interesting belt--designed and painted by my then 10-year-old son.

NICOLAI LARSEN

I polled 100 Chicanos at Stanford University and 100 older Chicano activists from the late 1960s to find out whom they considered the top 13 Chicano heroes. Three Chicanos who started their careers together made the list: César Chavez, Dolores Huerta and Luís Valdez.

La Virgen de Guadalupe, patronness of México, received enough votes to sit at the table, but out of respect occupies a loftier place.

In a history mobbed with machos, there was a sincere effort to vote not only for women like painter Frida Kahlo and poet Sor Juana Inez de la Cruz , also for mothers and grandmothers.

Not all the heroes had to be Chicano, that is, of Mexican ancestry. Thus Argentine-born Cuban hero Ernest 'El Che' Guevara made the list. The martyred Che, a strong symbol during the Chicano movement of the late '60s, occupies the central position. At his side is the Mexican revolutionary Emiliano Zapata.

Carlos Santana, who helped revolutionize North American music with Latin sounds, is painted standing and serenading the chosen 13. Among them are Chicano writers, activists and educators Tomás Rivera and Ernesto Galarza. Benito Juarez, a contemporary of Abraham Lincoln, sits next to Martin Luther King, Jr. Also sitting is Mexican revolutionary activist and writer, Ricardo Flores Magón.

Chicano heroes have always been an elusive lot. . . .Latinos are a group-oriented society. In the survey, the group-oriented focus came through time and again in votes for mothers, fathers, grandparents, Vietnam veterans, braceros, campesinos and pachucos. But it was best expressed by one student who chose as his heroes 'all the people who died, scrubbed floors, wept and fought so that I could be here at Stanford.'

JOSÉ ANTONIO BURCIAGA

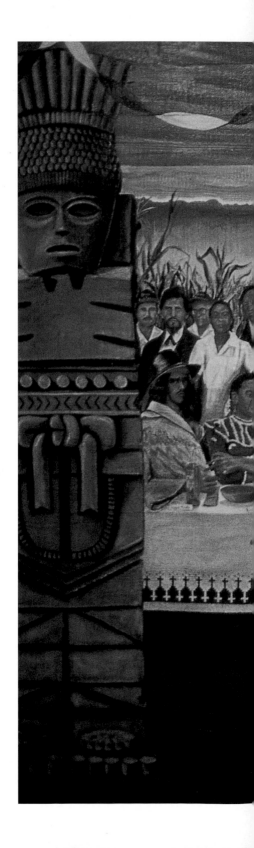

The Last Dinner of Chicano Heroes, 1986-89, by José Antonio Burciaga, Stanford University, Zapata House (Stern Hall) dining hall.

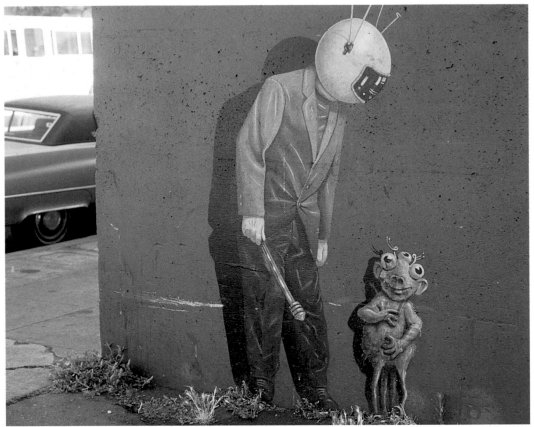

Untitled (destroyed), 1976, by Greg Brown, downtown Palo Alto.

I was working for the City of Palo Alto as an artist in residence on a CETA grant. I was doodling one day and came up with one of the characters I later put downtown. I did nine vignettes. After that I felt it was time to move on. The guy in a space helmut interviewing an alien (pictured above) was the third one I did. It was on Norm's Starlight Supermarket, which is gone now. The owner of the bank that replaced it wanted me to repaint that piece, which I had no intention of doing. I happened to come up with a concept I liked–the return of the alien.

The stuff I do now is much more refined. But when I went back to touch up the murals a few years ago, I worked real hard to try to keep them the way they were with some of that naivete, because I think it's part of their charm.

I started cartooning when I was a kid. When I was seven years old, my grandmother gave me a 'How to Cartoon' book. I used to copy things until one day it occurred to me that they didn't have to look just like in the book. I started manipulating them, playing with them. That's really how I started drawing.

I've always been slightly bent. I like realism because it sucks people in. I like the idea of sucking somebody into a little fantasy or vignette and then putting a twist on it that they're not expecting.

GREG BROWN

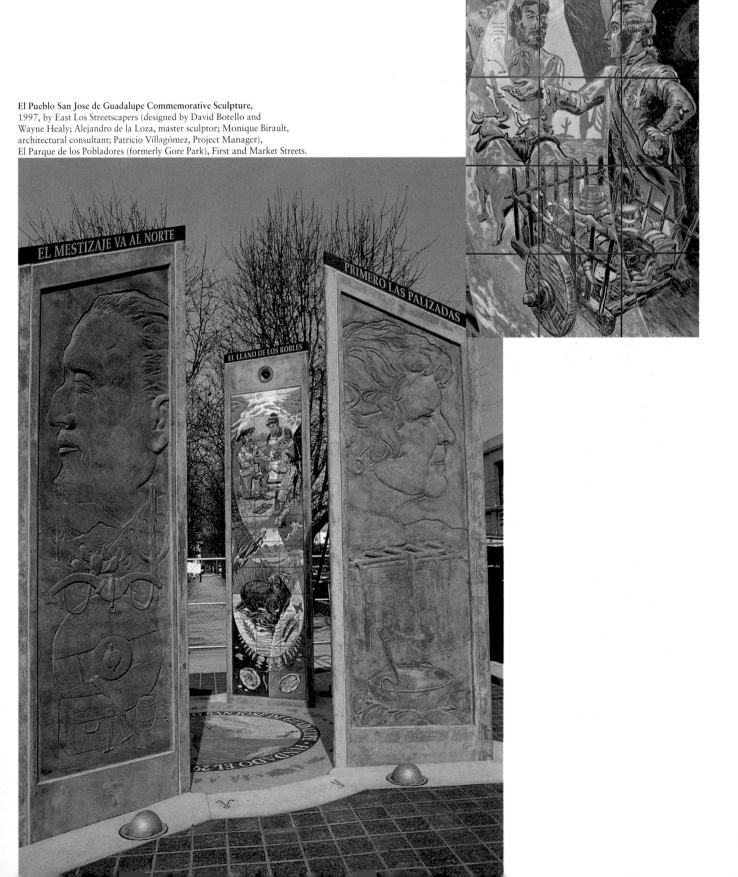

El Pueblo San Jose de Guadalupe Commemorative Sculpture,
1997, by East Los Streetscapers (designed by David Botello and
Wayne Healy; Alejandro de la Loza, master sculptor; Monique Birault,
architectural consultant; Patricio Villagómez, Project Manager),
El Parque de los Pobladores (formerly Gore Park), First and Market Streets.

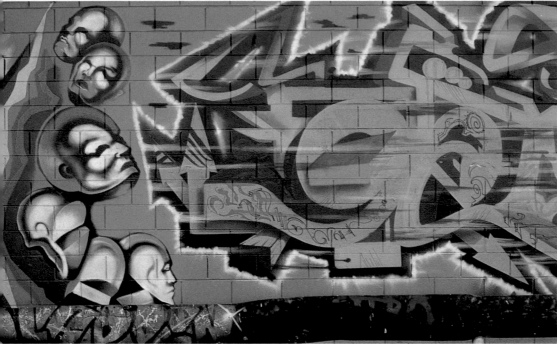

Generations (in progress)(detail), 1997, by Aladdin, King Road and Story Road, East San Jose.

The piece I did on this wall before was up for five years. I just felt I wanted to re-do it. I'm doing this new one out of my head. I'm having a lot of fun with it. Before I really wanted to send out a message with my pieces. Now I'm mostly doing it for myself. It has a 3-D wildstyle, multicolored piece. Next to that I did a character similar to Shiva with four arms. It's speaking about something more personal. Next to it I did two kids in astronaut uniforms hanging out of a ship. It's showing how kids are our future and how they learn things. They've stumbled upon some jewels and their faces are lit up.

I've been doing graffiti since 1982. I always try different things, just showing that I'm versatile. I do think I've gotten better because of all the techniques I've tried. I can't really say that I have one style, but if you follow my styles, you'd be able to say, 'Oh, Aladdin must have done that.'

Now I'm into tattooing and I've been doing it for two years. This year I'm concentrating on showing my work more in galleries.

ALADDIN

114

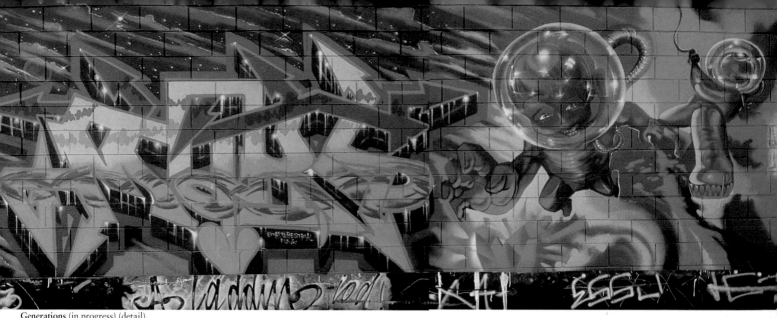

Generations (in progress) (detail).

Generations (in progress)(detail).

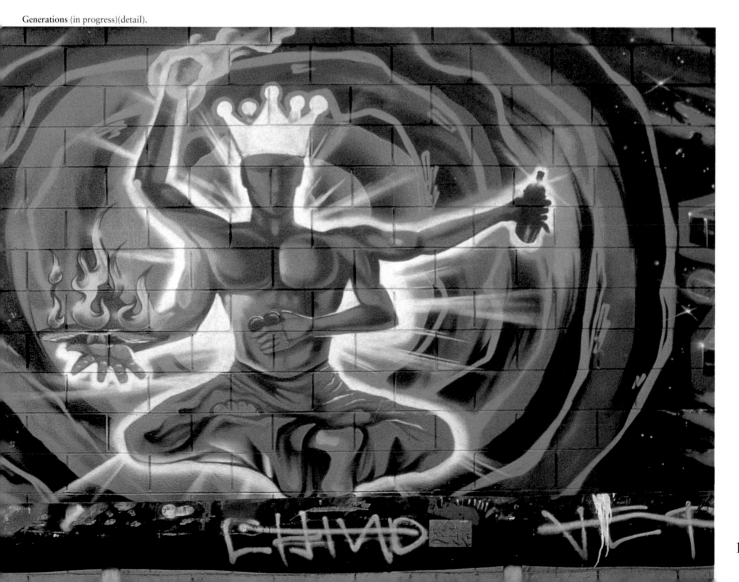

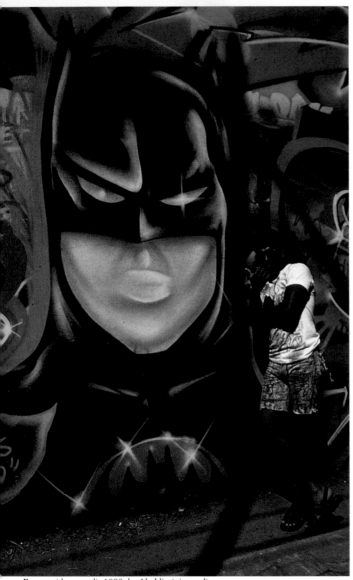

I did this about the time the first Batman movie came out. I was experimenting with different caps and different shades. Using shades to build some of the features as opposed to using a hard outline. I wanted to see what I could do with that size scale. It was about eight or nine feet high.

ALADDIN

Batman (destroyed), 1990, by Aladdin (pictured).

Cocaine, 1991, by Raevyn.

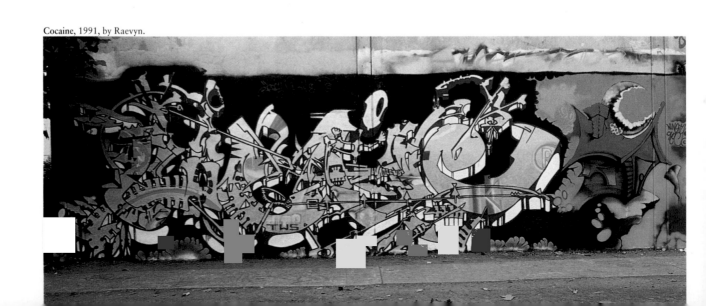

Siete Punto Uno (**Seven Point One**), 1990, by John Pugh, 49 East Main Street.

The pre-Columbian symbols in this mural convey an optimistic statement about the future, embracing the concept of growth after pain, rebirth after death. To me that's what the rebuilding of Los Gatos has been all about.

JOHN PUGH

This was the only local building left standing on the block after the Loma Prieta earthquake in 1989.

This is one of four lunettes Henrietta Shore painted for the post office. Completed under the auspices of the Treasury Relief Art Project (TRAP), all pay homage to local industries. The other three focus on fishing, limestone quarries and cabbage growing.

Henrietta Shore (1880-1963) was born in Toronto, Canada. She studied art in New York and Europe before moving to Los Angeles in 1923. A 1927 trip to Mexico was a turning point for her. She became friends with muralists José Clemente Orozco, Jean Charlot and Diego Rivera, and was influenced by their subject matter and by pre-Columbian art. In 1930 she moved to Carmel. She also painted two New Deal murals in Monterey, at the post office and in the Old Customs House.

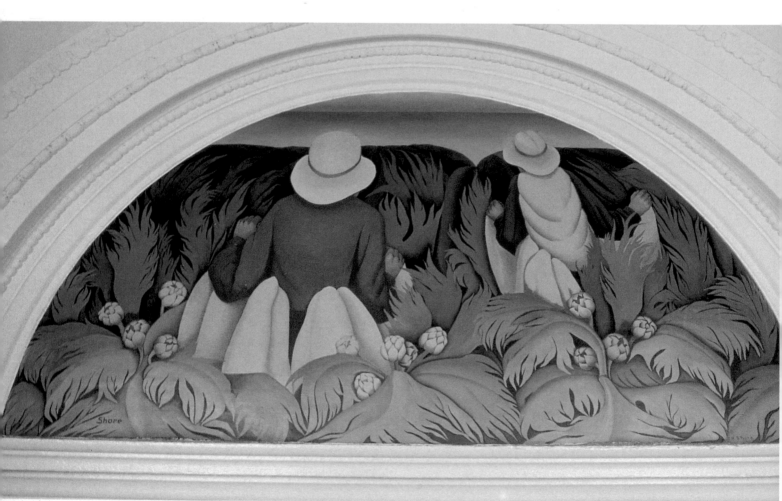

Artichoke Culture (one of four panels), 1936, by Henrietta Shore, Santa Cruz Main Post Office, 850 Front Street. Photo © 1997 Friends of Monterey Bay, by Michael McKaie.

Welcome to Santa Cruz, 1979, by Bill Burrita and Kent Karp, Upper Crust Pizza, 2415 Mission St.

*T*he mural below combines the elements of California landscape that I love as a plein-air painter. The challenge for me was to move from European formality into the more casual gardens of California. It's not a political statement, but you might say that being in love with the beauty of nature is becoming a political statement.

ANN ELIZABETH THIERMANN

A Peaceful Pause, 1995, by Ann Elizabeth Thiermann, Pearl Alley, 1221 Pacific Avenue (rear).

Enjoy the Game, 1992, by John Cerney, Highway 101 about 11 miles north of downtown Salinas. Photo courtesy of the artist.

I first painted a mural on this wall in 1985. I remember thinking I needed a barn, and one with the best angle for the highway. The farmer who owned the barn, 65 or 70 years old, didn't quite know what to think of me. However, if I signed a waiver saying I wouldn't sue him if I fell off my ladder, he said it was fine with him. I've gotten more into incorporating three-dimensional elements–anything that fakes people out when they drive by. In this mural there's a three-dimensional scoreboard and a real ball.

JOHN CERNEY

The overall theme of these lunettes is 'Water-Wealth-Contentment.' Only seven of the original 13 panels are on display at the Modesto 'El Viejo' Post Office. The remaining six are missing.

Ray Boynton was selected to head the Modesto mural project shortly after completing his murals in San Francisco's Coit Tower. An art professor at the University of California, Berkeley, during this time, he arranged for studio space in the training headquarters of the campus coliseum. It was there that Boynton and his five assistants painted the Modesto mural.

Cattle and Orchards, Meat Packing, Plowing, Making Cheese, 1937, by Ray Boynton, Modesto Post Office, 1125 I Street.

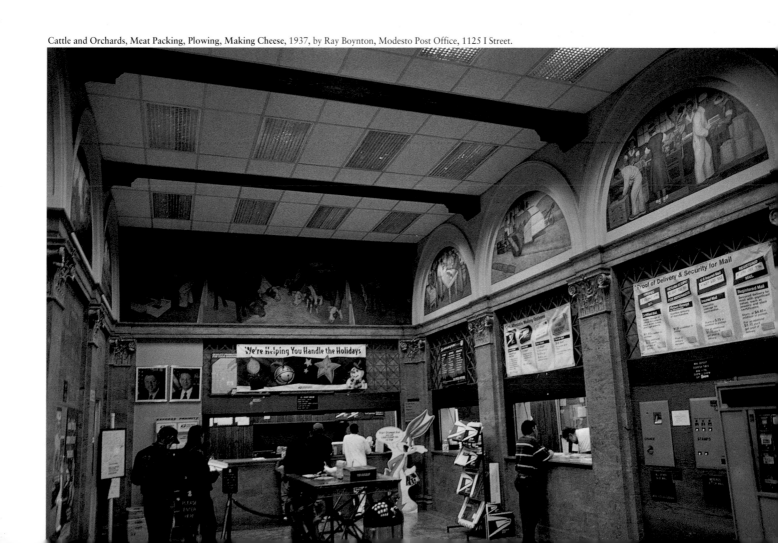

Originally, the small color sketch upon which this mural is based depicted mounted Arizona Indians. When Lew Davis submitted his drawing to the national 48 States Competition–sponsored by the Treasury Department's Section of Painting and Sculpture–he targeted his design for the Safford, Arizona, post office. When he was instead given Los Banos, he had to transform his figures into Spanish caballeros.

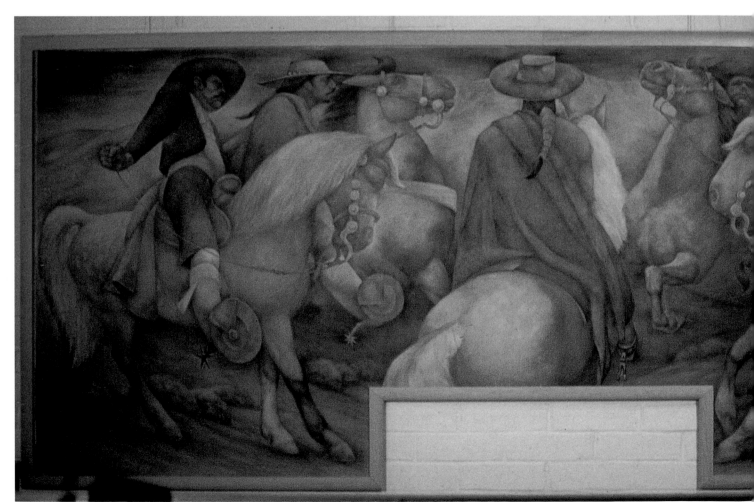

Early Spanish Caballeros, 1940, by Lew E. Davis, Ralph Milliken Museum (originally in the post office), 901 Pacheo Boulevard.
Photo by A.D. Sousa and courtesy of the Milliken Museum, Los Banos.

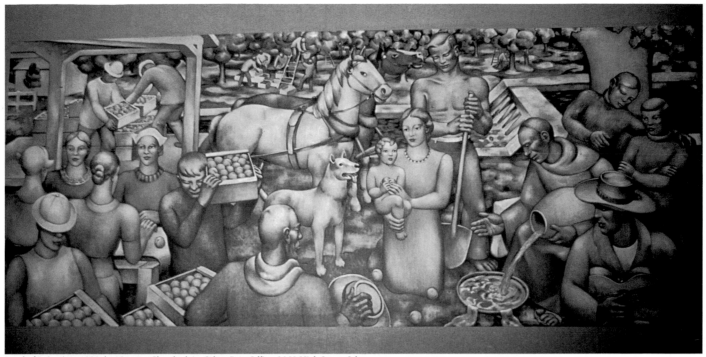

Land of Irrigation, 1938, by Norman Chamberlain, Selma Post Office, 2058 High Street, Selma.

Both murals on these pages were sponsored by the U.S. Treasury Department's Section of Painting and Sculpture, one of five federal New Deal art projects organized during the Great Depression. In its nine years of existence (1934-1943), the Section gave out close to 1400 commissions nationwide, primarily in newly built post offices.

Norman Chamberlain moved to Southern California from Michigan in 1921. He also painted a mural in 1937 for the Huntington Park Post Office in Los Angeles County.

F resno's west side is rich in history, cultural differences and agricultural production. My first self-sponsored mural was created here in Chinatown. It has been the seed for cultural restoration and historical preservation. My home town.

ERNIE PALOMINO

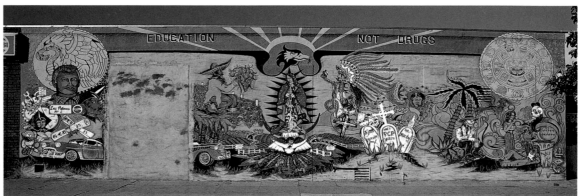

Farmworker Mural (repainted version), 1990s, by Alfonso Hernandez.

Farmworker Mural, mid-1970s, by Ernie Palomino, Tulare and F Streets, West Fresno.

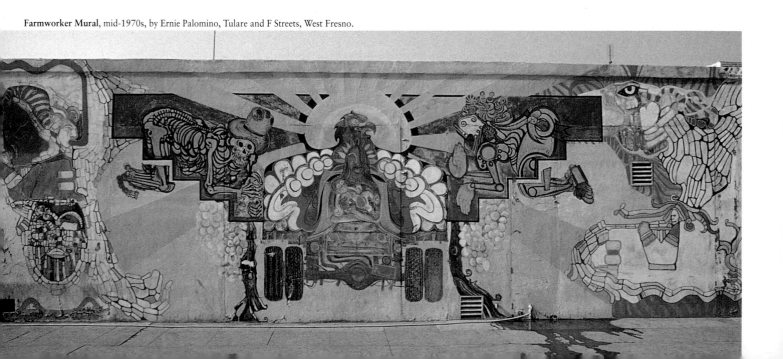

I designed and developed this mosaic mural for the new library. The 600-square-foot -plus mural depicts Morro Bay history and environs. The project utilized the help of dozens to fabricate, received business and County support, plus materiale from old friends like (Millard) Sheets, (Denis) O'Connor and LATCO's president, Bud Campbell, in Los Angeles.

PETER LADOCHY

Morro Bay, Past, Present and Future, 1985, by Peter Ladochy with community volunteers, Morro Bay Library, Harbor and Shasta Streets.

Cayucos is a Central Coast beach town on Highway 1 (14 miles from San Luis Obispo). Since its founding in 1992, the Cayucos Mural Society has commissioned and completed six outdoor murals. In 1994, the group published an eight-page guide to the then-16 murals of Cambria, Cayucos, Morro Bay and Los Osos.

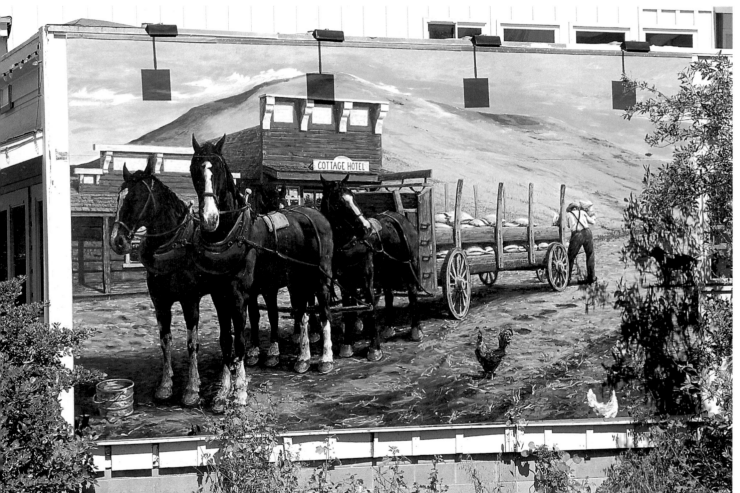

Delivery at the Cottage Hotel, 1993, by John Meng, Way Station, 80 North Ocean Avenue.

I never grew up on a farm. I don't have a lot of experience with horses, carts, or with old buildings. I just enjoy the painting part of it. The cart is the actual type that visited here. It's a grain or flour cart that carried sacks, a heavy wooden cart with a kind of small, sturdy wheel rather than the big wheels of a carriage.

JOHN MENG

T*he complexity of the content is subtle: there is action and repose, there is work and play, there is inside and outside. There is also a feeling of depth and distance, and a further dimension of the illusion of time. The foreground consists of children in a strong morning light. The interior shows two working blacksmiths with midday sunlight making a bright spot on the floor of the shop. In the distance stands an elderly couple in front of three large windows through which one views the hills of Cayucos, the historic Cass House and the light of a setting sun.*

<div align="right">

JOANNA SPINOZA

</div>

Cayucos Blacksmith, 1994, by Joanna Spinoza, Ocean Avenue Hardware, 36 North Ocean Avenue.

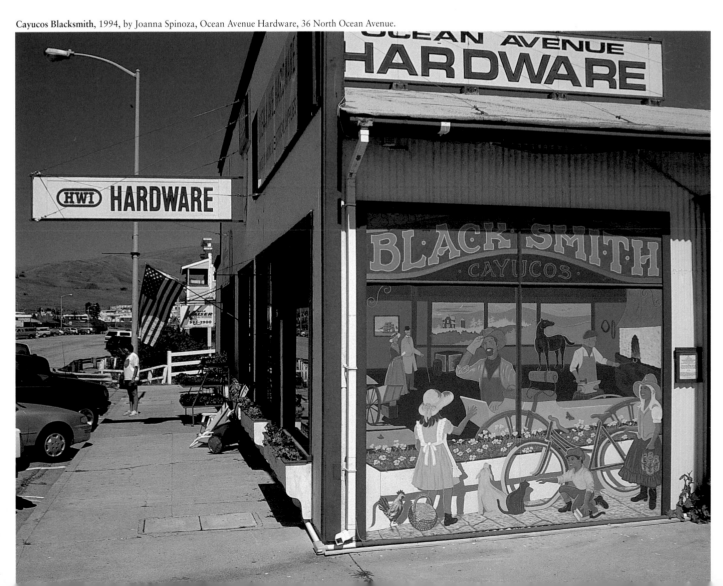

The composition of the mural is very architectural in form. The mural was painted on fabric in the East Los Streetscaper studio, precision cut into nearly 100 discrete panels, transported to the site and mounted directly to the precast building façade.

The spectacle of a rainbow is nature's way of demonstrating that the brilliance of visible sunshine is actually made up of a whole spectrum of colors. Likewise, the mural attempts to demonstrate the total city in a composition of chromatic and historical spectra.

Designed in 1992, the Quincentenary year of the European invasion of the Americas, the mural is framed by a seated Chumash woman on the left and a kneeling Spaniard on the right. Their cultural differences can be seen in their headgear (a headband of sand dollars compared to a steel helmet) and their tools (a stick to grind acorns compared to a sword). A gnarled oak branch leads into a view of a Chumash muralist painting a California condor on a cave wall.

Entering on the right side is a march of multicultural immigrants from around the world, each with a role to play in the shaping of the city.

Following the curve upward, the mural is fringed with the central coastline, the land divided up by the irregular geometry of the Mexican land grants. The aerospace industry is represented by a flight of World War II vintage Lockheed P-38 Lightnings as seen in the sky above Santa Maria over a half century ago.

At the top of the mural, an old person and a young person see eye to eye across the generations while human hands gesture for guidance from above.

WAYNE ALANIZ HEALY

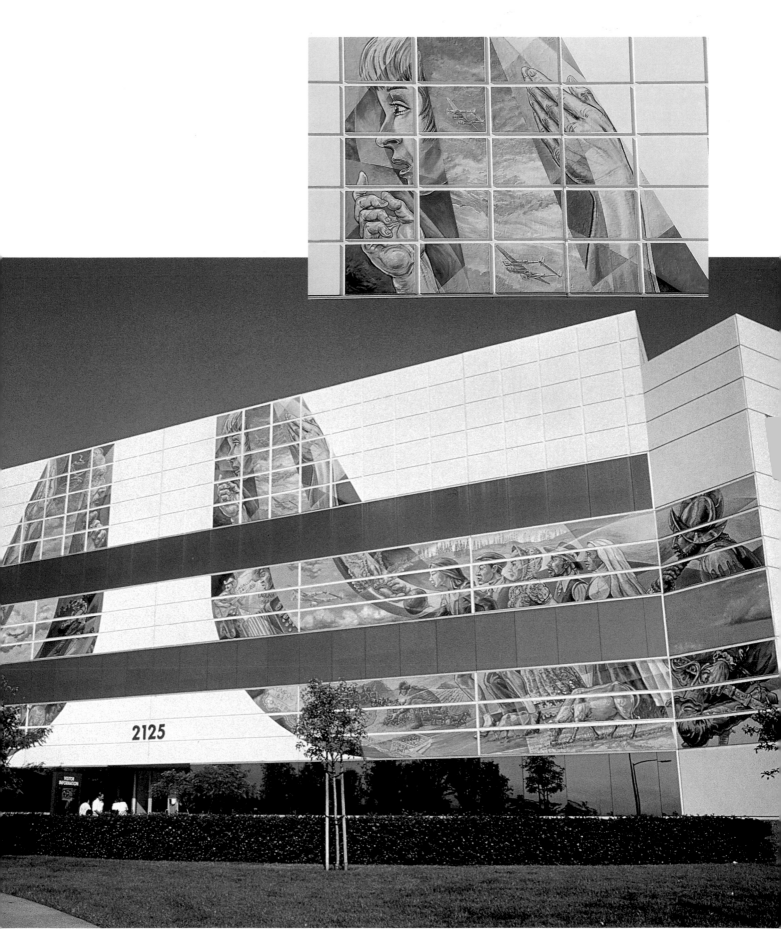

Santa Maria Spectrum, 1994, by East Los Streetscapers (David Botello and Wayne Healy, designers; Ernesto de la Loza and Rich Raya, production muralists; plus a painting crew of about 50 directed by Grace Amemiya, and an installation crew directed by Charles Solares), Bettaravia Social Services Building, 2125 South Centerpointe Parkway.

Lompoc's mural program began in 1988, the year after former mayor Gene Stevens and his wife visited British Columbia, Canada, and stumbled across Chemainus, the renowned mural town. In recent years Lompoc's flower seed industry has declined from 3,000 acres to less than 800, due to consumers' changing tastes. The local business community has embraced murals as a way to keep tourists coming, given the dwindling annual display of flowers in bloom. Currently more than two dozen murals are scattered throughout the downtown area. A free brochure by the Lompoc Mural Society is available at the Chamber of Commerce.

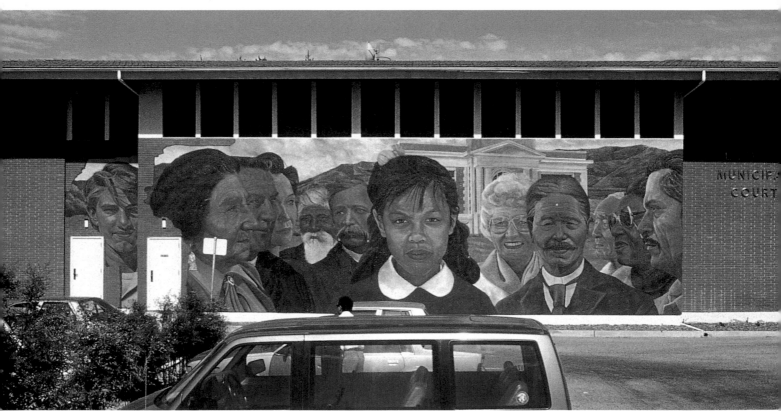

Tribute to the People of Lompoc, 1991, by Richard Wyatt, Lompoc County Courthouse, 115 Civic Center Plaza.

These 12 portraits celebrate the diversity of people who have contributed to Lompoc's history.

Among those represented are African American pioneer Louise Artis; Chumash leader Juanita Centeno; and Gin Chow, the Chinese philosopher, farmer and businessman whose lawsuit against Santa Barbara helped establish the foundation of California water rights law.

I really enjoyed this project because the people in Lompoc enthusiastically supported this mural. Also, it was a pleasure working with Maria de Herrera, who was the head administrator of the Santa Barbara Arts Commission.

RICHARD WYATT

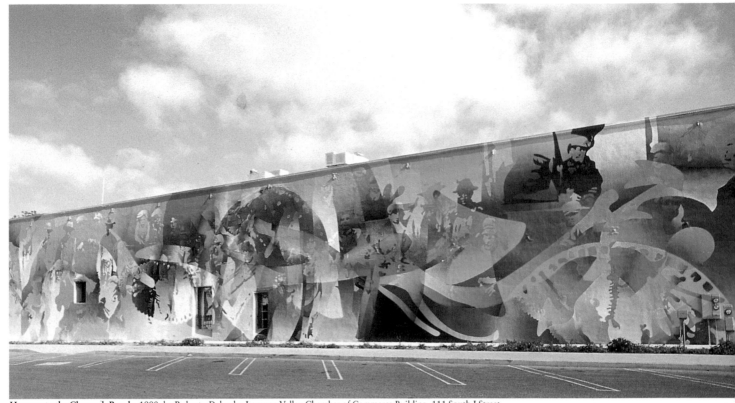

Homage to the Chumash People, 1990, by Roberto Delgado, Lompoc Valley Chamber of Commerce Building, 111 South I Street.

This large abstract painting is a tribute to Chumash Native American history and the local diatomaceous earth industry. Millions of years ago, diatomaceous earth was formed from the fossilized remains of plants, left behind when the sea receded from the Lompoc Valley. This area is the source of the largest and purest deposit of diatomaceous earth.

The reds represent diatoms, which are microscopic algae whose hard cell walls form the chalky, rock-like earth. The blue shapes were inspired by Chumash cave paintings of sea life. The mural's colors flow over each other, forming shapes of turn-of-the-century miners.

The mural is painted on the Spanne Building (home to the Chamber of Commerce), constructed in 1892 from large blocks of diatomaceous earth dug from the nearby hills.

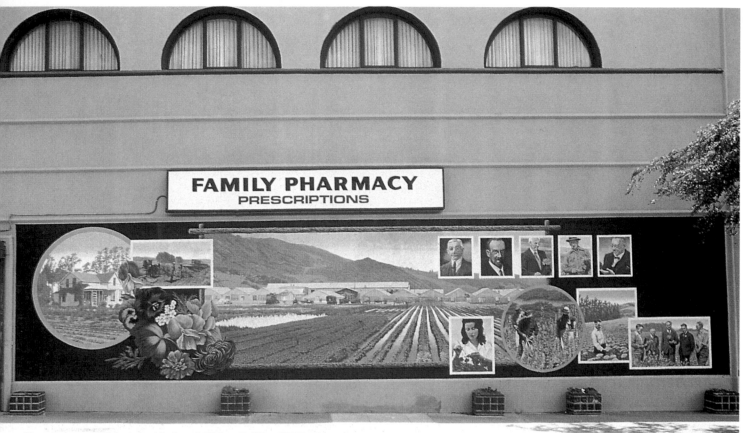

Flower Industry, 1990, by Arthur Mortimer, Oddfellows Building, 101 West Ocean Avenue.

T*his was my first time doing a mural out of town* (Art Mortimer lives in Santa Monica). *Lompoc did a whole series of murals, but they wound up picking me to do the first one. This is also the first elaborate full-color mural that I did. It's a collection of images, some old and some contemporary.*

The flower seed industry used to be really big in the Lompoc Valley, and it's not so big any more because land values have gone up too much. Lompoc Valley happens to have an ideal climate for growing flowers for seeds. It started in about 1903, when some seed grower discovered this. There used to be huge fields of flowers, this patchwork of colors that covered the valley floor. So the mural is to memorialize this because it's vanishing more and more.

The big picture in the center shows the valley and the industry the way it is today. There are a series of portraits in the upper-right-hand corner of people who started and ran the flower seed companies. There's a picture of a lady cross-pollinating nasturtiums in a greenhouse, because creating new varieties was an important part of the flower seed industry.

ARTHUR MORTIMER

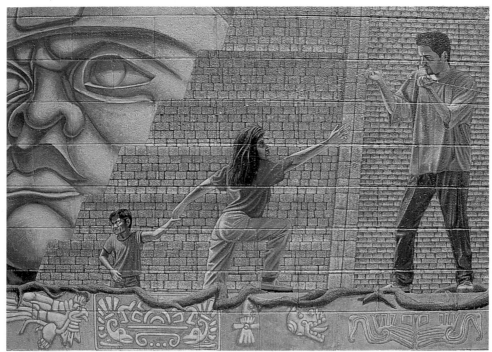

Raices (detail)

T his was my first mural. The concepts and the basic design were the work of a group of Latino youth formed and coordinated by Manuela Vanegas. I researched and completed the final design, and painted it with the dedicated assistance of the same group of young people. The mural moves beyond stereotypical Mexican symbols, and through its portrayal of history and culture gives a universal message of struggle and hope that many people can relate to.

LEO NUÑEZ

Raices (**Roots**), 1995, by Leonardo Nuñez with youth, 119 West Maple Avenue.

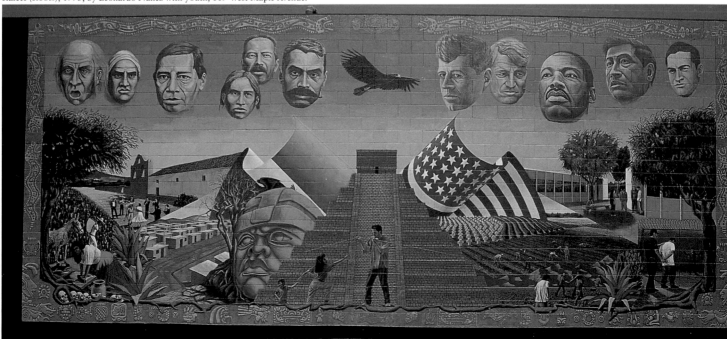

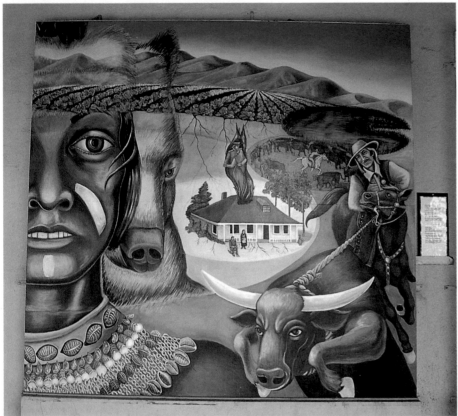

Guadalupe Mural (Panel 1: **The Founders of Guadalupe**), 1988-89, by Judith Baca, City Hall.

I want to convey the beauty of the farmworkers while at the same time revealing the harsh conditions that this surface beauty belies–the low wages, health problems, substandard living conditions. Caught up in the immediacy of their material crisis, it is often difficult for these farm workers to articulate the issues that are of concern to them, to make connections that will allow them to organize their thoughts. I am hoping that the murals will help them to do this.

The deep-seated social issues and problems in Guadalupe are historic, and once one understands this history it is clear how they are derived. California–not just Guadalupe–has a history, a long history, of interracial struggle. It is essentially the American problem: How do people from very different places come together, and develop some kind of respect for one another's cultures and their differences?

JUDY BACA

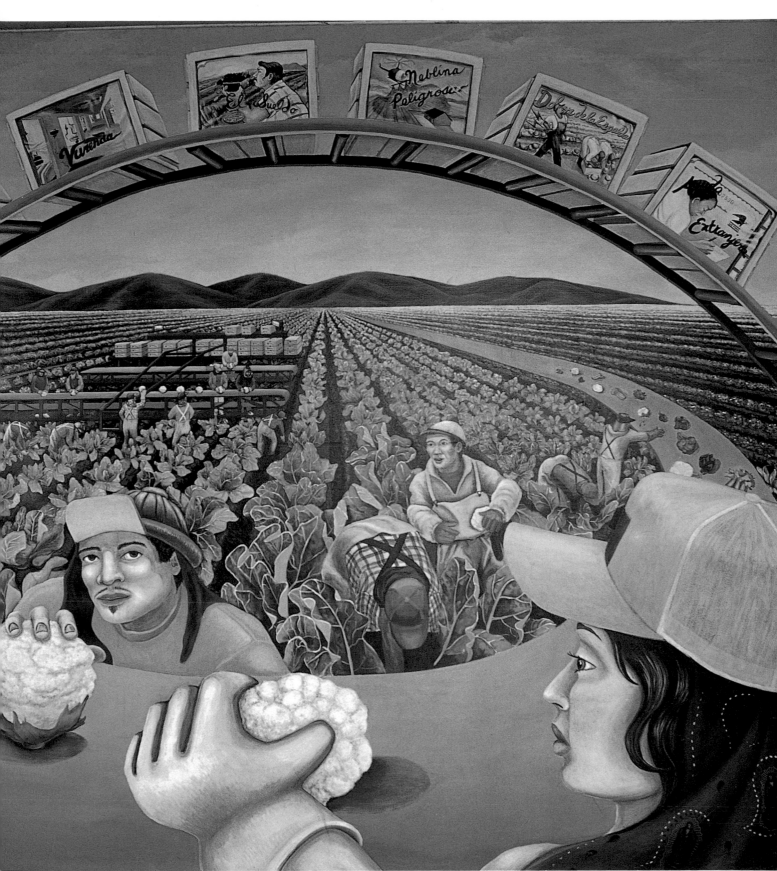

Panel 3: The Farmworkers of Guadalupe.

I t's ironic. My dream was to have the mural in LeRoy Park, where the people are. But they've put them in a protected place–not the park, but City Hall.

JUDY BACA

Panel 4: The Future of Guadalupe.

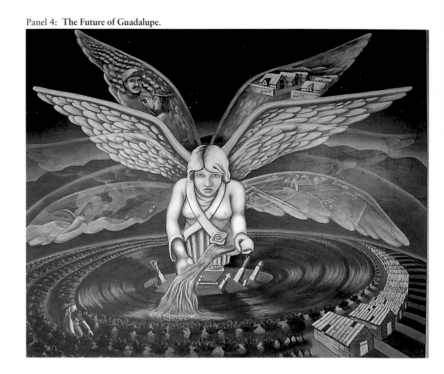

Panel 2: The Ethnic Contributions.

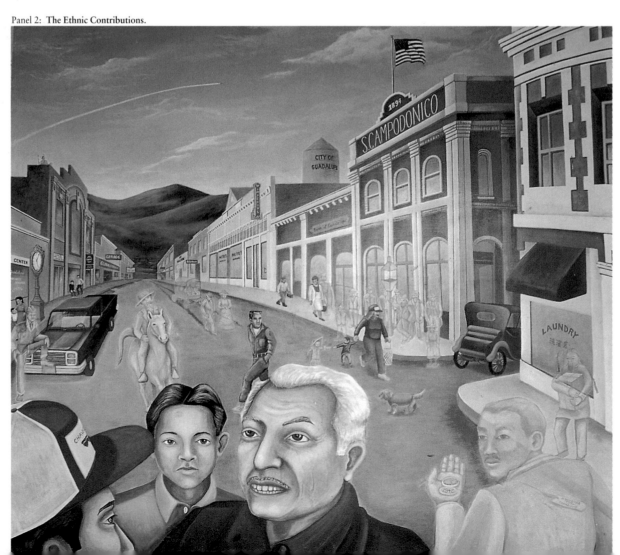

I painted four murals in la Casa de la Raza. The first one that I did (**A Book's Memory**) was highly influenced by Orozco. It is done with heavy, emotional brush strokes. It turned out to be the best mural in there. People like it because of its guts. It's a huge book. Things are coming out of the book, like confusion. I was quite upset with the War (in Vietnam) in those days.

La Casa de la Raza is hanging in there by a thread, even though the building's mortgage was paid off 20 years ago. But keeping up with the maintenance and the programs is a challenge for Armando Vallejo, the director there. He believes very much in cultural activities.

MANUEL UNZUETA

A Book's Memory, 1972, by Manuel Unzueta, Casa de la Raza (interior), 601 East Montecito Street. Photo courtesy of the artist.

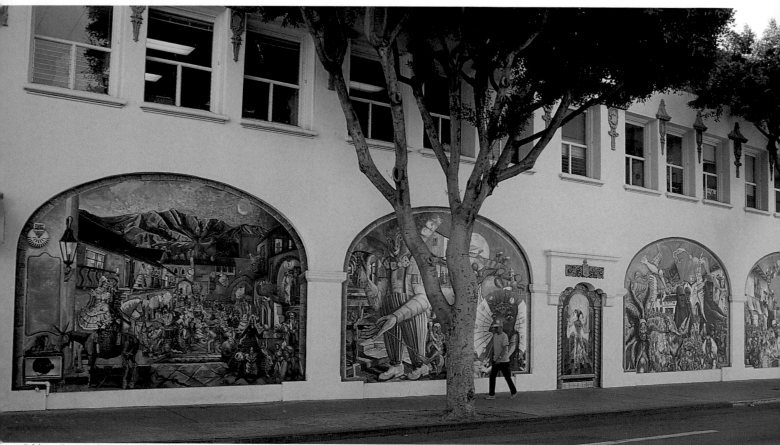

Celebrate Santa Barbara, 1995, by Ben Bottoms and Richard McLaughlin, Earthling Bookshop, State and Anapamu Streets.

The project was initiated by the Santa Barbara County Arts Commission, which wanted to acknowledge the annual Summer Solstice Parade and Festival, and Old Spanish Days (Fiesta) as strong parts of the cultural life of the community. In 1994, when the mural project began, the Solstice event celebrated its 20th anniversary and was, next to Fiesta, which began in the 1920s, the longest-running community event.

Three of the large panels relate to Solstice and the fourth to Fiesta. The landmark architecture of Santa Barbara appears in all the panels, and relevant geographic features are also depicted. The mural portrays the charm and beauty of the city of Santa Barbara and the creative exhuberance of its citizens.

The Solstice Parade, which the mural portrays in detail, was started by Michael Gonzales on his birthday in 1974–when he and two friends dressed up and celebrated in the street. The annual parade, which now draws 2,000 participants and 100,000 spectators, is generated by community workshops two months before the parade. It emphasizes street theater, giant puppets and handmade images. The unique rules of the parade prevent words and placards, live animals and motorized vehicles.

The central panel pays tribute to Solstice Parade founder Michael Gonzales, who died of AIDS in 1987. It is also a tribute to all artists and visionaries who have been stricken by this disease. He is dressed in a Pierrot costume with a jester hat–garb he often wore to perform in the parade. He is passing through a doorway towards a bright light. This panel is the spiritual focus of the mural.

RICHARD MCLAUGHLIN

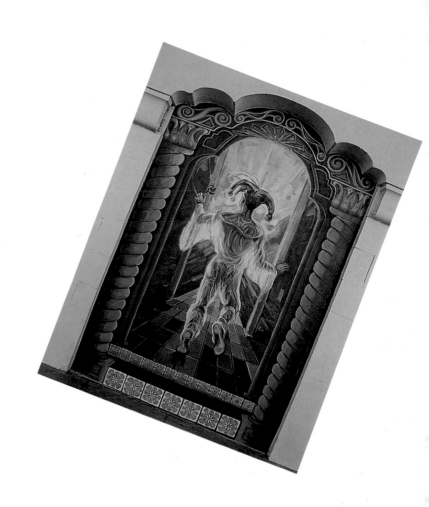

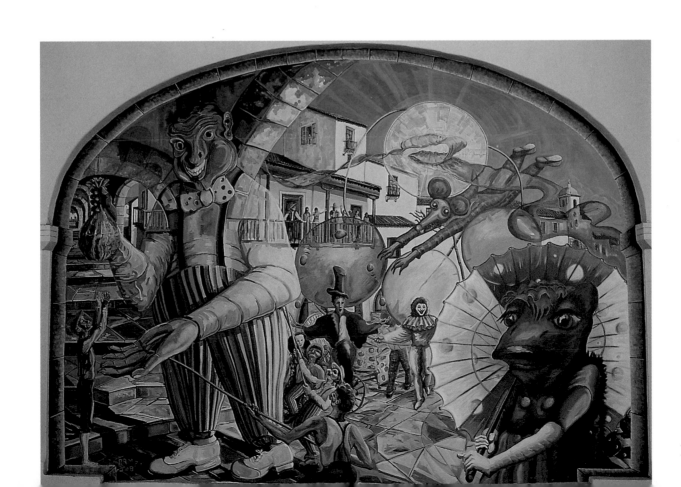

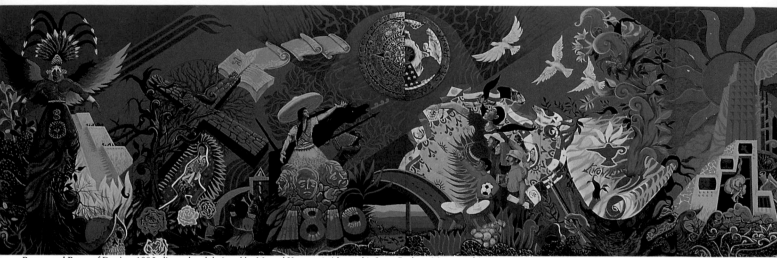

Routes and Roots of Destiny, 1995, directed and designed by Manuel Unzueta (with youth), Santa Barbara Museum of Art (rear exterior), 1130 State Street.

This summer project was to highlight the Latin American experience in the United States. The mural was also a prelude to a tremendous Latin American exhibition inside the museum. So the museum used a Chicano mural to introduce Latin American art. Diego Rivera, Frida Kahlo and I were part of the show.

Orozco was an important influence in my earlier work when it was really dark and emotional. Later on I was a little more influenced by Siqueiros' realism and his insistence on three-dimensionality. Over the last years I have observed very carefully the work of José Cuevas, who is not a muralist, and somehow the geometry of Tamayo attracts me in some of my work.

With the growth of the Latino community, a big 75% of my work has become cultural again. I'm using Mayan themes with modern ideas. I am using ideas of beatuiful Indian women from Mexico in a modern style.

MANUEL UNZUETA

When about 30 of my students and I came back from Mexico, they said they wanted to do a mural. About 50 students helped. Each panel has a theme. The far left panel and the small second one deal with the past of violence, prejudice, discrimination, racism and some shades of the Holocaust. We put it on the left because we assume we've already left those things behind. The panel on the far right is called *Justice and Liberty*, assuming that is what we are doing in the present and toward the future.

I work at Santa Barbara City College as a cultural facilitator. I was the official artist for the Community Colleges in California for two years in the late '80s. I did posters for 105 colleges, very much based on my murals. I would say that murals are very universal, and they are cultural. I personally believe that I'm using the power of muralism as a deterrent to crime. I'm involved in community ideas to engage the youth, to bring publicity to art as an activity to make a better society, because I'm an idealist still.

MANUEL UNZUETA

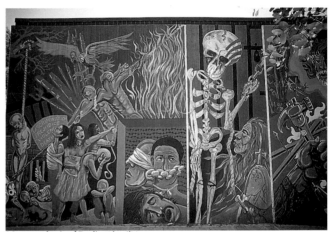

Metamorphosis of Reality (detail)

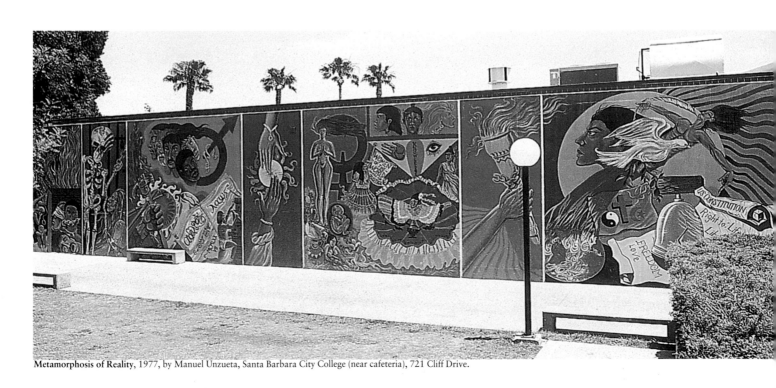

Metamorphosis of Reality, 1977, by Manuel Unzueta, Santa Barbara City College (near cafeteria), 721 Cliff Drive.

T his mural is painted in my neighborhood, on an avenue disproportionately exposed to numerous liquor stores, and alcohol and tobacco advertising. The images depict youth "taking back" public space, with messages of their own—stopping the violence, reaching out to the homeless, reconnecting to cultural and historical roots, encouraging positive, enriching activities. The theme and content were developed in drawing sessions with local continuation high school students, and participation on the mural was open to everyone. Following completion of this mural, community activists undertook the clean-up and landscaping of the adjacent field, transforming it into a people's park.

MB HANRAHAN

It's Not Cool to Target Kids, 1994, by MB Hanrahan with youth, 580 North Ventura Avenue (at Simpson).

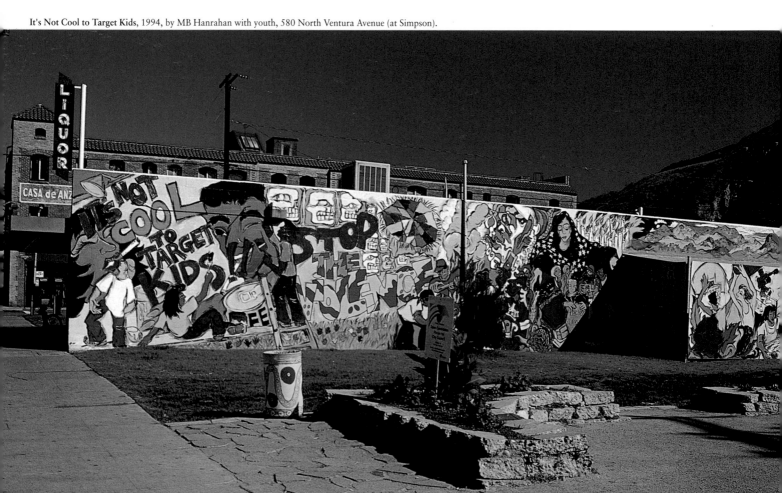

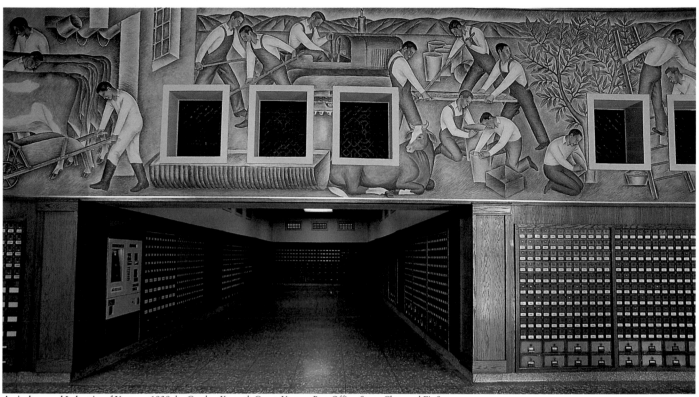

Agriculture and Industries of Ventura, 1938, by Gordon Kenneth Grant, Ventura Post Office, Santa Clara and Fir Streets.

This oil-on-canvas was a New Deal mural project. It was restored in 1966 during the expansion of the post office. Gordon Grant's other New Deal commissions include post offices in Alhambra (Los Angeles County) and Brady, Texas. He often incorporated Native American themes in his own work. In 1932 Grant assisted Albert Herter in painting murals at Wellesley College in Massachusetts, and also assisted Albert Hewlett on his mural at the City Hall in Bronx, New York. He died in an accident in 1940.

Michael and I were finishing up a mural, and I heard him telling a friend of ours about a neighborhood in town that had been displaced when the 101 Freeway came in. I'm a transplant to Ventura and hadn't heard about Tortilla Flats. So I said to Michael, 'This story should be a mural.' The project was put together from donated labor and donated materials. It took over a year to do. About 100 people worked on it. The wall is over 500 feet long and is formatted like a scrapbook.

There was nothing about Tortilla Flats in our local history museum, no pictures of the neighborhood anywhere. The subject matter of the mural was based entirely on oral histories from Michael and me tracking down former residents of the neighborhood and asking them for their stories. So these people provided the images and stories that then became translated into the mural.

MB HANRAHAN

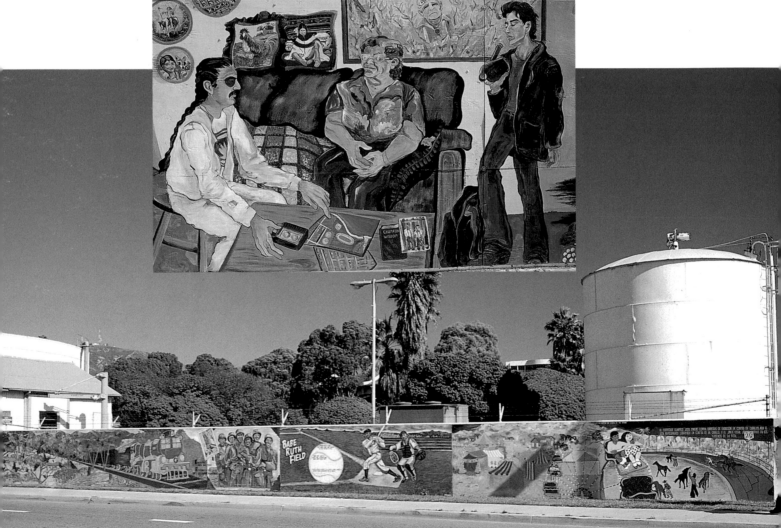

Tortilla Flats Mural and Reunion Project, 1995, by MB Hanrahan (artistic director) and Michael Moses Mora (project coordinator) with many others, Figueroa Street.

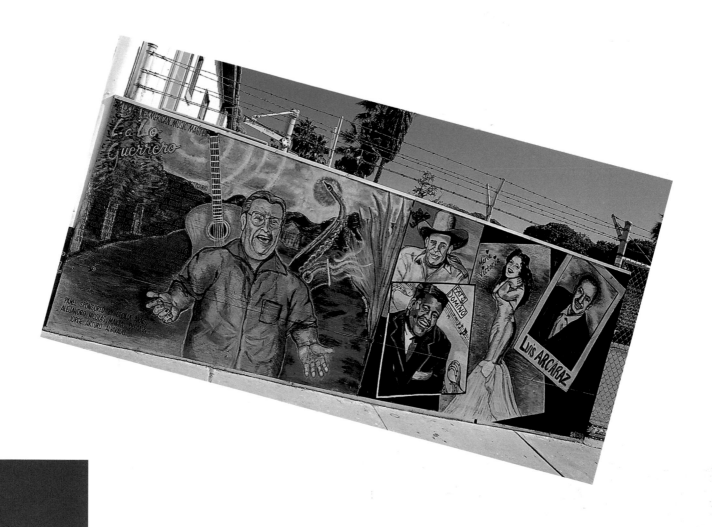

During the 1940s and '50s, the Green Mill Ballroom was the place to go to dance, listen to music, and celebrate weddings and other special occasions. One of those honored in the mural is Lalo Guerrero, the Mexican American orchestra leader who pioneered the blending of Afro-Cuban danzon, cha-cha and mambo with Afro-American swing and bilingual lyrics. (Art direction by Hanrahan/Mora; featured artist on this panel is Shawna Krohn.)

MICHAEL MOSES MORA

OXNARD

*T*he trilogy below depicts the past, present and future. The first panel is an intertribal mural. You see the corn mother, a plains Indian dancer and a southwest Indian eagle dancer. In smaller detail there is a council of elders and several Chumash images–an acorn, the deer, the condor and the dolphin. There is a symbol representing the Lame Deer Family and another for the struggle in Guatemala. In the volcano's lava is written FSLN and FMLN in support of the revolutions in El Salvador and Nicaragua.

The middle panel is a tribute to contemporary Latino, primarily Chicano, musicians. The centerpiece is Richie Valens in a modified Aztec calendar that depicts instruments. Featured in the corners are Carlos Santana (bottom left) wearing a t-shirt that says Free Nelson Mandela and For Total Freedom in South Africa, Los Lobos (top left), Daniel Valdez and Linda Ronstadt (upper right), and Maria Conchita Alonzo and Ruben Blades (lower right). Dr. Loco from the Rocking Jalapeño Band is in the center at the top of the panel.

I met Jaime Estrada working in a factory. Prior to doing murals he liked to draw cartoons, especially space characters. He'd never done murals. We did our first together in Santa Paula. This was our second collaboration. We were not paid. No original sketch of this mural exists. It went from our minds through our hearts to the wall.

Michael Moses Mora

All Our Relations (first panel), 1989, **Let the Music Set You Free** (second panel), 1990, **Coyote Places the Stars** (third panel), 1991, by Jaime Estrada with Michael Moses Mora, A Street near 5th Street.

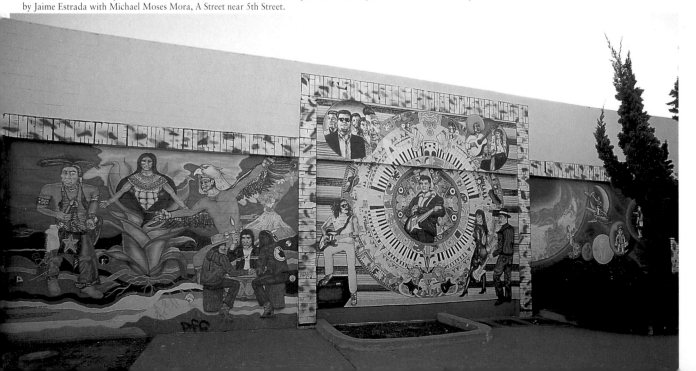

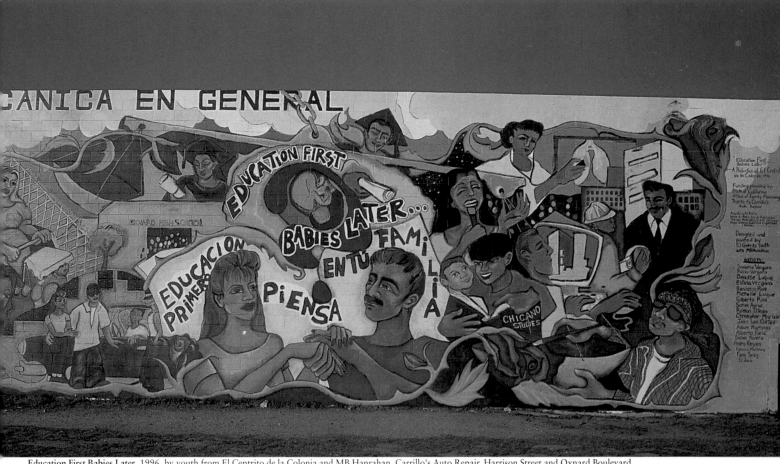

Education First Babies Later, 1996, by youth from El Centrito de la Colonia and MB Hanrahan, Carrillo's Auto Repair, Harrison Street and Oxnard Boulevard.

I had just gotten back from traveling in India, when we began work on this mural. The theme had already been decided on, and the images were developed from the drawings and ideas of the local teenagers (ages 11-16), who volunteered for the project. We really wanted our message to be about choices, the future consequences of our actions, and the individual's responsibility to oneself and one's family. We felt that decisions about pursuing an education and planning for families are human issues, specifically relevant in the neighborhood where we painted the mural, and universally significant to all cultures.

MB HANRAHAN

147

Cultural Contributions of North, South and Central America (shown is one of 10 lunettes), 1944, by Boris Deutsch, Terminal Annex Post Office, 900 North Alameda Street, Downtown.

Boris Deutsch (1895-1978) was a successful commercial artist in Los Angeles, and he worked for Paramount Pictures in the special effects department. He also taught advanced painting at Otis Art Institute for about six years. In addition to this series of lunettes for the Treasury Department's Section of Painting and Sculpture, Deutsch did two other New Deal post office murals: one in Truth or Consquences, New Mexico (1940), and the other in Reedley, California (1941).

*O*n the upper left are the hills that supply Los Angeles with water, the source of electrical energy. On the upper right, the 'hand of opportunity' reaches through a gushing arc of water. A monumental man prods the earth's stratifications, endeavoring to mitigate the travails of humanity. The workman is bowed under his labor and the woman, conscious of the earth's fertility, is looking down. The youth is awakening. These constitute a trinity of constant and evolutionary repetitions in progress and development.

HUGO BALLIN
*from **Hugo Ballin**, a Master's thesis by Carol Steinberg*

The two figures at the right are Benjamin Franklin and Dr. William Gilbert, a 16th-century English doctor who made significant discoveries about static electricity.

Hugo Ballin (1879-1956) was a writer, stage designer, movie producer and director in addition to being a painter. Among his other local murals are those in the sanctuary at Wilshire Boulevard Temple, in the lobby of the Los Angeles Times Building, in the Burbank City Hall and in the auditorium foyer at El Rodeo School in Beverly Hills.

Power, 1930, by Hugo Ballin, One Bunker Hill (interior lobby), 601 West 5th Street.

América Tropical today, covered by plywood pending preservation c.1997-98 by the Getty Conservation Institute. Eventually the plywood will be replaced by a roof enclosure with a pathway leading to the mural from the elevator, giving access to the roof so visitors can view the mural while it is protected from further deterioration. An educational installation will also be included.

América Tropical, 1932, by David Alfaro Siqueiros, Italian Hall (exterior 2nd floor), Olvera Street near Main St. and Cesar Chavez Ave. Photo courtesy of El Pueblo de Los Angeles Historic Monument and the Shifra M. Goldman Archive.

It has been asked that I paint something related to tropical America, possibly thinking that this new theme would give no margin to create a work of revolutionary character. On the contrary, it seems to be that there couldn't be a better theme to use.

It is a violent symbol of the Indian peon of feudal America doubly crucified by the oppressors, in turn, native exploitive classes and imperialism. It is the living symbol of the destruction of past national American cultures by the invaders of yesterday and today. It is the preparatory action of the revolution that enters the scene and readies its cartridges to effectively launch the life-restoring battle for a new social order.

DAVID ALFARO SIQUEIROS
as quoted in **The Mexican Muralists in the United States**

At the time it was painted, **América Tropical** was recognized as a major artwork. Nevertheless, by 1934, the mural had vanished under successive coats of whitewash by the order of Christine Sterling who, in 1929, with the support of various Anglo moguls including Harry Chandler of the **Los Angeles Times**, 'mothered' the concept of Olvera Street as a commercial Mexican street. . . .Obviously the theme of the Siqueiros mural, which spoke to continental realities–including the position of Mexicans in the United States who were not only subject to racism and exploitation but were being deported in the thousands because of the Depression–was at odds with the picturesqueness being promoted by Sterling in the Olvera Street complex. Renewal of tenants' leases was refused until the mural was covered.

My involvement in the campaign to restore the Siqueiros mural began in 1968 with an approach to the Olvera Street Merchants Association. Though interest was high among a few because it would certainly promote business on the Street, not one individual offered money or fund-raising aid.

Censorship has many faces. The Siqueiros mural has actually died two deaths, the victim of double censorship. The first was in the blatant form of white paint, the second with the more subtle technique of withholding funds for restoration.

SHIFRA M. GOLDMAN
edited from her article in **Artweek**, *July 5, 1990*

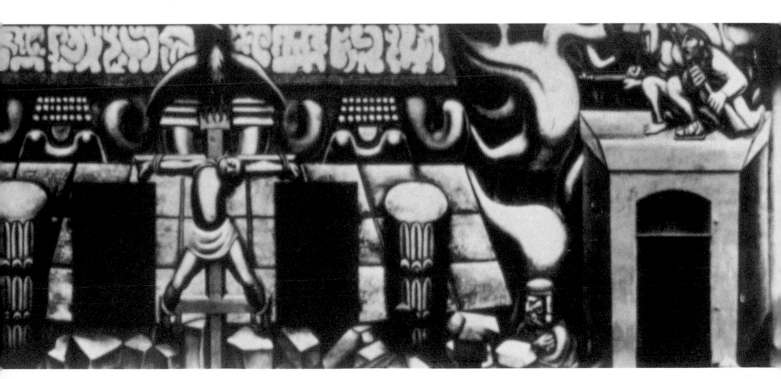

Bride and Groom (below left side), 1972-76, by Kent Twitchell, Victor Clothing Company, 240 South Broadway.

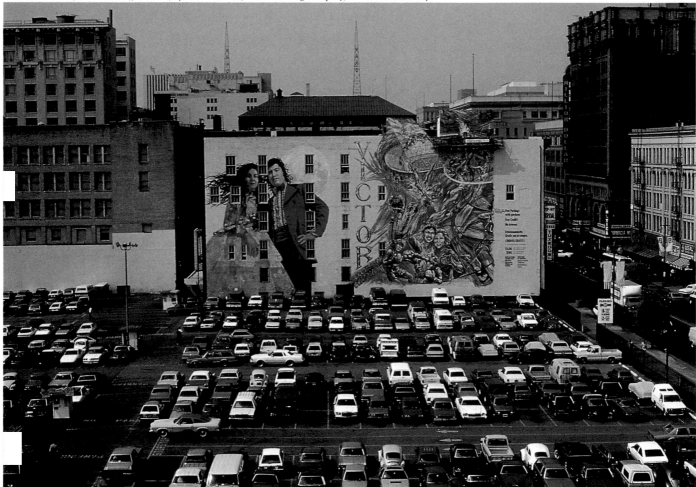

El Nuevo Fuego (The New Fire) (above right side), 1985, by East Los Streetscapers (David Botello, Wayne Healy and George Yepes, assisted by Rudy Calderon, Bob Grigas, David Morin and Paul Botello), Victor Clothing Company.

I decided the Bridal Shop owner, Carlos Ortiz, would make a good subject as the groom. I think that's why the mural ended up being five stories, instead of the original two stories. I was enamored at that time with an Hispanic girl, but Carlos had a girlfriend, too, that he wanted to impress.

KENT TWITCHELL

Our store (Victor Clothing Company) has about 98% Latino customers, and the murals are a way to give some of the profits back to them by helping the Chicano artist community. It's just a way to say 'thank you.'

RAMIRO SALCEDO
co-owner

The Pope of Broadway (Anthony Quinn), 1985, by Eloy Torrez,
Victor Clothing Company, west-facing wall.

Ed Ruscha Monument, 1978-87, by Kent Twitchell, 1031 South Hill Street, Downtown.

I wanted to paint a monument to the unorthodox hero of the art world, Ed Ruscha (see preceding two-page spread). *In many ways he represents a lot of us who came to Los Angeles from parts unknown in the Midwest. He came here from Oklahoma (Twitchell is from Michigan). He loves the movies, and grew up with them. We had a lot in common in terms of our favorite things.*

I had just gotten out of Otis (Art Institute). In 1978 I painted the face up there and it was just horrible. I probably painted his face about three times, at least. I painted his hands twice. The shirt is not paint-by-number. It's blended because I was not satisfied with the effect. But everything else on the mural is paint-by-number.

KENT TWITCHELL

Ed Ruscha Monument, 1978-87, by Kent Twitchell, 1031 South Hill Street, Downtown.

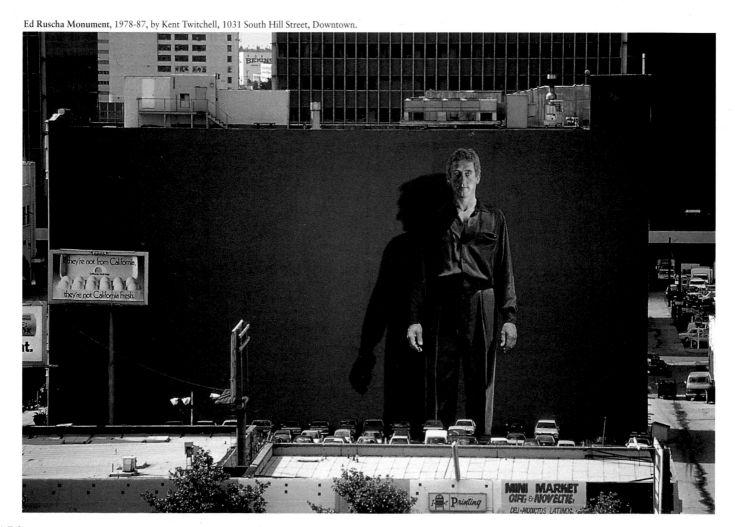

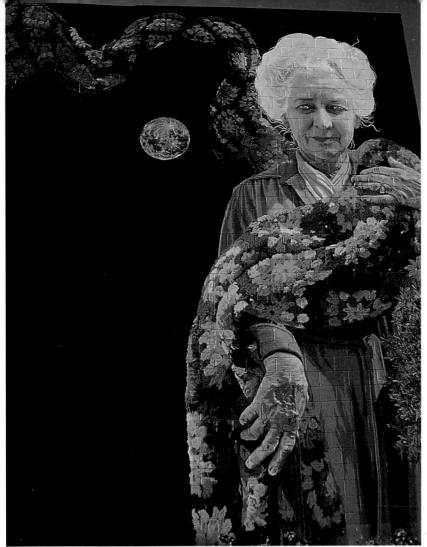

The Freeway Lady, 1974-1986, by Kent Twitchell, Prince Hotel, 1255 West Temple Street, Echo Park.

Her name is Lillian Bronson. She was a character actress who played everybody's secretary and aunt and grandmother from Clark Gable to Henry Fonda. I remembered her from when I was a kid as the scariest judge they had on Perry Mason. Probably the most famous thing she did was after I painted her. She played Fonzie's grandmother on 'Happy Days.' **The Freeway Lady** was painted out in '86 by a company from the San Francisco Bay Area who had come down looking for walls that would be good for commercial ads. They were going to pay the building owner $50 a month so he said sure. After they painted out my mural, they found out it's against the law to put an ad or billboard so close to the freeway unless it's advertising something that is actually in that building.

A lawyer I knew kept asking me to sue because it would be a landmark case. I really didn't want to sue. I just wanted to stay away from that whole thing. After about a year and a half, she finally convinced me. The only thing the owner of the building had done wrong was fail to notify me. He has the right to paint it out. Anybody who has anything on their building has the right to destroy it. But you're supposed to make a concerted effort to find the artist in case the artist wants to remove it, photograph it or otherwise document it. It's a fair law, so I went along with it. Nobody should have to live with a work of art if they don't like it.

My lawyer took it to court and won. The owner agreed and signed all the papers to pay for its restoration but then dragged his feet. We believe he will sell the building as soon as he pays for restoration, so I'm now considering painting her somewhere else. The thing is, nothing has ever happened because he never paid a dime.

KENT TWITCHELL

Chinese achievements in music, literature and art are shown in the context of a party of important artists, organized by the great Chinese calligrapher and poet, Wang Xi-Zhi, about 1700 years ago.

Shiyan Zhang is known as a master lacquer painter in China. He lived in the United States from 1988 to 1993. This is his only American mural.

The first documented mural in China was more than 2000 years ago. It was described by Confucius, who wrote that he'd seen a great mural in an emperor's palace. In about 1977 (after 200 years of neglect), a revival of murals started. In five years there were 500 murals throughout the country. There are many more now, mostly indoors and using very fine materials–lacquer, mosaic, glass and porcelain.

SHIYAN ZHANG

The Party at Lan-T'ing, 1991, by Shiyan Zhang, Chinatown Public Library, 850 Yale Street. © 1991 Social and Public Art Resource Center.

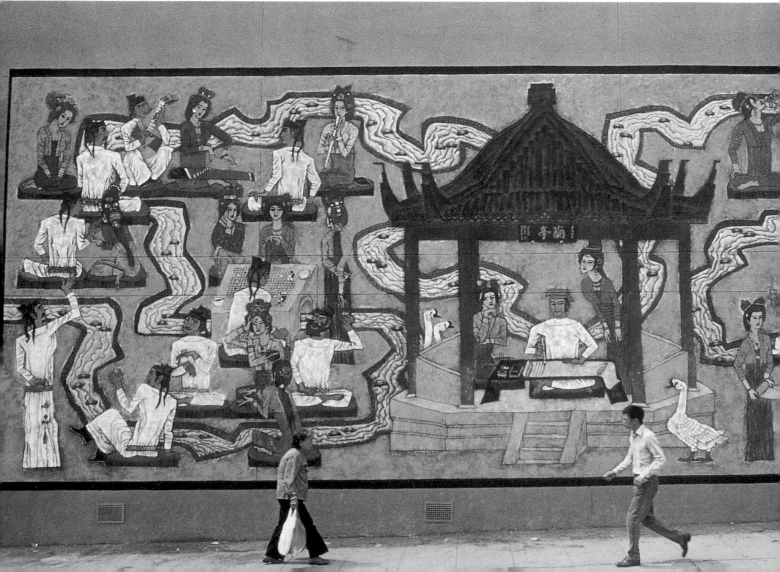

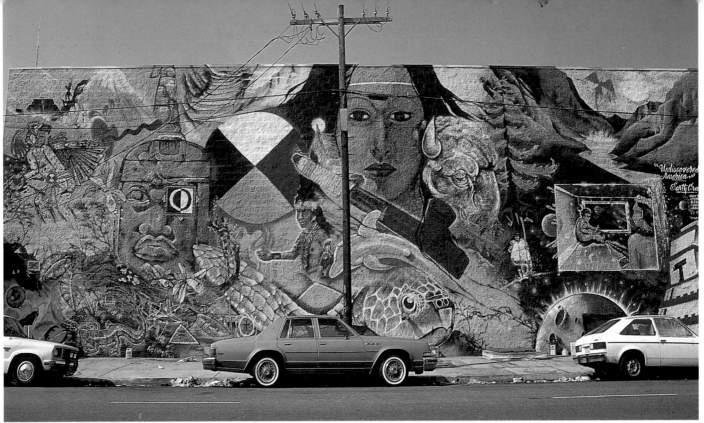

Undiscovered America, 1992, by Earth Crew (Erik 'Duke' Montenegro, Benjamin James Frank Jr., Rojello 'Angst' Cabral and Joseph 'Nuke' Montalvo, coordinated by Helen Samuels), Tokima Foods, 843 East 4th Street, Downtown. © 1992 by the Social and Public Art Resource Center.

Earth Crew is a culturally diverse group of young urban artists: aerosol writers, breakdancers and rap musicians. They are dedicated to ecological preservation and peace. In addition to the painting above, members of their crew have done two local murals honoring Earth Day–in the Pico-Union neighborhood and at Gold's Gym in Venice.

Undiscovered America is about the achievements of Native American groups from Alaska to Argentina. It was done in the face of the 500th anniversary of the arrival of Columbus in the Americas, and celebrates the healing of relations between all peoples of the world.

159

T*he theme is travel, but rather than travel in one plane of space, I thought more of traveling in time and in the imagination. The three chambers represent different periods of time and correlate to California history. There's an inference that if you had the proper ticket, you could travel to one of these different vistas of time. The last scene, the 20th-century scene, is really L.A. in the '50s. The reference I found for that was from this incredible book called* **L.A Before the Freeways.** *The central city then had a kind of intimacy that is totally gone.*

The cat is caught between two time zones, which accounts for its change in color and texture. The man walking in, whose back we see, is life-size and represents the universal wanderer. Some people accuse me of putting a self-portrait on the man with the serape and pistol looking out, but I always thought he looked more like Woody Allen. The lady on the suitcase is Carole Lombard. I wanted to portray a famous actress who wasn't immediately recognizable. The clock is a reference to the Salvador Dali clock where the hands are limp. Time is melted, and, in a sense, defeated in the piece.

TERRY SCHOONHOVEN

Traveler, 1991, by Terry Schoonhoven, Union Station Metro Red Line (east end), Alameda Street, Downtown.

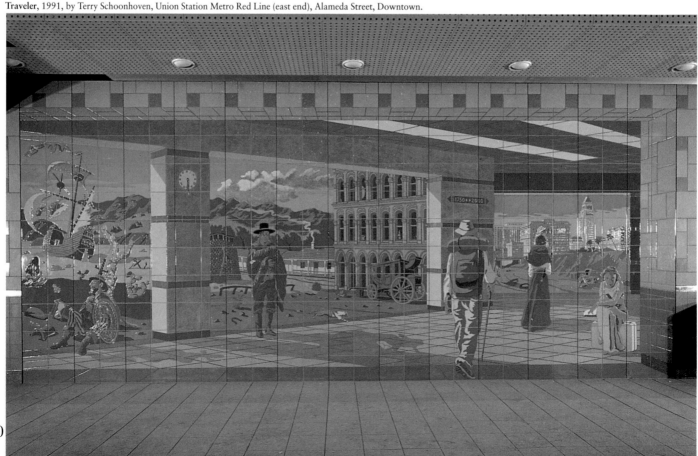

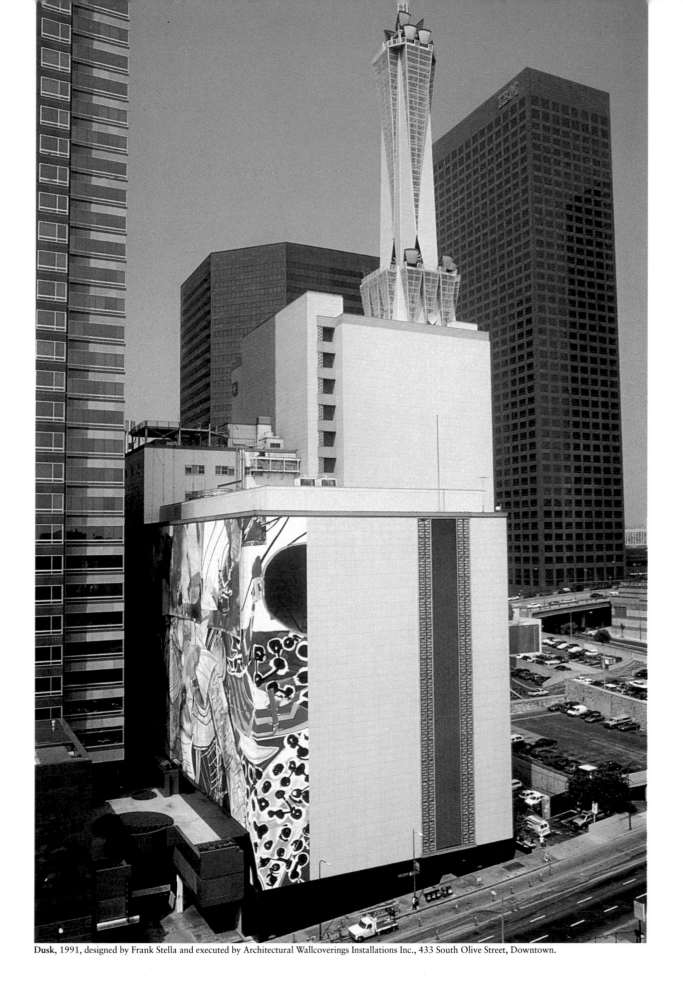

Dusk, 1991, designed by Frank Stella and executed by Architectural Wallcoverings Installations Inc., 433 South Olive Street, Downtown.

161

In 1984 the Summer Olympics were held in Los Angeles. Ten veteran public artists painted murals on downtown freeways.

Our objective was to get artists who represented the energy of various communities within L.A. We wanted a diversified aesthetic statement–not all hard-edged portraits, still lifes, or the same style, but a variety.

ALONZO DAVIS
muralist and project coordinator

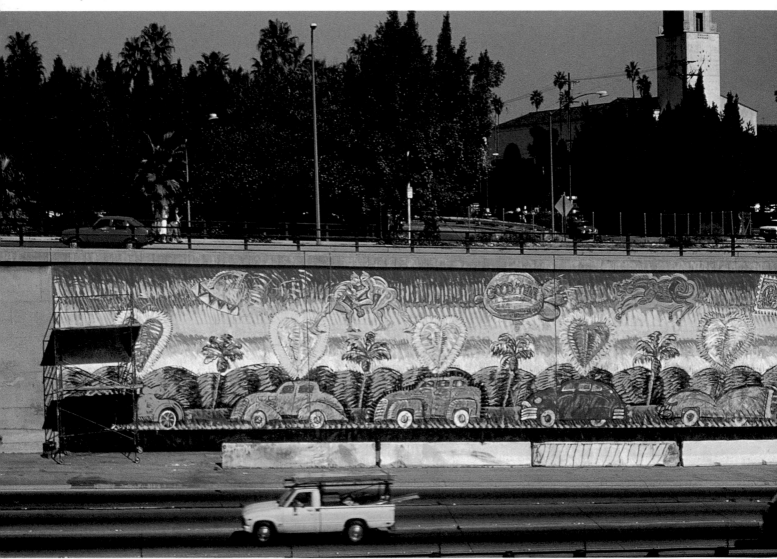

Going to the Olympics, 1984, by Frank Romero, 101 Freeway between Alameda and San Pedro Streets, Downtown.

Unity (destroyed), 1984, by Roderick Sykes, Harbor Freeway (110) at Figueroa Street exit (closed).

W hat I really enjoyed about the freeway murals project was the fellowship, the unity. Everyone was trying to help each other to get it done. In the front panel, it's actually my face, me as a kid in St. Louis, where I'm from. I used to run track, and I always wanted to go to the Olympics. But as time went on, someone was always faster than me.

The mural's statement is about getting rid of the generation gap and the color gap, as well as my joy at being involved with the Olympics.

RODERICK SYKES

Richard Wyatt's collection of portraits of past and present Angelenos is part of a collaborative environmental project with artist May Sun, architect Paul Diez and fabricator Oscar Weathersby that includes an aquarium and a river bench.

City of Dreams/River of History, 1996, by Richard Wyatt, Union Station (East Portal), Alameda Street at Macy, Downtown.

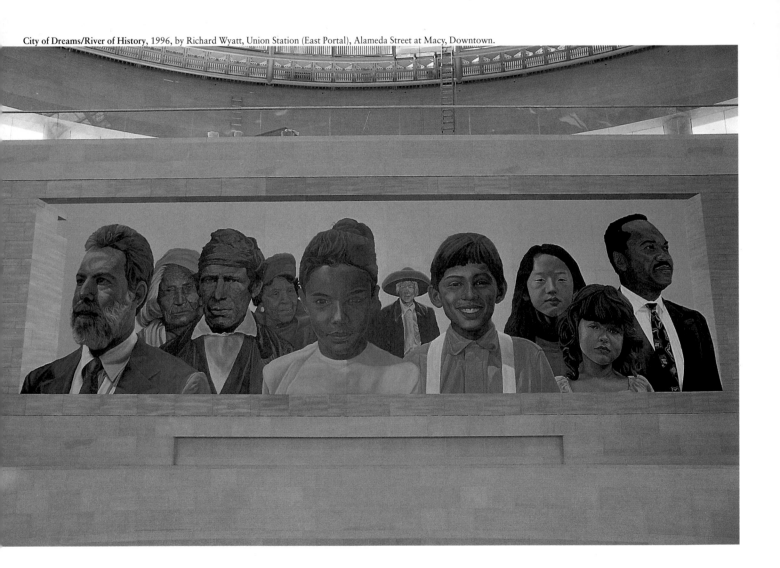

This site-specific oil painting (22' x 78') on honeycomb aluminum is a layered historical portrait of a variety of cultures who contributed to the development of the City of Los Angeles. The mural was enormous to paint in my studio, so I had to paint it sideways in sections. I think in long-term collaborative projects, it really helps to know the people you are working with. For instance, I've known May Sun since our college days at UCLA (1975). And I've known Oscar Weathersby, the aquarium fabricator/facilitator, since junior high school.

RICHARD WYATT

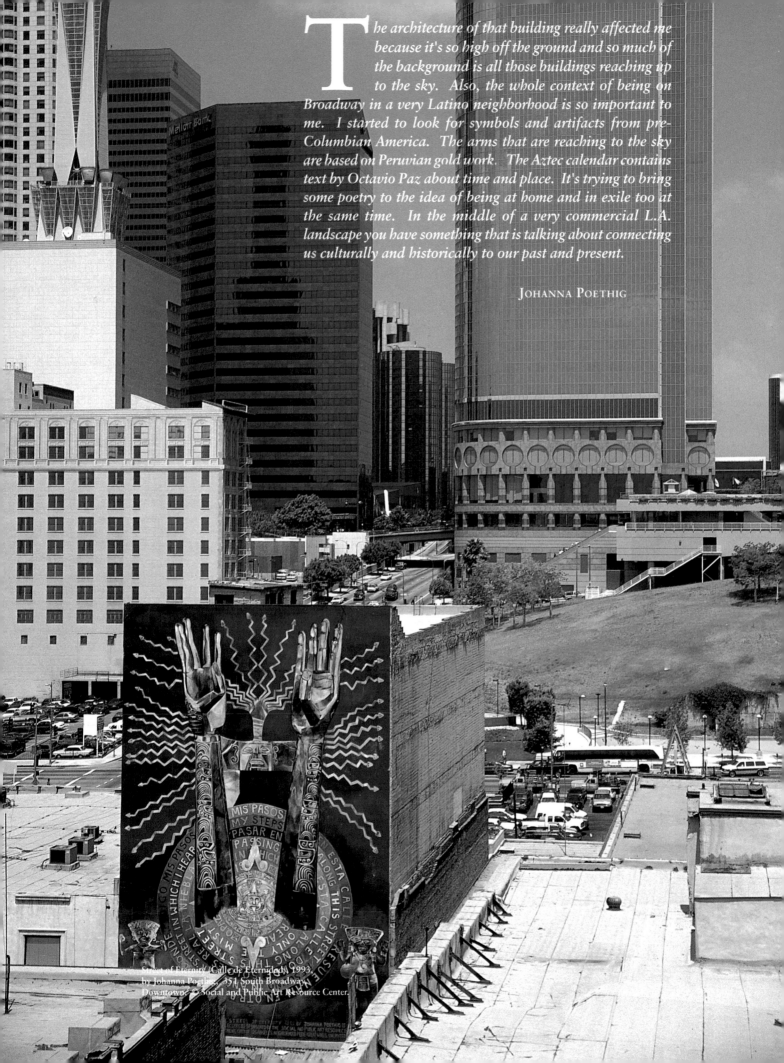

The architecture of that building really affected me because it's so high off the ground and so much of the background is all those buildings reaching up to the sky. Also, the whole context of being on Broadway in a very Latino neighborhood is so important to me. I started to look for symbols and artifacts from pre-Columbian America. The arms that are reaching to the sky are based on Peruvian gold work. The Aztec calendar contains text by Octavio Paz about time and place. It's trying to bring some poetry to the idea of being at home and in exile too at the same time. In the middle of a very commercial L.A. landscape you have something that is talking about connecting us culturally and historically to our past and present.

JOHANNA POETHIG

Street of Eternity (Calle de Eternidad), 1993, by Johanna Poethig, 351 South Broadway, Downtown. © Social and Public Art Resource Center.

Harbor Freeway Overture, 1991-93, by Kent Twitchell, Citicorp Plaza parking garage, 8th Street at the Harbor Fwy. (110), Downtown.

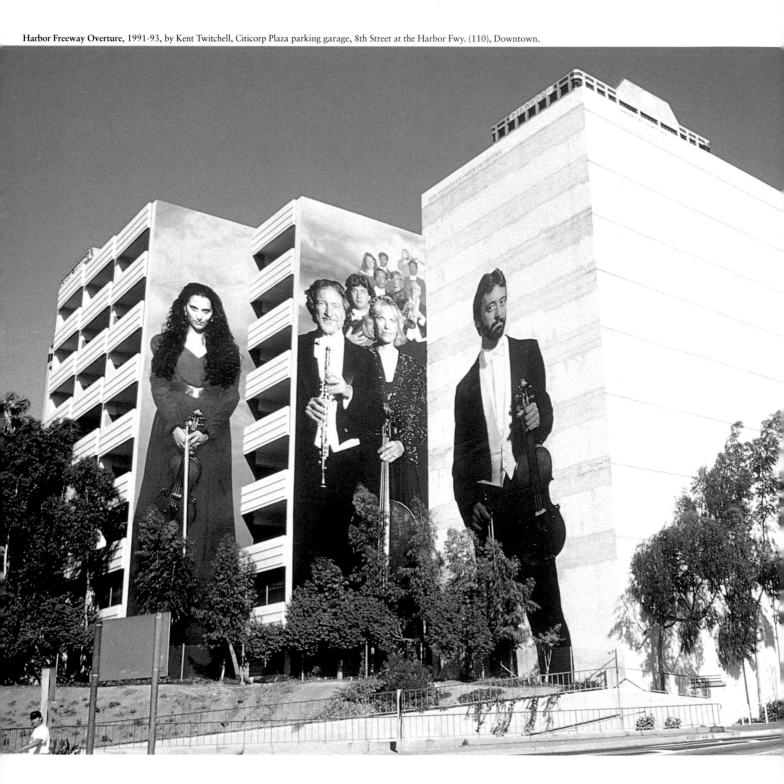

This is the most detailed mural that I've ever done. I painted the figure on the right, Ralph Morrison, in 1991. He is the lead violinist and the concert master for the Los Angeles Chamber Orchestra. If you had binoculars and closed in on his vest, you would see almost every thread. The second figure that I painted–on the far left–was in 1992. Julie Giganti is her name. Then in 1993 I painted the ensemble in the middle.

The Asian gentleman in the central background is Tachi Kiuchi, the CEO of Mitsubishi Electronics of America. They put the money up for the project. He had nothing to do with his face being there. It was my idea. For centuries artists used to paint the patrons in their work. I think it's a great tradition. It went out of favor with modernism. Maybe it's one reason corporate America often ignores fine art. Everyone likes to be appreciated for their efforts. Today the media seldom give credit to companies who sponsor fine art. We might have a healthier art world if we were kinder to our benefactors.

KENT TWITCHELL

Les Grimes painted frolicking pigs on the factory walls for 11 years before falling to his death from a scaffold in 1968. Arno Jordan was hired to continue the work.

Hog Heaven, 1957 to present, by Les Grimes and Arno Jordan, Clougherty Packing Plant, Soto Street and Bandini Boulevard.

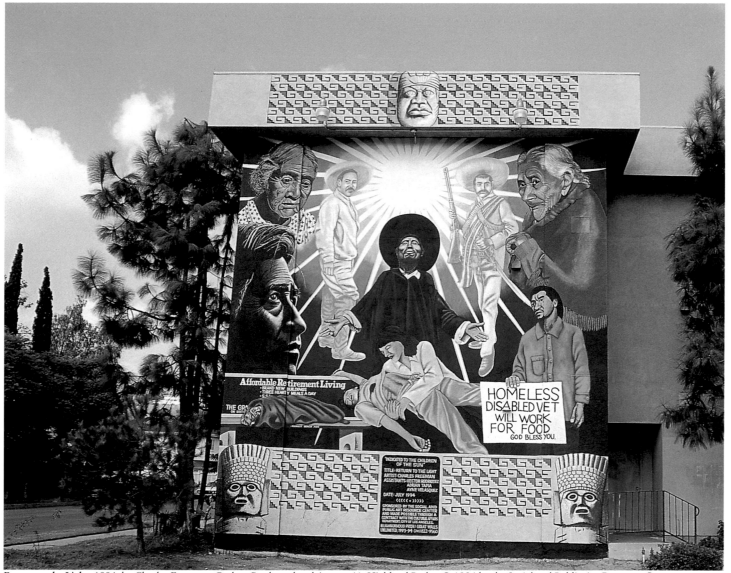

Return to the Light, 1994, by Charles Freeman, Carlota Boulevard and Avenue 41, Highland Park. © 1994 by the Social and Public Art Resource Center.

Realizing our spiritual destiny is to **Return to the Light**, I was inspired to reflect that in this work. We are captive in this material world for a brief time, and most of us become ensnared in the traps of those conditions of darkness (hatred, greed, envy, etc.). It becomes imperative that we work to unfold the powers of wisdom, purity and goodness. Therefore, you see depicted two of the most prevalent social ills of our time–the senseless killing of our young people and the insensitivity to people without adequate shelter (young and old). The Shaman or Curandero in the center represents a healthy state of wholeness. César Chavez represents vision or sole purpose. The elderly are symbols of rich experience and wisdom. The ethereal images of Pancho Villa and Emiliano Zapata signify strength and courage. All these characteristics become essential to our ultimate destination.

CHARLES FREEMAN

169

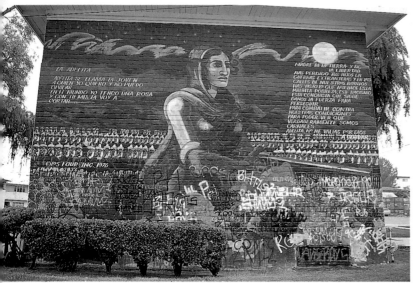

La Adelita, 1976, by Los Four (designed by Carlos Almaraz), 1581 Alcazar Street, Ramona Gardens.

Memorial to Smoky (Arturo Jimenez), 1992, by Joe Rodriguez and Solomon Huerta, 1504-10 Lancaster Avenue, Ramona Gardens.

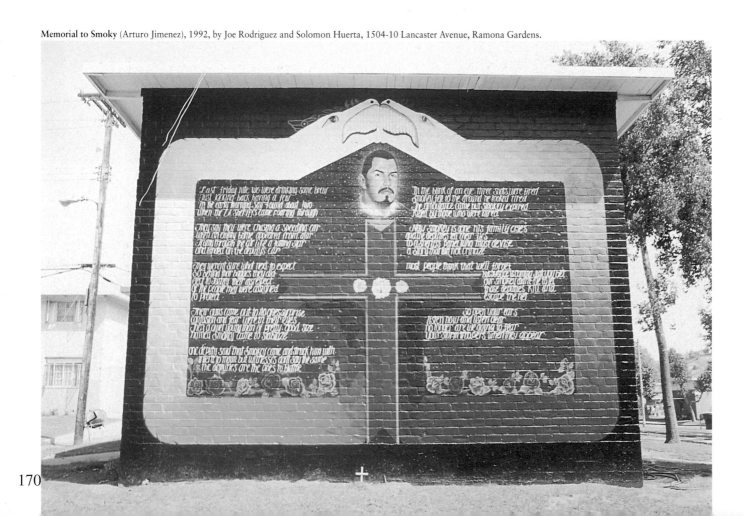

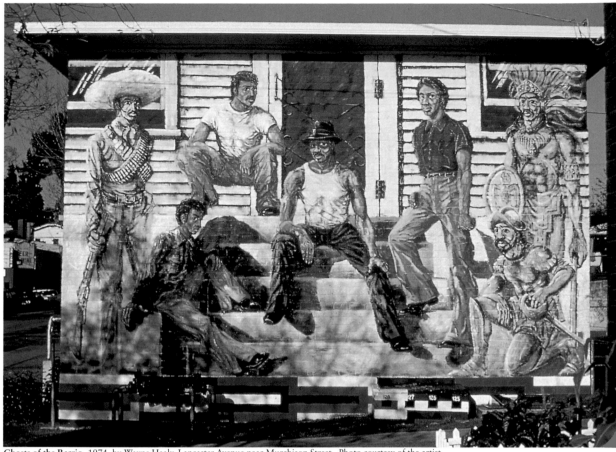

Ghosts of the Barrio, 1974, by Wayne Healy, Lancaster Avenue near Murchison Street. Photo courtesy of the artist.

A fter painting group murals with the artists of Mechicano Arts Center (which coordinated the mural program at Ramona Gardens), *this was my first solo mural. Over the years it has been reproduced many times in art, history and cultural tomes, including the encyclopedia.*

The composition is built around four vatos or home boys on a front porch, flanked by ghostly images of their cultural ancestors, i.e., Azteca, conquistador and mestizo, all in military garb. The implication is that the vatos' Pendletons, starched khakis and pleated shirts constitute the uniforms of the barrio foot soldier. Painted during the height of La Causa, when there was a significant drop in gang warfare, the direction of the vatos' fight was for their civil rights. Today, however, gang violence is greater than ever.

WAYNE ALANIZ HEALY

In 1970, we (the people of Barrio Logan in San Diego) took over Chicano Park. Then, on March 27, 1973, all the artists came out and started to paint murals on the Coronado Bridge. It was wonderful. There were 12 of us calling ourselves El Congreso de Artistas Chicanos en Aztlán (CACA). In about 1975, we changed our name to El Congreso de Artistas Cosmicos de las Américas because I wanted to include people of all colors. CACA did its first mural in Estrada Courts in 1974. It was the spinning Z of Aztlan. CACA also did a mural in San Francisco's Balmy Alley during the mid '70s (gone now).

I first created a poster, 'You Are Not a Minority,' on October 8, 1977. The poster commemorated the 10th anniversary of the murder of Che Guevara in Bolivia. I was so moved because I used to listen to Cuban radio on a friend's shortwave. That's how I learned that October 8th is remembered every year in Cuba and around the world.

Exactly a year later, we did the mural. We changed it to **We Are Not a Minority**. In the beginning we wanted to talk to the people—you. Then we realized that you is really we. We are sending this message to the world, and especially to the System, a racist system continuing to try to belittle us and calling us minorities. I painted that mural over and over, like at the University of Calexico I did it twice. In 1980, I went to Phoenix and painted **We Are Not a Minority**, but instead of doing Che, I painted the Virgin of Guadalupe.

MARIO TORERO

We Are Not a Minority, 1978, by El Congreso de Artistas Cosmicos de las Americas (CACA), 3217 East Olympic Boulevard, Estrada Courts. Photo courtesy of Mario Torero.

We Are Not a Minority, 1996 (restoration), by Mario Torero and Carmen Kalo, assisted by Ernesto de la Loza.

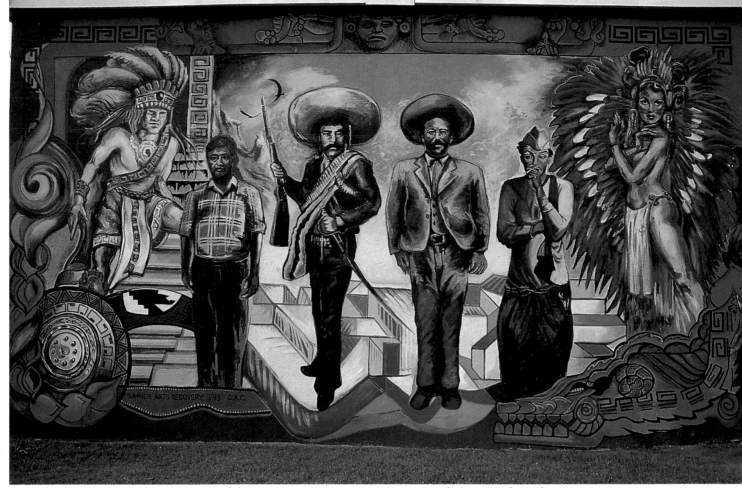

Los Cuatros Grandes, 1993, designed by Ernesto de la Loza, Hunter Street near Lorena Street, Estrada Courts, Boyle Heights.

E strada Courts housing project is the largest concentration of murals (about 40) in one area in the world. This was the first mural that had been done there in 10 years. Ruben Guevara, a freelance artist, poet and performance artist, did a proposal and got the funding. The goal of this thing was to empower the people. We had several meetings with the residents of Estrada Courts where we brainstormed, and they picked all the elements of the mural. I tied it all together and designed it pictorially. The residents and the youth, first timers actually, painted the mural. The age range was eight years old to about 40. There were at least 30 people who worked on it. All I did was supervise, and I gave them insight on how to scale it and how to transfer the art onto the wall.

The four main figures are César Chavez, Emiliano Zapata, Pancho Villa and Spanish comic actor Cantínflas.

ERNESTO DE LA LOZA

173

After 23 years, I was finally able to restore my first solo mural to better than its original color. I received a grant to repaint **Dreams of Flight** from the Social and Public Art Resource Center (SPARC) in Venice, California. I am very thankful for this opportunity, because it had been in a dreadful condition for many years. It had been covered with a resin coating in the late '70s, as other murals in Estrada Courts were. This coating was meant to protect them, but it had the opposite effect. The resin started to decay the mural within the first year–cracking and pulling the inexpensive acrylic paint off the walls. After a few years I returned with an air compressor and gun, and sprayed three gallons of Nova acrylic glaze over and into the cracks of the entire painted surface. This kept the mural from flaking off the wall.

This past autumn, 1996, I scraped, wire-brushed and washed the curled paint chips from the higher surface of the mural. Then I brushed on a thick coat of Nova acrylic gel. Now that the remainder of the mural was secured, I was able to overpaint 99% of the artwork.

Now that over 20 years have passed since I first designed this personal mural, some things have changed in our society for the better. I decided to change one of the children from a boy to a girl. I even put her baseball cap on backwards. I always thought the child in the center with long hair could be considered either a boy or a girl, but I wanted to make it obvious that this was a girl, dreaming of flying her model airplane.

Other than this change, the mural seemed to come out with more color and detail than it had when first rendered. I guess 23 years changes a person's style, hopefully for the better. I've always wanted this mural to speak to the children who see it, and say that 'Your Dreams can come true.'

DAVID BOTELLO

Dreams of Flight, 1973-78 (restored in 1996), by David Botello, 3241 East Olympic Boulevard, Estrada Courts.

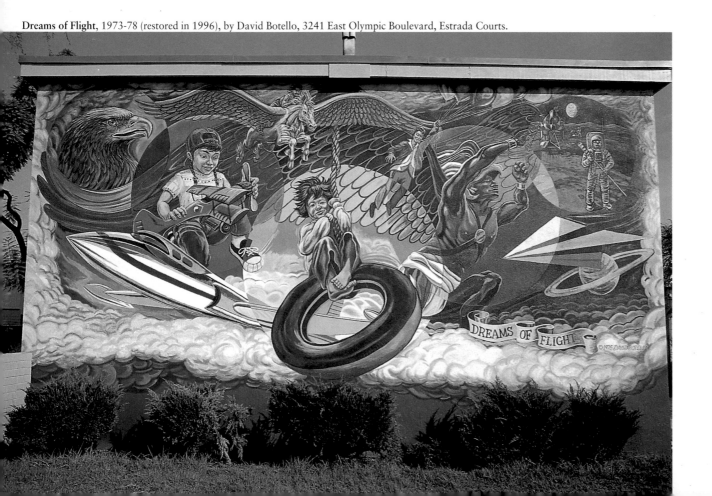

Tome Conciencia! (Be Aware!), 1987, by Taller de Gráfica Monumental (Mauricio Gómez and students from the Universidad Autónoma Metropolitana, Xochimilco, Mexico), One Stop Immigration, 3600 Whittier Boulevard, East Los Angeles.

Where Heroes Are Born (detail), 1981, by Juan Orduñez, 3881 North Broadway, Lincoln Heights.

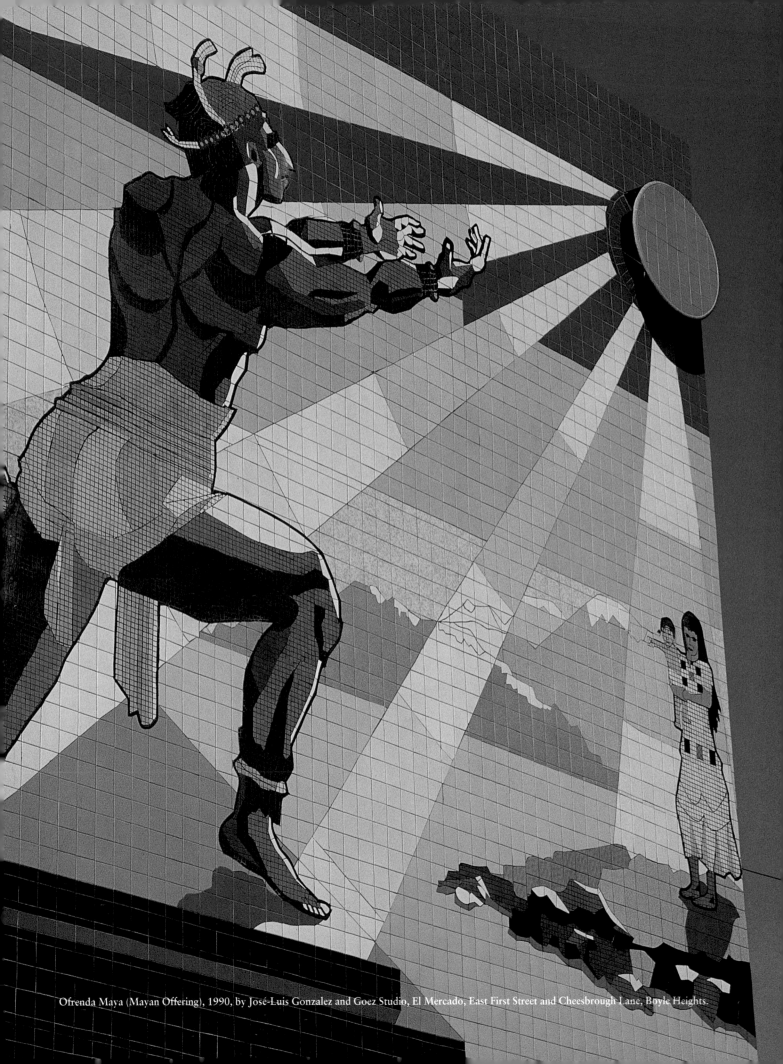

Ofrenda Maya (Mayan Offering), 1990, by José-Luis Gonzalez and Goez Studio, El Mercado, East First Street and Cheesbrough Lane, Boyle Heights.

When I turned 30 in 1969, I opened my own studio in East Los Angeles at First and Gage. That became Goez Art Studio. I had already been an artist for 12 and a half years. I was one of the very few fortunate individuals who began earning a living as an artist when I was 17 years old. The name Goez derives from my last name, Gonzalez, and I did that to create curiosity. People didn't know if it was Jewish, German or Spanish. I wanted to attract my brother, John, to come back to the United States. He was in Spain because he was tired of being called a 'wetback' and other derogatory names. When he got back to the USA, he invited David Botello, a friend from school, to come in as our partner. I had already invited Robert Arenivar, who passed away in 1985. Robert turned out to be one of the best designers of a lot of the murals. Goez was at the forefront of the mural movement in East L.A. We were dreamers. We had a lot of things in mind that would bring about a cultural and historical awareness to the community. Our goals were education, beautification and cultural awareness.

John stayed with me for a long time, until about 1978. (David left in 1975 and soon co-founded what became East Los Streetscapers.)

I kept Goez going. We didn't write grant proposals; we were trying to live by our own efforts. We've been out of sight since about 1980, but we've been busy with big projects.

I've done just about everything at El Mercado (a restaurant and shopping complex), including the tile floors and the three stages. There's a lot of art work in there. When I was doing the Olympics mural (Exposition Park Welcomes the World, 3965 South Vermont Avenue) in 1984, El Mercado's owner, Mr. Rosado, contacted me. I proposed to him that I would first develop a theme. Then upon that theme, I would do some designs. If he liked the designs, we would go with blueprints. If he liked the blueprints, we'd go with a model. And if he liked the model, we would start the work. The theme was Mexico. It was fortunate for me that he liked everything we were doing. In going to El Mercado night after night, I saw that it was attracting the national Mexicanos from Oaxaca to Sonora. So naturally I had to create an inviting feeling by putting little touches of different parts of Mexico throughout the restaurant.

The Ofrenda Maya was important to do, because I wanted to show the family since the whole El Mercado is family oriented. I have the Indian next to a pyramid, kneeling and offering his newborn son to the Sun God. His wife and child are in front.

We're constantly adding more to El Mercado. I've submitted another design, that's been approved, for a large (64-foot) fountain to be totally hand-carved in stone. That place is practically my own gallery or museum. Mr. Rosado has turned out to be a good patron. He appreciates what I'm doing. As artists we want to do our own thing that best reflects our interpretation of the art. But many times we have to do what we feel is right, putting ourselves in the place of the beholder.

JOSÉ-LUIS GONZALEZ

177

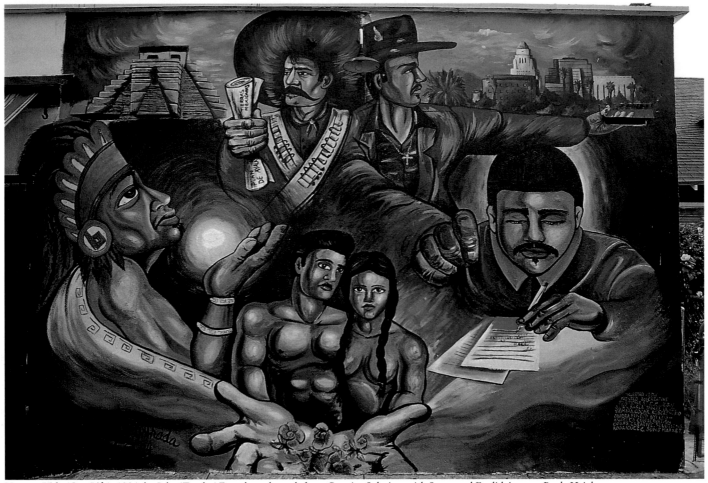

Nuestra Vida (Our Life), 1994, by John 'Zender' Estrada and youth from Creative Solutions, 4th Street and Euclid Avenue, Boyle Heights.

I was doing so many mural projects that I didn't have time to do the grids and the sketching on paper. I had to adopt a quick way. I just looked at what I was doing and went with the spraycan, and boom, drew it to scale. It saved a lot of time, plus kids right away got into that. They saw the speed of it. They helped me do the underpaint, then I did the painting on top with all brush. Every now and then I would do some special effects with the can. A lot of people wonder whether I'm an aerosol artist or a traditional muralist. Well, I'm neither one. I like to somehow break the rules.

This mural was a favor for the owner. He wanted something that reflected the East L.A. lifestyle of that area. It was very gang infested. There was a guy there who was well-known from the gang, and everyone feared him. But he came up to us, and he was excited about a mural in his neighborhood. I thought it was so cool that I did a representation of him–he's the one doing his homework. The two figures in the middle are offering flowers to you, saying, 'This is what our culture offers to the community– the education and the history of it.'

JOHN 'ZENDER' ESTRADA

George Yepes was born and raised in the City Terrace neighborhood of East Los Angeles. Between 1980 and 1986, he painted murals with East Los Streetscapers. This mural was his first major project after leaving that group and beginning to do murals on his own.

The title was inspired by Our Lady Queen of Angels, the saint after whom the city of Los Angeles is named. The image expresses a desire for world harmony by portraying a Latina with the flags of more than 100 countries draped around her. The Mexican flag is over her heart.

What's important is the art. I'd rather somebody know my work than know me. . . . I paint for history–for what they're going to say about the artwork 50 years from now. I want history to look back and say, 'Wow, this guy could paint.'

GEORGE YEPES

Mujer de Este de Los Angeles (Lady of the Eastside), 1989, by George Yepes, 418 South Pecan Street, Boyle Heights. © 1989 by the Social and Public Art Resource Center.

We designed this mural to fit four walls of a staircase that leads students up a bridge that crosses the street to Bravo Medical Magnet High School. On the tallest, narrow wall is an indigenous healer–included to represent the ancient traditions. Next to her are young people working on a large android figure, which speaks to building the future. The present is upheld by four students in the foreground and two graduating students at the upper right. Those in the front are protecting the small globe of the earth from land levelers, chainsaws, the smokestack industries and ships that over-fish the oceans.

At the far left is a thin, Black child of an impoverished Third World country, contrasted below with the multi-billion-dollar space industry. The largest person is a doctor at the right who is performing surgery. An intertwining DNA molecule, a heart and a pair of lungs are also there floating with the surgeon at the edge of the large arc of the earth. This arc of the earth is the biggest element of the mural and can be seen aligned perfectly from across the street.

My partner Wayne Healy received a Cultural Affairs grant for this project. He's the mathematician and engineer of the group and I'm the colorist and organizer. Together we share our ideas, then design and get fellow artists and apprentices to help us paint.

DAVID BOTELLO

Stairway to Global Health, 1991, by East Los Streetscapers (David Botello, Wayne Healy, Rich Raya),
Bravo Medical Magnet High School, 1200 Cornwell Street, Lincoln Heights.

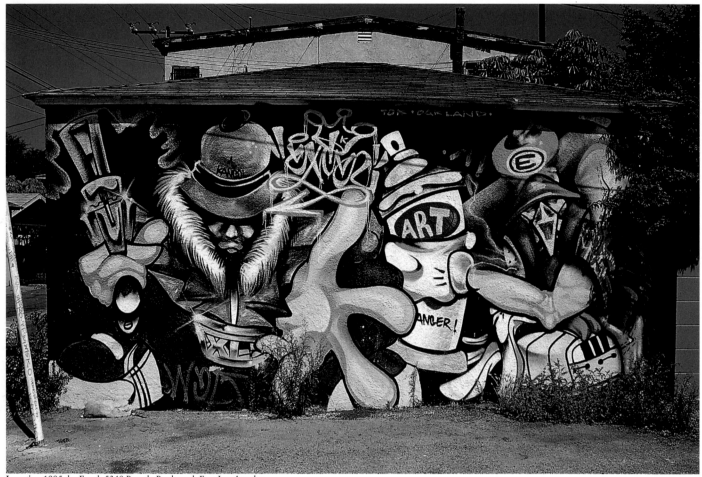

Lunatics, 1995, by Excel, 5340 Beverly Boulevard, East Los Angeles.

One character is holding a spraycan and one is holding a gun. I put the gun on him to symbolize how bad stuff is these days. It doesn't mean that I'm going to be packing a gun around on the street to kill someone over some graffiti. To me graffiti has nothing to do with shooting each other. It is kind of chaotic, but it's against the system. It's not against people. It's just drawing, just having fun. At the time I did this, I was living in Orange County. I'm from a crew out there in Southern California called AWR--Angels Will Rise or Art Work Rebels. I hooked up with this guy who owned a store called Lunatic. He asked me to paint the side of his store.

It all started with airbursh. I used to be an airbrush aritst. Then eventually I got into tattooing. Now my friend and I have a shop out here in San Jose. It's called New School Studio, and I tattoo pretty much every day. We still paint a little. We've got a bunch of yards in San Jose. I try to paint once a week.

EXCEL

I t's the front of a studio of another artist. There was always this gang tagging on that wall. I was hanging out there one day when she said, 'You know, I'd like something up right there.' I went home, got some paint and came back. I think it took me three hours to do it. We met some of the gang members. They thought it was cool. They're actually the ones who've been maintaining the mural. Nobody has written on that mural since I painted it, mostly due to them.

MAN ONE

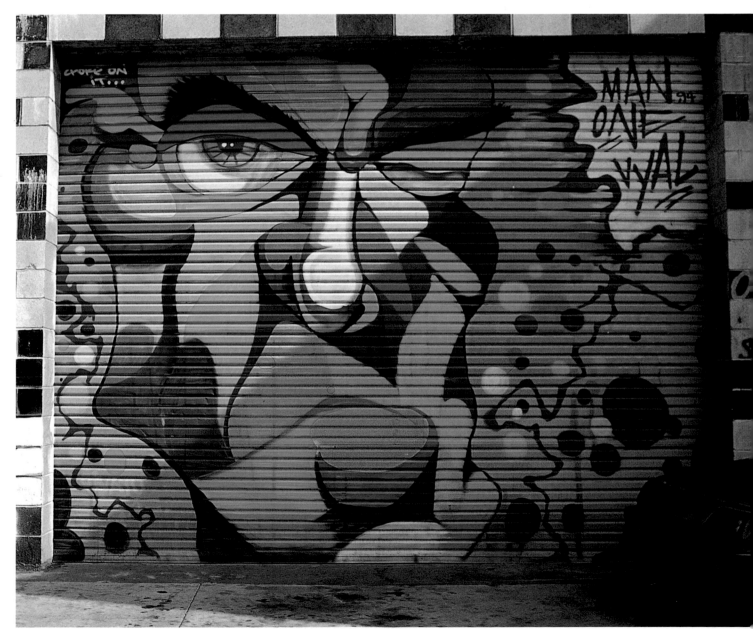

Untitled, 1994, by Man One (assisted by Vyal), 1607 César Chavez Avenue, Boyle Heights.

The **Virgin's Seed** was commissioned by Our Lady of Guadalupe Parish, the elementary school all nine kids in my family attended and the church where generations of my family have celebrated their rituals. Monsignor Atwell, the parish priest of 32 years, my father, sister and myself are depicted in the work.

The work is a symbolic narrative that examines the dichotomy between God and man, and the impact of spirituality on society. It is my contemporary tribute to one of the greatest Mexican religious icons, the Virgin Mary–Our Lady of Guadalupe. A spiritual mural, it walks the tightrope between traditional values and contemporary artistic attitudes.

I depicted Our Lady of Guadalupe in the same respect and honor that she has been given and has received for centuries. The composition revolves around her calm strengths and indigenous beauty. She is like an eye of a tornado, the light of the night. She is honored by angels of many colors and even a fallen angel. To the left of her, a blue giant Juan Diego of the future brings gifts of roses and a modern bride in a metal dress, while symmetrically a lovely woman brings gifts of science and the groom. The offering of the bride and groom symbolizes the unity of love between humans. At the far left a small woman fights a huge skeleton with the light of truth and justice. With that light she will prevail over all obstacles no matter how intimidating.

The virgin's seed is symbolized by an embryo emerging from the earth. The embryo represents the future, our children and the responsibilities they foster. One must be responsible for the education of our young and not let our children or ourselves be trapped inside the mind of a television set, the new god on its pedestal. On the far right side of the mural is a crowd of people including caring and uncaring individuals–there are always demons amongst the good.

PAUL BOTELLO

The Virgin's Seed, 1991, by Paul Botello, Hazard Avenue at Hammel Street, Boyle Heights. Photo courtesy of the artist.

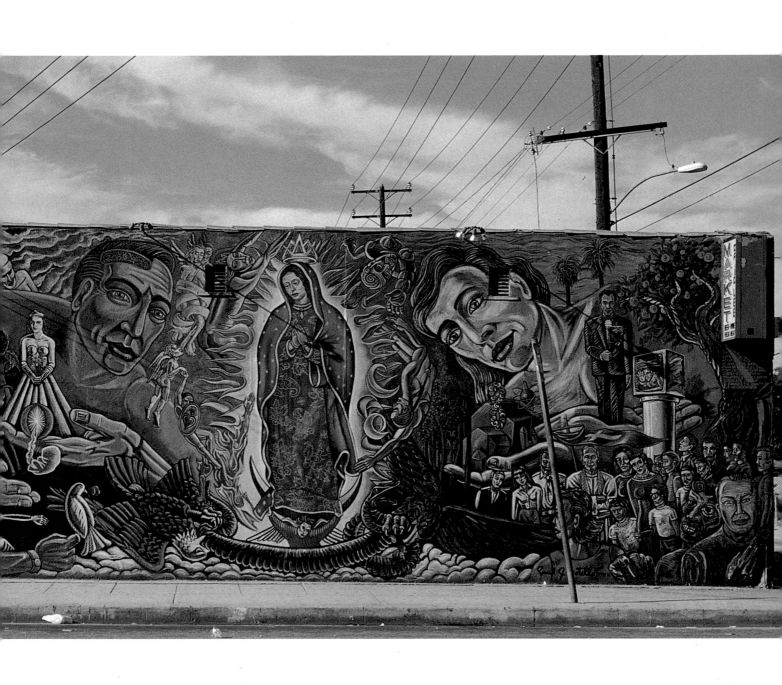

The Quetzalcoatl Mural Project began as Daniel Robles' dream and inspiration. An honors graduate of Roosevelt High School, he was killed by continuing, unnecessary street violence on July 2, 1995. One of his dreams was to work on a mural. This project was created to give young Mexican-American artists a way of staying in the community and out of trouble.

A collaboration of Aztec, Mayan, Native American, African and other cultural motifs along the top of the panel symbolizes indigenous cultures in unity with each other. Quetzalcoatl, the mystical feathered-serpent, winds its way throughout the mural.

The mural emphasizes the political significance of cultural self-definition of 'el Chicano.' **Mexico–Tenochitlan–The Wall That Talks** is dedicated to the Chicano Movement ('la causa'), and in memory of Daniel Robles and United Farm Workers leader César Estrada Chavez. We hope to raise people's cultural consciousness and to continue beautifying the communities in the greater Los Angeles area.

JERRY ORTEGA

Mexico–Tenochtitlan–The Wall That Talks, 1996, by Andy Ledesma, John Zender Estrada, Rafael Corona, Jaime Ochoa, Dominic Ochoa, Isabel Martinez, Oscar de Leon, Mario Mancia, Jesse Silva, Anthony Ortega and Jerry Ortega. Arroyo Furniture, 6037 North Figueroa Street (at Avenue 61), Highland Park.

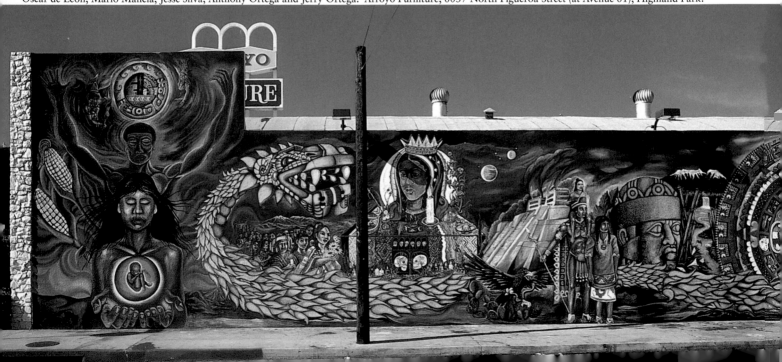

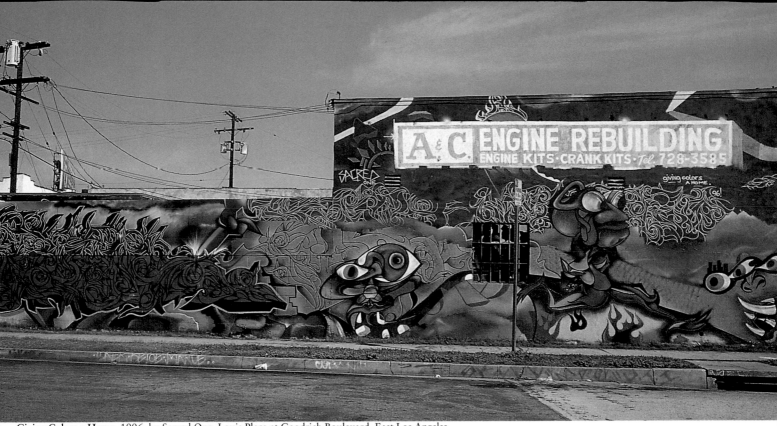

Giving Colors a Home, 1996, by Sacred One, Louis Place at Goodrich Boulevard, East Los Angeles.

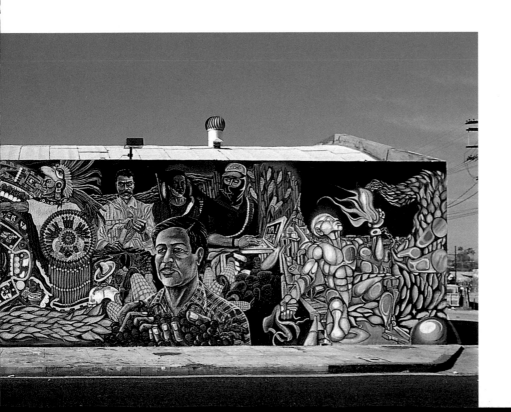

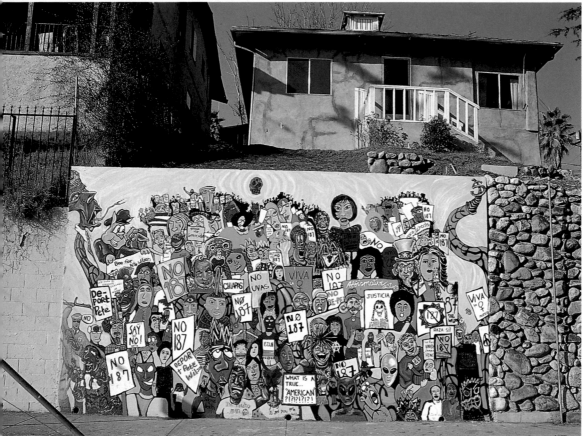

Commemoration to the 120,000 People Who Marched Against Proposition 187, 1995, by Raul Balthazar with youth, Piedmont Avenue and Figueroa Street, Highland Park.

Sponsored by Plaza de la Raza in Lincoln Heights, this mural portrays marchers demonstrating against California's landmark and highly controversial ballot initiative, which called for broad cuts in social services to illegal immigrants. It had recently passed when the mural was painted.

The mural is a take-off from a song by the Red Hot Chili Peppers (one of the sponsors of the project), called 'Under the Bridge.' They wanted me to listen to the song and try to create something. The song refers to a 'Lady'–heroin, the drug. The lady aspect has many layers of meaning and messages. I wanted to do a profile and I figured the 40-foot wing would give it a design shape that I hadn't done before.

The horses at the left end add an element of motion. The concert hall is an homage to the musican. Musicians look at concert halls as their church, their place of devotion. The big skull and bones are a connection to my Mexican cultural tradition. I put them in because the mural didn't look ethnic enough. That was the farthest west I'd ever painted.

Every mural has a different space and a different environment, and I want to capture that when I do a mural. Painting is for my own insight. I want to learn things through the experience.

ERNESTO DE LA LOZA

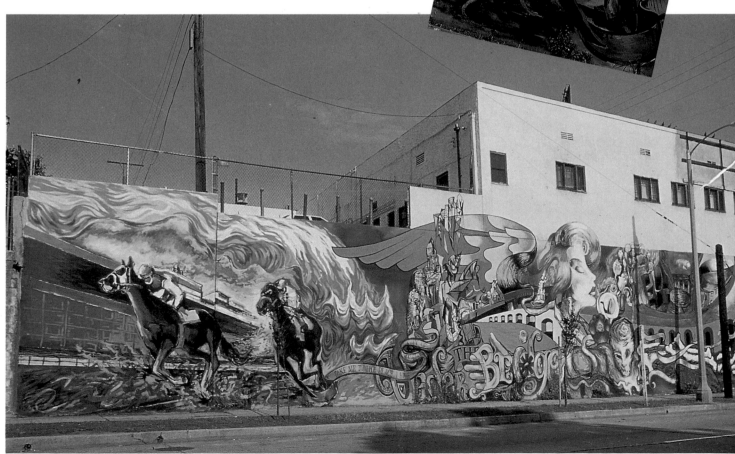

Under the Bridge, 1994, by Ernesto de la Loza, Silverlake Boulevard at Sunset Boulevard, Silverlake.

I am from El Salvador. I came to Los Angeles about 15 years ago after living in Mexico for six years. My mural (**Immigrant**) shows what's in the hearts of many people who come to this country looking for a better life. No one paid me to paint Selena, but some who came by told me that my mural made them feel she was still alive. I often see fresh flowers left at her feet.

Emiliano Zapata was a Mexican leader who believed land should be taken from the rich owners and be given to the poor workers. That is past history. Today Commandante Marcos of Chiapas, Mexico, is carrying on this fight.

HECTOR PONCE

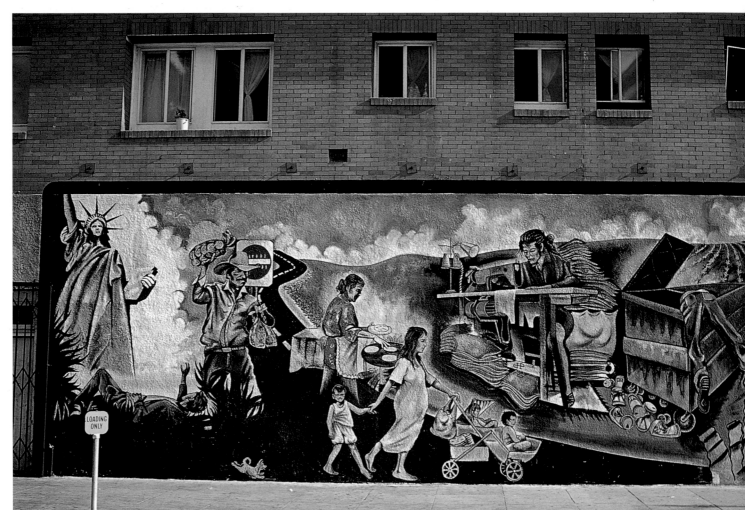

Immigrant, 1992, by Hector Ponce, Pico Boulevard at Hoover Street, Mid-City.

Revolution Evolution (Emiliano Zapata and Commandante Marcos of Chiapas) (destroyed), 1994, by Hector Ponce, 6th Street, Mid-City.

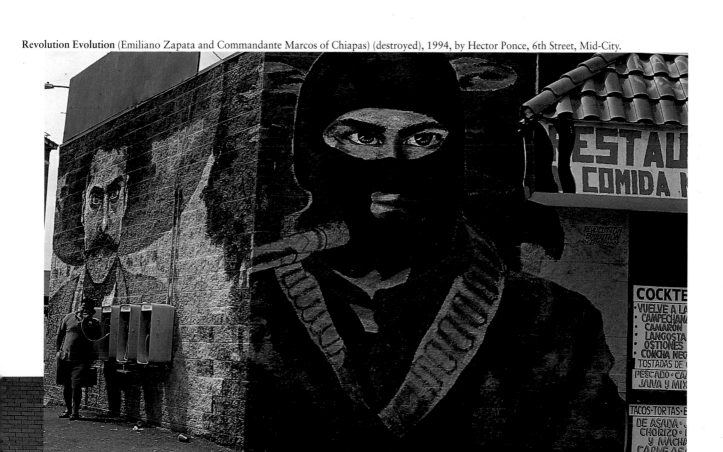

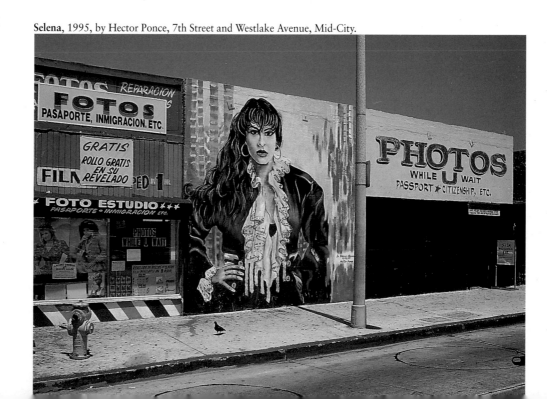

Selena, 1995, by Hector Ponce, 7th Street and Westlake Avenue, Mid-City.

A n agricultural people from ancient times, Koreans invented various folk
games and plays with which to forget the difficulties of life and
consolidate their community spirit. The farmers band music and dance
provides great entertainment for rural folks. In the past, each village
had its own farmers band which played at community events. Almost every villager
could play one of the instruments.

DONG-IN PARK

Korean Farmers Dance, 1994, by Dong-in Park, Olympic Boulevard at Western Avenue, Koreatown.

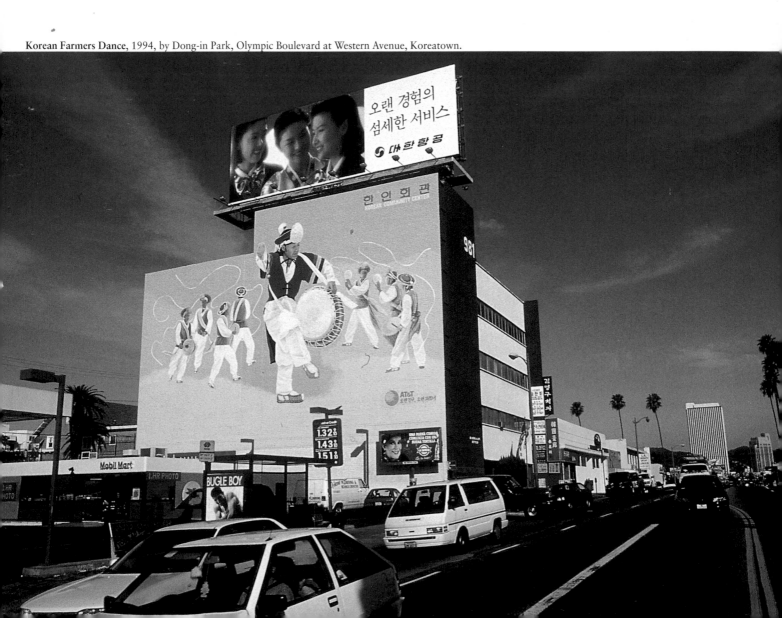

La Ofrenda (**The Offering**), 1990, by Yreina Cervantez, Toluca Street at First Street, Echo Park. © 1990 by the Social and Public Art Resource Center.

Untitled, 1992, by Carlos Ruiz (Wiro), 11th Street and Grandview Street, Pico-Union area.

The Moon, 1992, by Francisco Letelier (assisted by Leonardo Ibañez),
MacArthur Park Metro Red Line Station, Wilshire Boulevard at Alvarado Street, Mid-City.

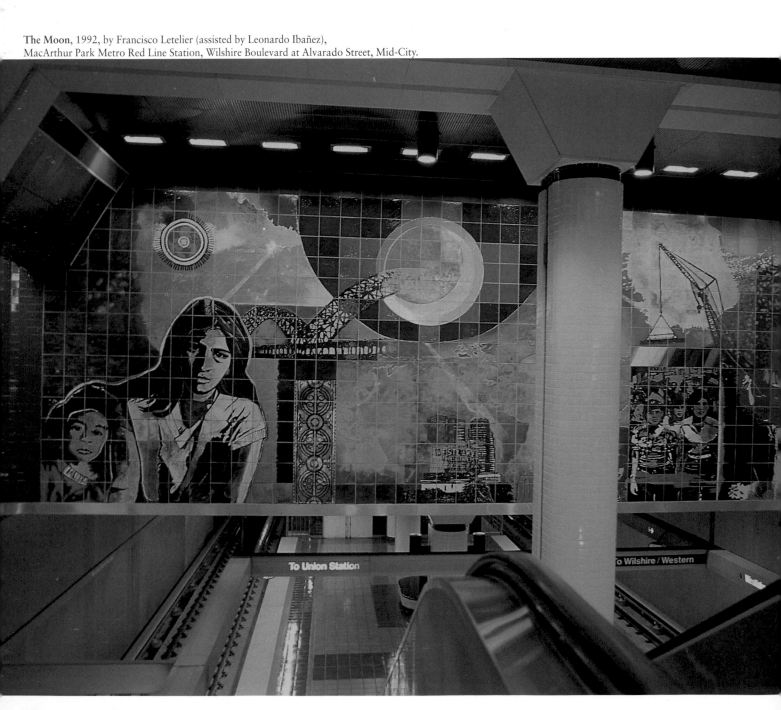

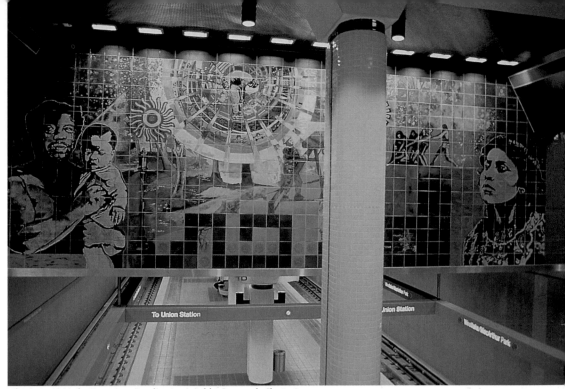

The Sun, 1992, by Francisco Letelier (assisted by Leonardo Ibañez),
MacArthur Park Metro Red Line Station, Wilshire Boulevard at Alvarado Street, Mid-City.

T hese murals were inspired by the communities surrounding the MacArthur Park area. This area exemplifies a meeting of worlds and cultures as South and Central American populations create new homes and in many ways transform the city of Los Angeles. The titles of the murals come from the pyramids called **The Sun** and **The Moon**, built in Mexico during the Toltec empire. These pyramids were later 'inherited' by the better-known Aztec civilization.

I envisioned something which spoke to the changing nature of the city and its inhabitants, and to the kinds of things that all of us inherit or make our own when we arrive in a new place. Images of families and of construction workers from the past and present, contrasted with the pyramids and the city skyline, are coupled with images from the MacArthur Park area.

Working in glazed ceramic tile is very different from working with paint. Colors you apply to the tile change during firing, with some combinations producing surprising results. As we adapted to these challenges, the medium itself, a marvelous blending of earth, fire and color, lent its alchemy to the project.

FRANCISCO LETELIER

195

E ducation, hope and immigration are my themes. Painted for Esperanza (Hope) Elementary School, a school composed of immigrants from Central America, the mural is site-specific in both theme and composition, integrating architectural components of the building in the design. There are 27 portraits of actual students, parents and teachers.

People immigrate to the U.S. because they hope for a better life. Through education a better life can be accomplished. A teacher, like a modern day liberty, is a beacon in the night as she guides her students over the building blocks of life. Blocks can be obstacles and they can be steps; they can be used to build both buildings and character.

A Shared Hope (**Esperanza Compartida**) (2 panels), 1995, by Paul Botello, Esperanza School, 680 Little Street, Pico-Union area. © 1995 by the Social and Public Art Resource Center.

Once a mountain of chaotic blocks, now a city of angels. A family of angels united with the city guard the children as they play and learn in a safe environment. Supported by pillars of the community, man and woman reaching into their spirit, working together, becoming the foundations of our city and our children's future. Each student holding in their hands their own destiny. They are guided by the love and sustenance of their parents.

PAUL BOTELLO

197

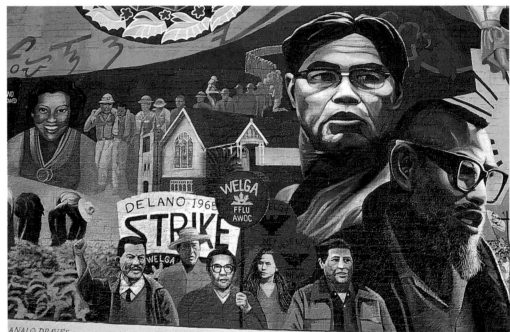

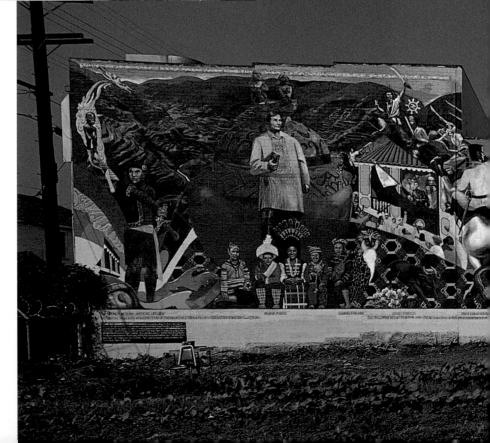

Filipino Americans have been in the United States of America for over 400 years. They are the earliest settlers from Asia, and presently constitute the largest population of Asian Americans in California and the second-largest in the entire nation. Despite their numbers and long and proud history, it has yet to be established in literature, film, the arts and academia that the Filipino experience is an integral part of American life.

It is this irony that compelled me to assert the significance of Filipino and Filipino American history and experience, highlight the events that Filipinos pioneered as catalysts for change, and emphasize the uniqueness of Filipino culture as a way of providing Filipino Americans a link to their roots and a means to assert their identity as a people.

Unfortunately, Filipino Americans are still largely ignored and invisible. They assimilate without getting represented. Their link to the past has been severed from them and their capacity to speak from an authentic and original voice has been ripped from their throats. My mural design attempts to heal these wounds.

ELISEO ART ARAMBULO SILVA

A Glorious History, A Golden Legacy (**Gintong Kasaysayan, Gintong Pamana**), 1995, by Eliseo Art Arambulo Silva, 1660 Beverly Boulevard, Echo Park. © 1995 by the Social and Public Art Resource Center.

I n 1995, I began working with ARTScorpsLA, a community-based public art group that works with spraycan artists, and with Hollywood Beautification Team, to do a series of projects in and on schools in the Los Angeles area. All the projects were big, but the wall outside Belmont High School was enormous--580 feet long and rising three to 45 feet, like the side of a battleship. It called for a big theme, and we chose the history of the universe from the Big Bang to the freeways of modern-day Los Angeles.

Earth Memories presents an evolutionary timeline: the formation of the planets, water world, the age of reptiles, dinosaurs and the death of that era, the formation of mammals, the development of man from the cave artist to Mayan priests, and the present. The design was put together by a group of 10 young graffiti writers, a recent art school graduate and myself in a week-long marathon. The technique was brush painting, with spray for finishing and detail--especially in the section of planets, and for eyes, highlights and accents.

We did not anticipate controversy, but when we were painting the section showing the evolution of man from earlier forms to cave-man artist, a woman came along and stopped to talk. 'You're doing a good job,' she said, 'but why don't you paint something democratic instead of this communist evolution stuff!'

EVA COCKCROFT

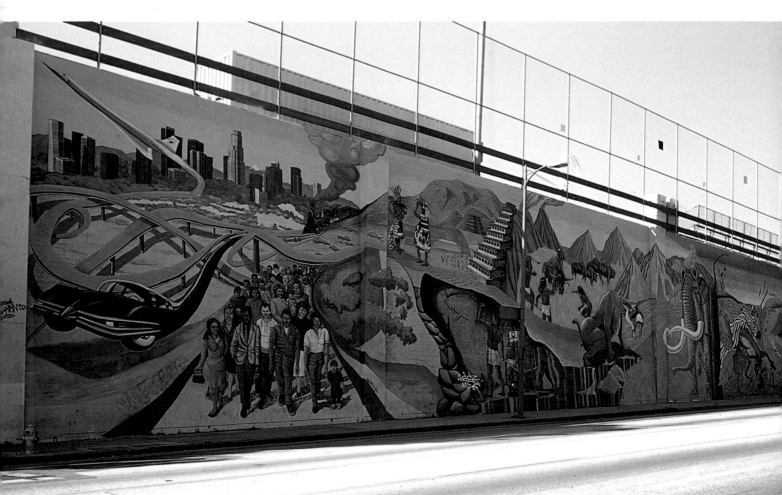

Earth Memories, 1996, by Eva Cockcroft, Eric Nieman, Jaime Reyes and Edwin Perez, with others, Belmont High School, Beverly Boulevard at Loma Drive, Echo Park.

Earth Memories (detail).

A coalition of nonprofit community groups came together to do this particular project. They picked me in part because I had this idea to do the history like a family scrapbook. Rather than using important documents and official photographs of events, I thought it would be neat to just find pictures from people's photo albums that would tell the story of what the people's lives were like and what kinds of things they participated in.

The Jewish Federation of Los Angeles made it an inter-generational project. They recruited seniors and high school students. I hired two friends of mine. We were all involved in the design process. Sandy Moss taught a 10-week class in which we did all the research. We went around to historical sites of Jewish history in Los Angeles. We went to see murals about Jewish history. We went to places with photo collections. Then we sorted through all the photos and started narrowing down the selection of images. Each panel was divided into a different historical era. Different groups worked on different panels selecting images. Then I wound up selecting the final few and doing a design.

My two associates and myself were the main workforce. The volunteers, kids and seniors, came when they could.

Originally the idea was that it would start in monochrome at the left end. As it moved toward the present day, it would get more colorful and at the right end it would be in full color. We did the whole thing in monochrome and then I was going to add the color later with some glazes. But once we got the monochrome up there, I liked it the way it was.

ARTHUR MORTIMER

Fairfax Community Mural, 1985, Arthur Mortimer lead artist with Stephen Raul Anaya, Peri Fleischman , Sandra Moss, 23 adults and 19 teens, Fairfax Avenue at Oakwood Avenue, West Hollywood.

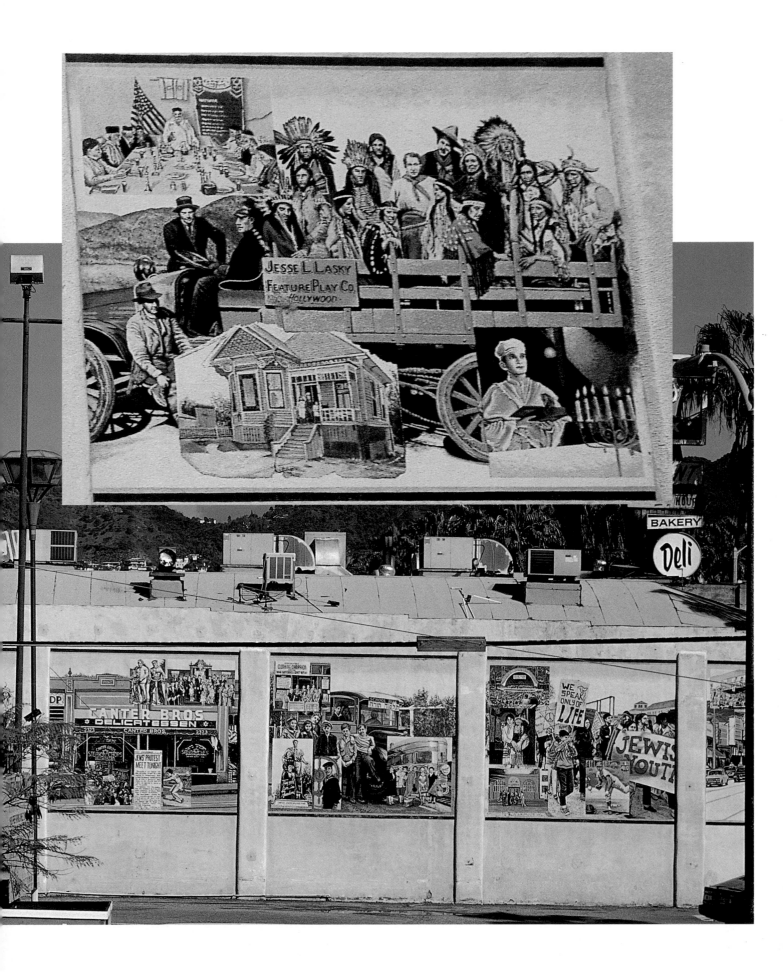

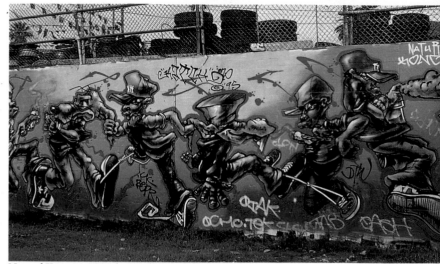

Natural Koncept, 1995, by Katch One, Belmont Yard,
2nd Street at Glendale Boulevard, Echo Park.

Aerosolics, 1989, by Dante, Risk and Slick, Comedy Store, 8433 Sunset Boulevard, West Hollywood.

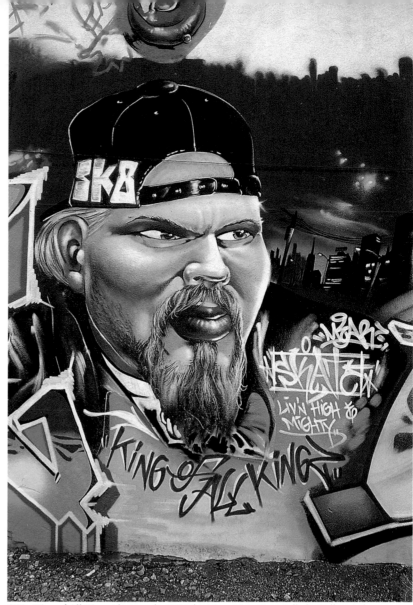

SK8: **King of All Kings** (destroyed), 1993, by Mear, Zero One Gallery, Hollywood.

I did this mural to put SK8's memory in everyone's eyes. He was like a big brother. He helped bring a lot of my crew members up from being really ridiculous children to pretty decent men and women. He was a teacher of the street. He was doing some graffiti in a train yard in North Hollywood. He was crossing a track while an Amtrak train was rolling through the yard. It killed him instantly. It was important to graffiti, too, to bring his face out. No one cares when a graffiti artist dies, so bringing him out was like our own media. Because that's what graffiti art is, a way of communicating within our own inner circle.

I've been an artist my whole life. I use a lot of symbolism. My style is very subliminal. I like to bring a sense of dramatic intensity through light and shadows on a face, or even on some lettering. I'm very much into the concept of the painting. Just because you can paint a picture doesn't mean much to me. It's what the picture says after it's been painted. My artwork revolves around my personal ideologies of the way I see life—what makes me angry, what makes me happy, what gives me joy.

MEAR

Hollywood has a huge, legendary history of jazz. There have been a lot of jazz clubs. I couldn't show all the artists who performed during that period (1945-72). Instead, in the background, I created the illusion of etched names for some of the others, so everyone got some recognition.

I was working on Gerry Mulligan and listening to Gerry Mulligan's music, when lo and behold he drives up. He had no idea this was going on. He was in town for the Playboy Jazz Festival.

RICHARD WYATT

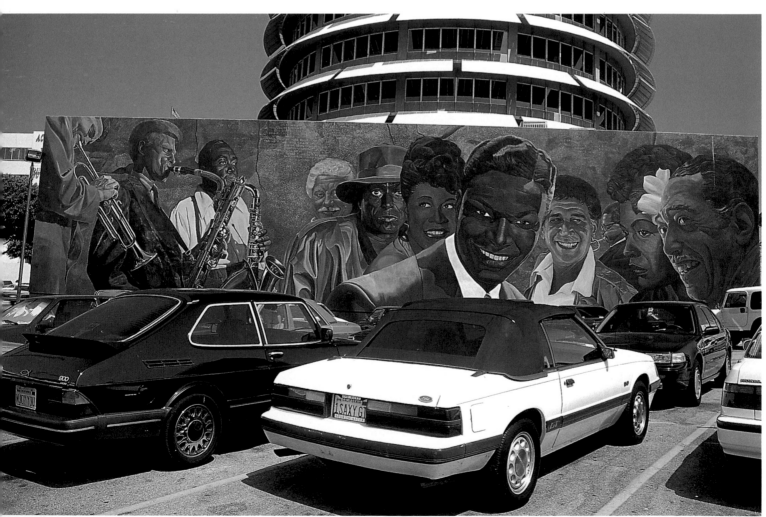

Hollywood Jazz 1945-1972, 1990, by Richard Wyatt, Capitol Records Building, 1750 North Vine Street, Hollywood.

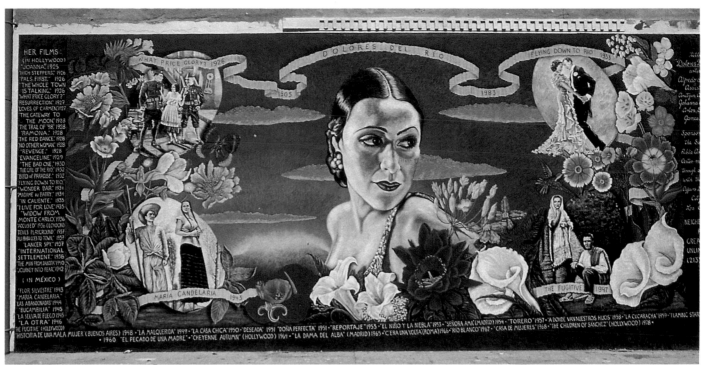

Dolores Del Río, 1990, by Alfredo de Batuc, 6529 Hollywood Boulevard (at Hudson Avenue), Hollywood. © 1990 by the Social and Public Art Resource Center.

I grew up in Mexico where Dolores Del Río had been big before my time. I sort of knew that she had done some work in Hollywood, but through my research I learned that she had been a major superstar.

The central portrait of the mural is from a publicity shot from the early 1930s. I integrated in the composition four images taken from four of her films. First is a scene from her first starring vehicle, 'What Price Glory,' the 1926 movie that launched her career. In 'Flying Down to Rio,' Fred Astaire's film debut, she is dancing with the future dance legend. 'María Candelaria' (lower left), one of her first movies after she moved to Mexico in the early 1940s, garnered kudos and awards all over the world. For the fourth, after considering a 1959 western where she plays mother to Elvis Presley, I finally chose John Ford's 'The Fugitive' in which she co-stars with Henry Fonda.

ALFREDO DE BATUC

207

W e began work on the Minority AIDS Project (MAP) in 1990. After lengthy conversations and photo sessions with MAP staff, clients and community members, we designed a mural that reflected both the myriad of services provided by MAP and the 'Love is for Everyone' spirit of the organization.

The most intriguing design challenge was the series of barred windows that ran through the middle of the wall. Only one window actually provided light or air to the building and, after much discussion about security, we received permission to remove the bars and insert plywood panels. The figures in the mural, including those seen in silhouette, were drawn from black and white photos we made on site. The colorful background is inspired by 'Afro-traditional' quilts rooted in a distinct African American aesthetic of improvisation. Simple black line drawings within the white squares of the quilt represent MAP services: food, clothing, housing, education, counseling. Each of the quilt shapes bears the name, written in silver, of a community member who has died of AIDS. We wrote the text at the bottom of the mural to bring home the issue of AIDS on a personal level.

At the time we were painting the mural, MAP shared the same building with the Unity Fellowship Church. Sundays were among our favorite days to paint because of the incredible gospel music and words of encouragement that would pour forth from the congregation. We are grateful to have had the opportunity to work with MAP, the church and the community to design and paint this mural.

MARY-LINN HUGHES AND REGINALD ZACHARY

Love is For Everyone, 1991, by Mary-Linn Hughes and Reginald LaRue Zachary, 5149 West Jefferson Boulevard,
© 1991 by the Social and Public Art Resource Center. Photo courtesy of Mary-Linn Hughes.

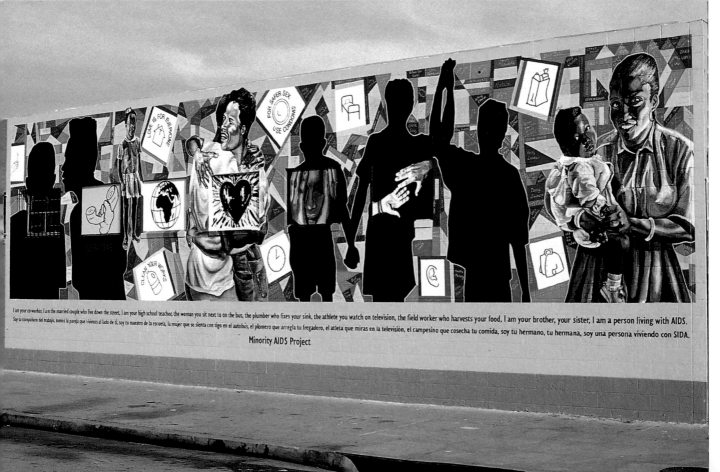

I am your co-worker, I am the married couple who live down the street, I am your high school teacher, the woman you sit next to on the bus, the plumber who fixes your sink, the athlete you watch on television, the field worker who harvests your food, I am your brother, your sister, I am a person living with AIDS.

Soy tu compañero del trabajo, somos la pareja que vivimos al lado de ti, soy tu maestro de la escuela, la mujer que se sienta con tigo en el autobús, el plomero que arregla tu fregadero, el atleta que miras en la televisión, el campesino que cosecha tu comida, soy tu hermano, tu hermana, soy una persona viviendo con SIDA.

Minority AIDS Project

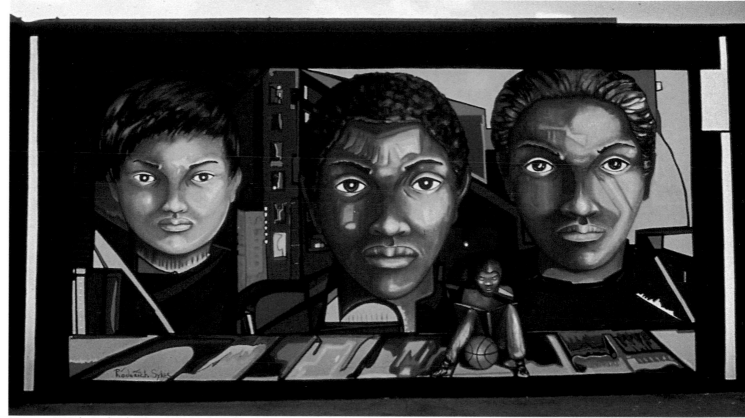

Literacy, 1989, by Roderick Sykes, 1406 South Highland Avenue at Pico Boulevard, Mid-City. © 1989 by the Social and Public Art Resource Center.

T he faces are those of kids that live in the area: a Korean, Latino and African American. Their faces are not happy, not sad. Beneath them is a kid sitting on the ground with a basketball. The basketball is between his legs, but he's reading a book. It's mainly to motivate the young men in this area to stop and think that they need to feed their minds.

One thing I do in most of my pieces, even in my paintings, is show the pain that I have. I reflect that in the faces and the imagery–more so than smiling faces. The agony of the struggle in the faces, my culture, my race of people here in America, what it takes to be a warrior. I don't care what color the face is. I usually try to show the struggle. If you look into this human being, you'll find yourself. It's not all smiling faces, although smiling faces are wonderful too.

RODERICK SYKES

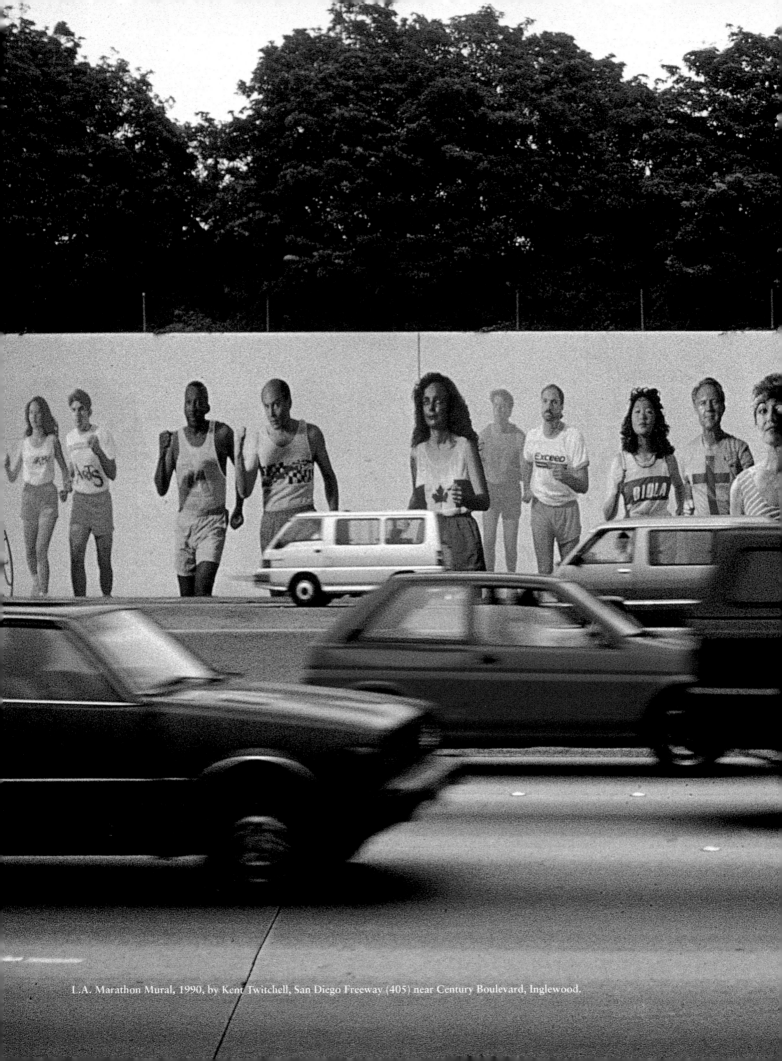

L.A. Marathon Mural, 1990, by Kent Twitchell, San Diego Freeway (405) near Century Boulevard, Inglewood.

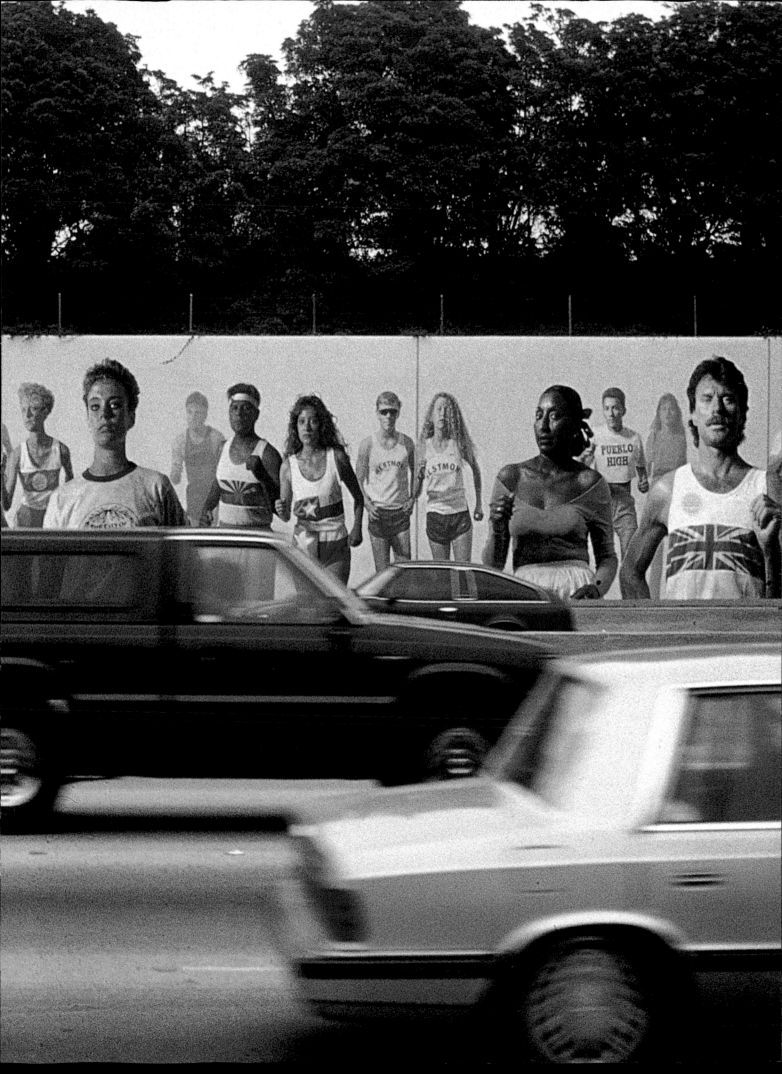

Los Angeles is burning. Working people have risen, outraged at the acquittal of the police who we repeatedly saw beating Rodney King. Lawyers and cops, with their rodent, shark and pig heads, flee City Hall. 'An Injury to One is an Injury to All' proclaims a banner (in many languages) held aloft by worker-angels, including Malcolm X, Emiliano Zapata and Mother Jones.

This mural was donated as a symbol of solidarity from the labor movement to the people of Los Angeles. Sponsored by the Labor Art and Mural Project, the L.A. Federation of Labor and numerous AFL-CIO unions and individuals, it was publicly dedicated to the victims of racism, unemployment and police violence.

MIKE ALEWITZ

An Injury to One is an Injury to All, 1993, by Mike Alewitz, Communication Workers of America, 5855 Venice Boulevard, Mid-City.

Venice Beach, 1990, by Rip Cronk, Beach House Market, 1101 Ocean Front Walk, Venice.

The building owner, Werner Scharf, requested that I paint a trompe-l'oeil mural that included a portrait of the artist. This is a popular theme in mural art, so I decided to give it a new twist. In the composition, the building front is painted from the perspective of the viewer on the boardwalk. This is the first of three overlapping trompe-l'oeil illusions. In the second, the artist is painted defacing the mural with a graffiti tag of 'Venice.' The third trompe-l'oeil reality is a set of windows painted as if looking out from the wall. These match an existing set of windows within the picture plane. Passersby unravel the overlapping realities as they approach the location.

The public mural is not bound by the economic strategies and elitist priorities of the gallery. The regional and pop cultural motifs and community orientation of the mural distinguish it from other creative disciplines. Everyone, from every strata and age group, assesses the aesthetic value of the public mural. It is not exclusive. The mural works as a unifying and integrating force within society. As it incorporates the disenfranchised urban population, the public mural subverts the dynamic that reduces aesthetic value to dollars and cents, and restores art to the role of cultural mediator.

RIP CRONK

213

We found three recurrent themes emerged from the essays we asked the students to write before we began our research: class, historical roots of oppression (slavery) and the need for education. When a gang war erupted in the Oakwood area (of Venice) in the fall of '93, the violence spread through the community and reached the campus of Venice High School. Large fights broke out between Latino and Black students. Shootings occurred on and off campus. At this point I decided it was important to include a message in the design that would address this issue of anger exploding in the downtrodden and how self-destructive it is. Venice High's most recent wall art celebrates justice and the ongoing struggle against ignorance and prejudice.

What Happens to a Dream Deferred?, 1993, by students from five local high schools under the direction of artists/teachers Marco Elliott and Joann Carrabbio, Venice High School, , 13000 Venice Boulevard. ©1993 by the Social and Public Art Resource Center.

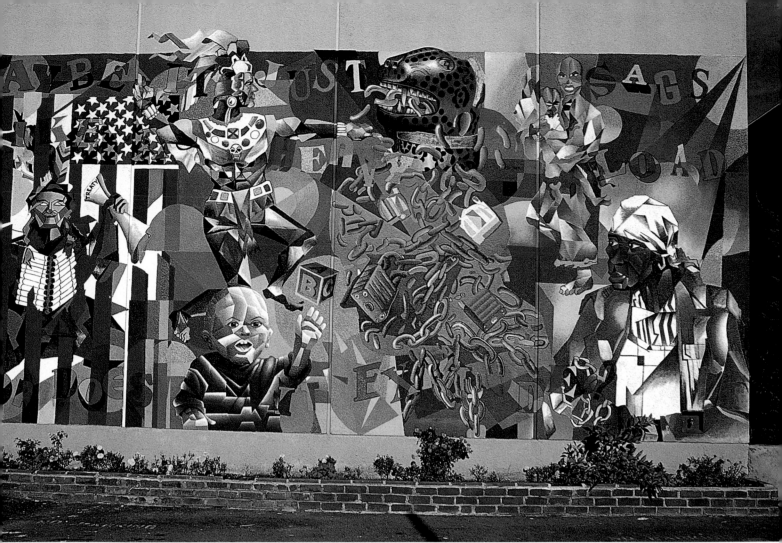

What Happens to a Dream Deferred? phase 2, 1995, by students under the direction of artists/teachers Marco Elliott and Joann Carrabbio, Venice High School. ©1995 by the Social and Public Art Resource Center.

The common perception of today's urban youth is that he is armed and possibly dangerous. If I were to paint a portrait of the average Spanish-speaking youth in our City of Angels in a very positive light–as someone, for example, who craves to be of service to the community, as someone of high moral values who sees personal gain as improper, as someone finally who pursues aesthetic goals with a passion–would I lose credibility? Would anyone question my common sense?

MARCO ELLIOTT

215

I n 1971 Judy Baca and I sat down at her kitchen table in Venice and wrote up a plan that became the Citywide Mural Project, a proposal to put two murals a year in each of the 15 City Council districts. By 1976, the Citywide Mural Project had evolved into the Social and Public Art Resource Center (SPARC), and the number of murals dreamt of had grown into dozens..

In the early '80s, I moved back east, where I come from, settling into a loft in New York City. I painted– but no murals. In 1991, the mural siren called and I found myself back in Venice designing and painting **Chagall Comes to Venice Beach.** The crew included young muralists, seniors, day-trippers and homeless people from the beach.

Chagall Returns to Venice Beach, 1996, by Christina Schlesinger, Israel Levin Senior Adult Center, 201 Ocean Front Walk. © 1996 by the Social and Public Art Resource Center.

In 1994, disaster struck with the great earthquake rocking and cracking the Israel Levin Center. The walls of the building were so badly damaged the mural had to be sandblasted off. A petition was started at the Center to restore the mural.

Renaming the mural **Chagall Returns to Venice Beach**, *I made a few design changes. We added Moses receiving the Ten Commandments from a black God, and a scene commemorating the 3,000th anniversary of Jerusalem. The entire Ocean Front Walk wall is a new design. In the five years since the first 'Chagall,' two people vitally connected to the project had died: Rick Barnett, whose original idea the mural had been, and Dora Bayrack, who wrote a poem for the wall. I painted Rick's portrait—he is the rabbi with the little rabbi on his head—and Dora's words still sing on the corner of Ozone and the boardwalk.*

CHRISTINA SCHLESINGER

217

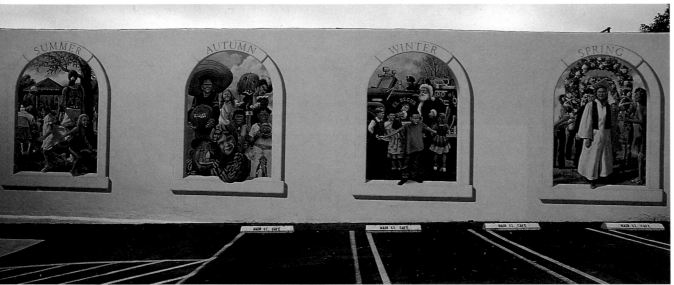

Hometown Traditions, 1996, by Don Gray, Main and Pine Streets.

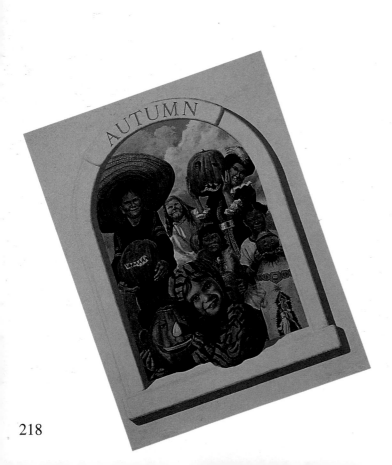

The residents of El Segundo work hard to maintain a small-town feeling–not an easy task in the middle of Los Angeles. They succeed to a remarkable degree. During my stay there, I really did feel like I was in some little midwestern town.

This mural reflects the continuity of valued traditions in El Segundo–from Halloween pumpkin-judging contests to floral arches held above spring graduates.

DON GRAY

A letter by El Segundo resident Joan Parker to Mike Armstrong, president of Hughes Electronics, described the El Segundo murals project and suggested that Hughes might sponsor the large wall already designated for the 'Aerosopace Mural.' She also wrote that the mural might include an image of Howard Hughes. Mr. Armstrong gave a nod to the project, and added that DirectTV somehow also be represented in the painting. The Heritage Walk Murals Committee hoped the painting could represent the aerospace industry as a whole, more than simply one company. The Masons (the painting is on a wall of the Masonic Lodge, chosen for its visibility) wanted something patriotic. So those were the things I needed to keep in mind as I began work on a design.

I wrestled with a few different designs before settling on this one. The Hughes portrait became the starting point. The Wright Brothers were added, superimposed as ghosted figures strolling past the planet Jupiter; and then Amelia Earhart. At that point I had a title: **The Spirit of Aerospace.** I added the DirecTV-type satellite, the shuttle launch and an image of astronaut Jack Schmitt on the moon to bring the painting forward in time, and included a diagram describing a location for a future city in space. I played with scale and curves to help move the viewer in, out, around and through the space of the painting.

I think of the painting sometimes as a view of heaven and the human spirit that has no limitation. I hope the painting is enjoyable and might even give some inspiration. I hope it's as fun as any Disneyland ride for the first minute and a half when you come upon it. That's a feeling that I've experienced when walking up to other large murals. The residents of El Segundo, many people at Hughes, my wife and mentor, Cheryl, and visitors to the site during the project made the going easy. I'd love to do more.

SCOTT BLOOMFIELD

The **Spirit of Aerospace**, 1996, by Scott Bloomfield, South Bay Masonic Lodge, 520 Main Street (near Mariposa Avenue).

Beginning as a spoof on the 'surreality' of advertising, this mural incorporates art historical references and magic realist figures to create an allegory of human values. The mural itself is a 'billboard' that offers up universal symbols and image-ideals for pondering: Quetzalcoatl, angels, happy flying business people–happy because of a successful venture or because of sudden news of world peace. The 'Everyman' in the center is based on René Magritte's 1957 surrealist painting, 'The Ready-Made Bouquet.'

NOA BORNSTEIN

Magritte in Los Angeles (detail). Photo courtesy of the artist.

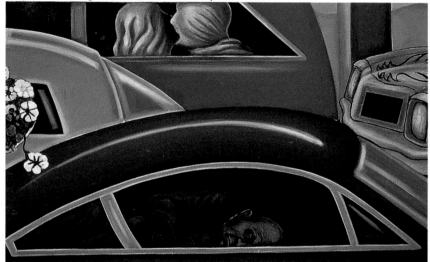

Magritte in Los Angeles, 1984, by Noa Bornstein, Snappy Food Mart and Deli (formerly a Chevron Service Station), La Cienega Blvd. and Imperial Hwy.

Palomino Ponies–1840, 1942, by Maynard Dixon, Canoga Park Post Office, 21801 Sherman Way, Canoga Park.

O, I am Maynard Dixon,
And I live out here, alone
With pencil and pen and paint-brush
And a camp stool for my throne
King of the desert country
Holding a magic key
To the world's magnificent treasure
None can unlock but me!
At times come terrible moments
When desire fills full my soul,
And women and wine and cities
Seem a compelling goal;–
But I wake with a start to my desert
And its lovely vistas unfurled,–
I'd rather be Maynard Dixon,
Than anyone else in the world!

MAYNARD DIXON
*from **The Art and Life of Maynard Dixon***

Great Wall of Los Angeles, 1976-83, Judith Baca project director with 40 artists and 200 youth,
Coldwater Canyon Avenue between Burbank Boulevard. and Oxnard Street, Van Nuys.
© 1976 by the Social and Public Art Resource Center.

O ne of the most catastrophic consequences of an endless real estate boom was the concreting of the entire Los Angeles River, on which the city was founded. The river, as the earth's arteries–thus atrophied and hardened–created a giant scar across the land which served to further divide an already divided city. It is this metaphor that inspired my own half-mile-long mural on the history of ethnic peoples painted in the Los Angeles River conduit. Just as young Chicanos tattoo battle scars on their bodies, the Great Wall of Los Angeles is a tattoo on a scar where the river once ran. In it reappear the disappeared stories of ethnic populations that make up the labor force which built our city, state and nation.

JUDY BACA

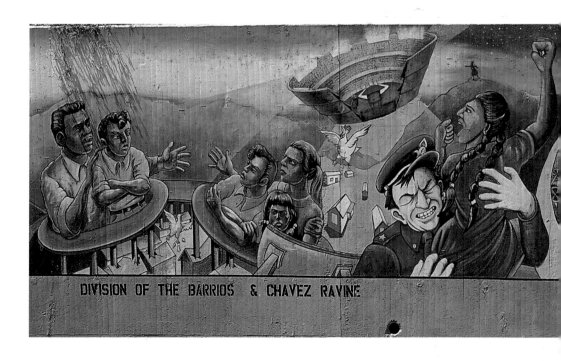

DIVISION OF THE BARRIOS & CHAVEZ RAVINE

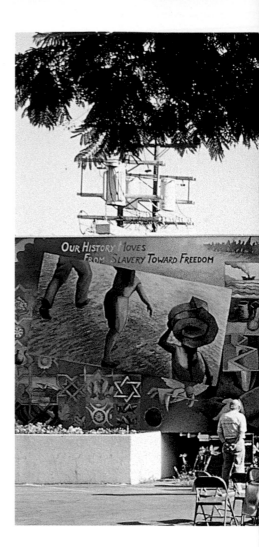

Extinct is Forever (detail).

Extinct is Forever (partially destroyed) (detail), 1990, by Hector Rios (Hex) (assisted by Omega), 5539 Riverton Avenue, North Hollywood.

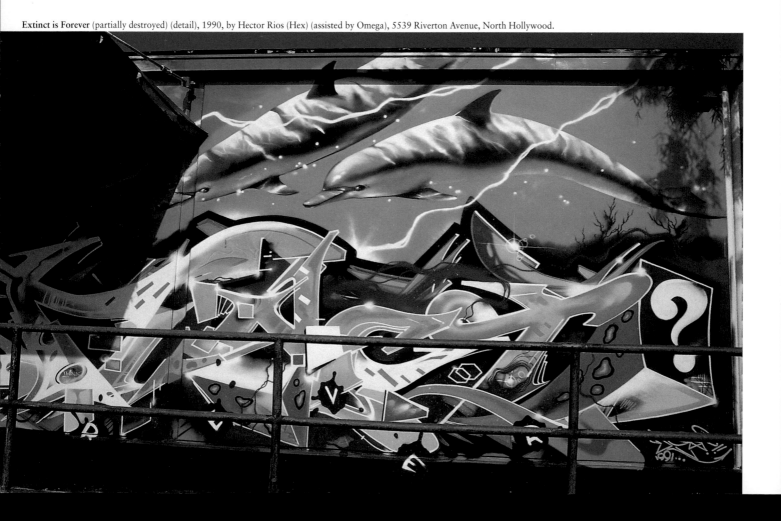

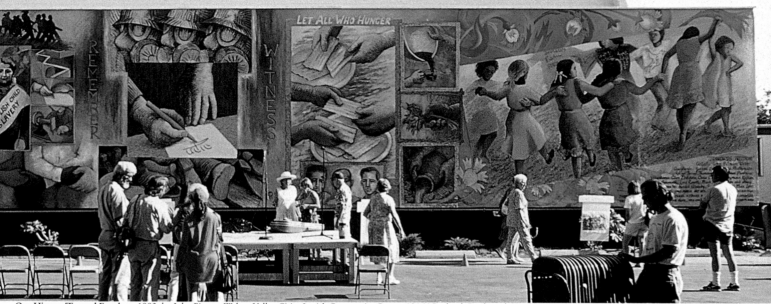

Our History/Toward Freedom, 1993, by John Pitman Weber, Valley Cities Jewish Community Center, 13164 Burbank Boulevard, Van Nuys.

I have based the design on the themes of Exodus, Passover and Seder. I have tried to emphasize those universal themes which intersect with the experience of other groups. Exile, liberation and celebration are repeated and shared experiences. In particular, concerning shared struggles important to Jewish experience in the U.S., I have included references to the trade union struggle for labor emancipation and to the civil rights struggle for full citizenship rights for all. The mural is about remembering, but remembering the central themes of Jewish history in the ways they are shared with others.

JOHN PITMAN WEBER

225

In 1925, the African-American-owned company that later became Golden State Mutual Life Insurance Company opened for business in an upstairs storefront on Central Avenue. It was founded to provide insurance to African Americans, because no other financial institution would insure them. Today Golden State is licensed in 22 states and the District of Columbia. The company also has one of the most important private collections of Black art in the country.

The mural's first panel covers California's history from 1527 to 1850. Among the important figures portrayed are ex-slave/philanthropist Biddy Mason, explorer James Beckwourth, politician William Leidesdorff and U.S. Consul Thomas O. Larkin.

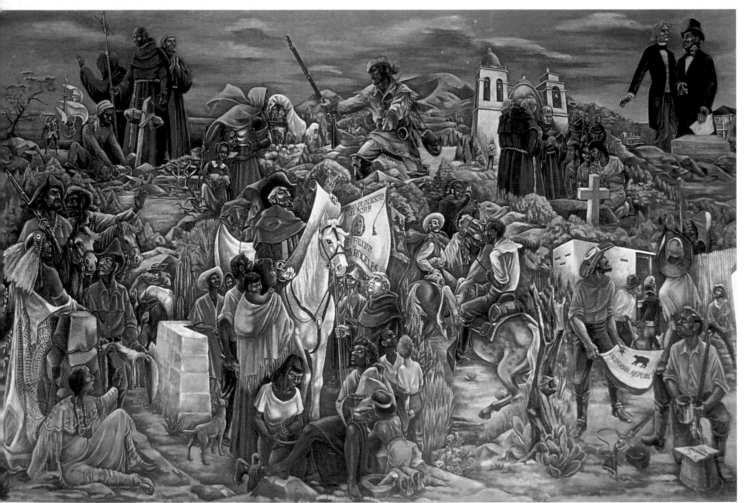

The Negro in California History: Exploration and Growth, 1949 by Charles Alston, Golden State Mutual Life Insurance Company (lobby), 1999 West Adams Boulevard.

The Negro in California History: Settlement and Development, 1949 by Hale Woodruff, Golden State Mutual Life Insurance Company (lobby), 1999 West Adams Boulevard.

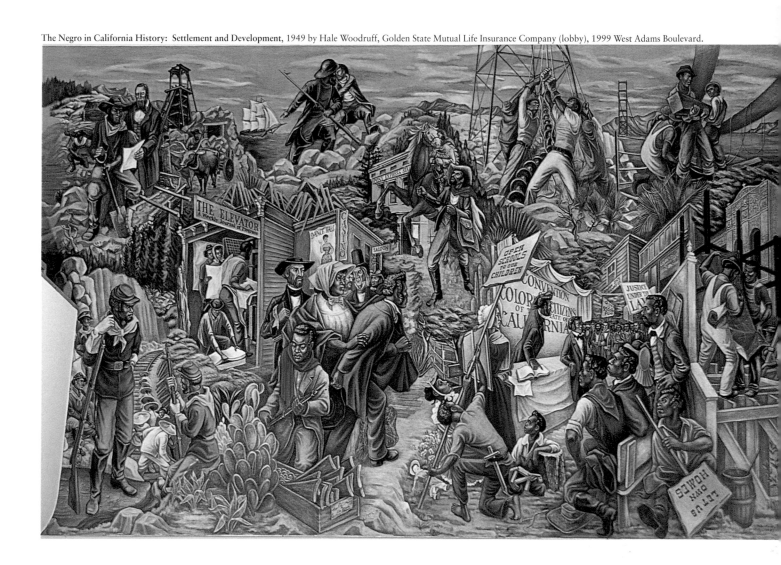

The second panel focuses on the role of African Americans in the state's growth and development. We see gold miners, Boulder Dam and Golden Gate Bridge construction workers, Pony Express riders and activists in the struggle for educational equality.

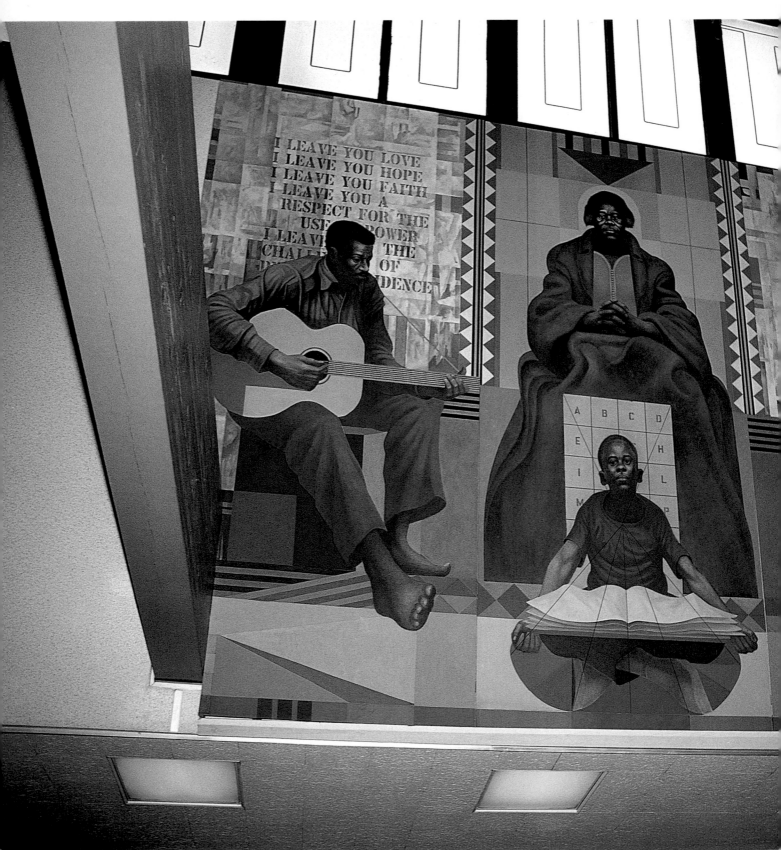

Mary McLeod Bethune, 1977, by Charles White, Los Angeles Public Library, 3665 South Vermont Avenur, Exposition Park. Use of this image is courtesy of Heritage Gallery, Los Angeles.

Dr. Mary McLeod Bethune (1875-1955) was one of the most influential African American women in United States history. She established a school for young Black women in the South that later became Bethune-Cookman College. She also founded and served as president of the National Council of Negro Women. The text of her 'Last Will and Testament,' a poem of ethnic pride and self-respect, appears in the mural's background.

F or me the most important thing has always been to say something that is meaningful, and much more important than the media I use. Whatever media that I could do it strongest, that's the media I've always used. That's why murals are extremely important to me, even though it's hard to get mural commissions these days. They allow me the room to say the kind of things I try to deal with . . . my personal interpretation of truth, the beauty in life and dignity.

CHARLES WHITE
(from a 1965 interview with the
Smithsonian Archive of American Art)

The powerful image below was painted after the April 1992 acquittals of the police charged with beating African American motorist Rodney King. This was the artist's first mural.

Freedom Won't Wait, 1992, by Noni Olabisi, 54th Street at Western Avenue. © 1992 by the Social and Public Art Resource Center.

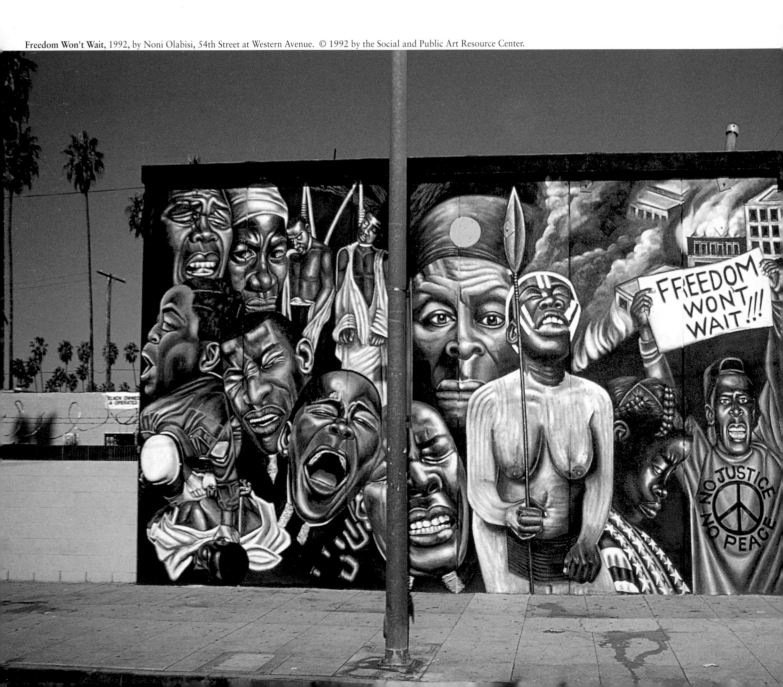

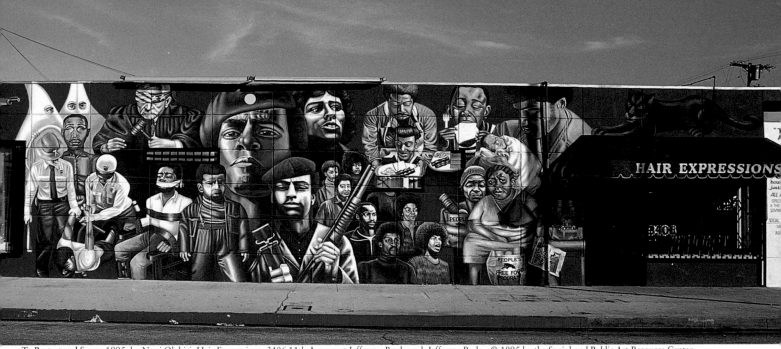

To **Protect and Serve**, 1995, by Noni Olabisi, Hair Expressions, 3406 11th Avenue at Jefferson Boulevard, Jefferson Park. © 1995 by the Social and Public Art Resource Center.

*We want an immediate end
to POLICE BRUTALITY and
MURDER of BLACK people!*

*We want land, bread, housing, education,
clothing, justice and peace.*

ALL POWER TO THE PEOPLE!

The statements above are taken from the Ten Point Program and Platform created by Dr. Huey P. Newton and Bobby Seale, founders in 1966 of the Black Panther Party for Self Defense. This mural is dedicated to the fearless men and women who committed their lives and dared to be free. To <u>Protect</u> when lynching seemed to be the order of the day, the Black Panther Party armed themselves with law books and guns, reading their rights as citizens (including their Constitutional right to bear arms) and patroling their neighborhoods against police brutality. And to <u>Serve</u> the Black Panther Party created and operated nationwide programs such as breakfasts for school children, free food programs, free medical clinics, free clothing, and it set up independent schools for self-determination.

This mural commemorates the Black Panther Party and its unforgettable, great contribution to African American history. And the mural is dedicated to all political prisoners, as well as those who lost their lives fighting for truth, justice and freedom. The spirit of these brothers and sisters cannot and will not die.

ALL POWER TO THE PEOPLE!

Noni Olabisi

231

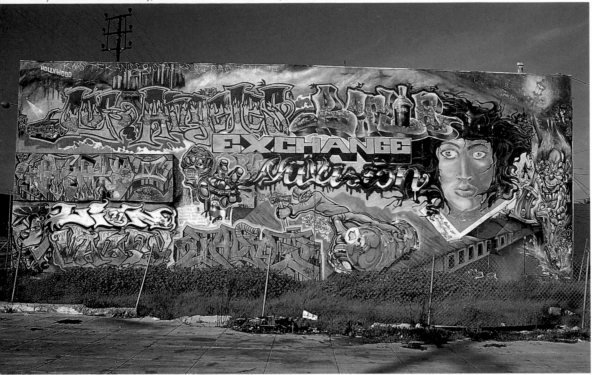

Los Angeles-Berlin Exchange (in spraycan), 1992, by Toons, Dru One, A One, Mith, Hex (Hector Rios) and youth from Berlin Germany, Vermont Avenue and 88th Street, South L.A.

I found out through a friend of mine that some people were coming from Germany, and that they were going to do a mural. It was a group of eight or nine kids. They were staying in South-Central and Compton. It was after everything had happened with the riots. We spent a lot of time with them before we did the mural. We took them around to show them the city.

Those kids were full of energy. It was such a refreshing change from typical white people in California, or even Los Angeles. It would have been a whole different thing with people being more apprehensive. These guys were just following their hearts, I guess.

I came up with the theme of Los Angeles. I put in a downtown cityscape, Hollywood and South-Central. I also did a helicopter shining down on a low rider. The piece was split into two sides with the guys from California doing one side, and the guys from the East, Germany, doing the other side. We just blended them together. They came with their style and we came with our style. It merged really cool.

The direction I'm going in, I'm trying to take my graffiti art to another level. When a normal person looks at what we do, you see the letters and they're hard to read. It's like any other type of art. You have to study the history and know what it's all about so that you can understand it. When hip hop and all that came into my life, it showed me that people involved in it basically had no boundaries. It's like a journey.

TOONS

232

T*he concept came from a drawing I did in 1978.
That was my first paid job. I put a lot of myself
in each of the women.*

ALICE PATRICK

Women Get Weary But They Don't Give Up, 1991, by Alice Patrick, National Council of Negro Women, 3720 West 54th Street. © 1991 by the Social and Public Art Resource Center.

T*his is a motivational mural designed to encourage young people. It depicts men and women who had visions to become great, then went about setting these dreams in motion.*

ELLIOTT PINKNEY

Visions and Motion, 1993, by Elliott Pinkney, Community Youth and Sports Foundation, 4828 Crenshaw Boulevard. © 1993 by the Social and Public Art Resource Center.

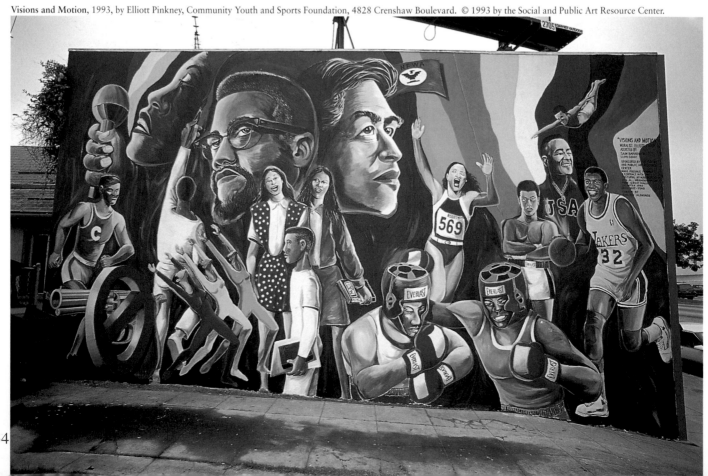

History of Women in the Labor Movement in California, 1991, by Eva Cockcroft, Southern California Library for Social Studies and Research, 6120 South Vermont Avenue, South L.A.

The history of women in the labor movement was a subject I had wanted to paint for a long time. I almost did it in New York, for Local 1199, but at the last minute the project fell through. When I came to California in 1989, I continued to look for an appropriate site. A friend introduced me to the Southern California Library for Social Studies and Research, a private library that is home to books and archives about labor and progressive movements. It was a perfect fit. The library was enthusiastic about the idea and I began to apply for grants. After two years without any luck, I decided to fund it myself. I was teaching two days a week–the rest of the time, I worked on the wall.

The mural honors both anonymous women workers and important organizers. It contains portraits of political and labor organizer Dorothy Healy (left); International Ladies Garment Workers Union leader Rose Pesotta (center left); Charlotta Bass, publisher of The California Eagle who fought for civil rights and jobs for World War II workers (center); United Farm Workers Vice President Dolores Huerta; and agricultural workers leader Luisa Moreno (center right). I was painting in the aftermath of the Rodney King beating and the background scene of police beating strikers (based on a 1930s photograph) seemed particularly apt. During the riots that followed the verdict, the liquor store across the street was torched, but the mural was not touched.

EVA COCKCROFT

235

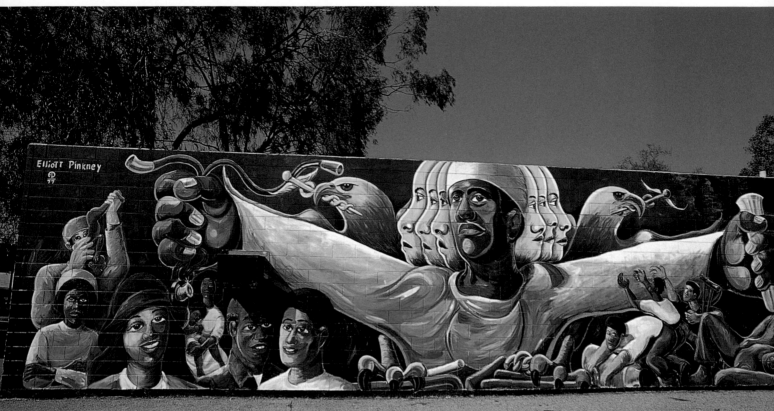

Medicare 78, 1977, by Elliott Pinkney, 920 South Alameda Street (at Rosecrans Avenue).

My studio for the summer and winter of 1977 and '78 was the walls of the city of Compton. I did eight to 10 murals through a grant from the California Arts Council. Most of them were commemorative types of murals and are no longer in existence.

ELLIOTT PINKNEY

The faces are portraits of my students at South Gate Middle School. One day in the classroom, during a lesson, I asked them to face East. To my amazement, they faced every-which-way. This caused me to work the concept of the four directions into the mural. The mural charts the passage of time through the day, and implies the passage of the seasons through the year.

The cloth begins with a Guatemalan back-strap weaver. In the North, a Nez Perce bag flows into an Osage blanket, and towards the East, an eagle dancer of the Plains dances on a Navajo rug. The Mayans and Aztecs represent the traditions of the South and the Chumash represent those of the West.

The mural is about honoring the traditions of the indigenous people, and how these traditions influence and mold the future of our young people.

JANE BOYD

Vision and Tradition, 1995, by Jane Boyd, South Gate Park, Pinehurst Avenue between Southern Avenue and Tweedy Boulevard.

This is one of the few public pieces dedicated to the Japanese Americans in America. In our society there is little known about the plight of the American citizens of Japanese heritage. Still to this day, many people only know that the Japanese were the sworn enemy of the United States during World War II. Yet thousands of natural-born citizens of Japanese descent were instrumental in establishing economic growth in both agriculture and the fishing industry on the West Coast.

Homage to the Harbor District Japanese-American Pioneers (left half), 1995, by Trace Tres Fukuhara, Harbor District Japanese Community Center, 1766 Seabright Avenue, West Long Beach.

Homage to the Harbor District Japanese-American Pioneers (right half).

Their experience at the onset of World War II of losing everything they had worked for and being incarcerated in desert compounds under armed guards went unnoticed and undocumented until recently. Despite this imprisonment, many of the able-bodied young men volunteered in the army and fought gallantly, defending their country, and became the most decorated soldiers, to this day.

After the war, in an era of suspicion and resentment towards people of Japanese ancestry, they worked hard to reassimilate into society. I am very pleased and fortunate to have been able to touch upon this subject in my mural.

TRACE TRES FUKUHARA

M y interiors are extremely different from my exteriors and the attention to details more elaborate. Each work is something of an experiment, using illusion to make interior spaces work. Monuments and ceremonial structures were very important to city life for centuries. American cities are relatively new compared to Rome, London or Paris. So what I'm trying to do very often in my work is to reconstruct in symbolic form at least a semblance of connection with the past.

RICHARD HAAS

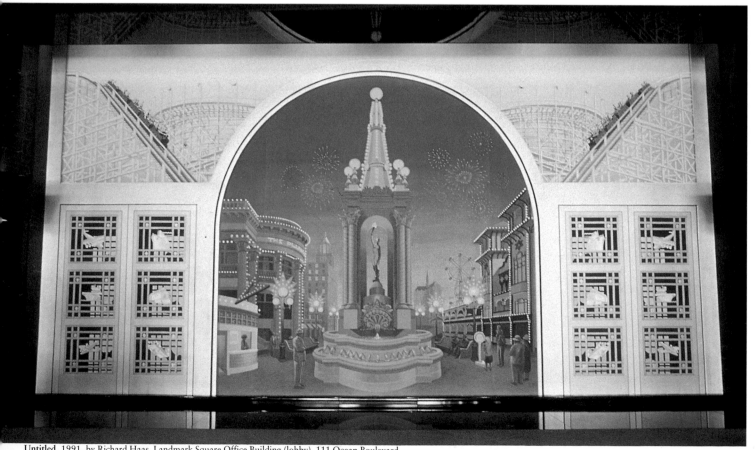

Untitled, 1991, by Richard Haas, Landmark Square Office Building (lobby), 111 Ocean Boulevard.

This mosaic, executed by 40 artisans, was created for the Long Beach Municipal Auditorium. It was possibly the single largest achievement of the New Deal's Federal Art Project. In 1979, a major community effort saved the mosaic from destruction when the auditorium was demolished and replaced by a new convention center complex. It was mounted in its current location in downtown Long Beach in 1982.

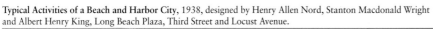

Typical Activities of a Beach and Harbor City, 1938, designed by Henry Allen Nord, Stanton Macdonald Wright and Albert Henry King, Long Beach Plaza, Third Street and Locust Avenue.

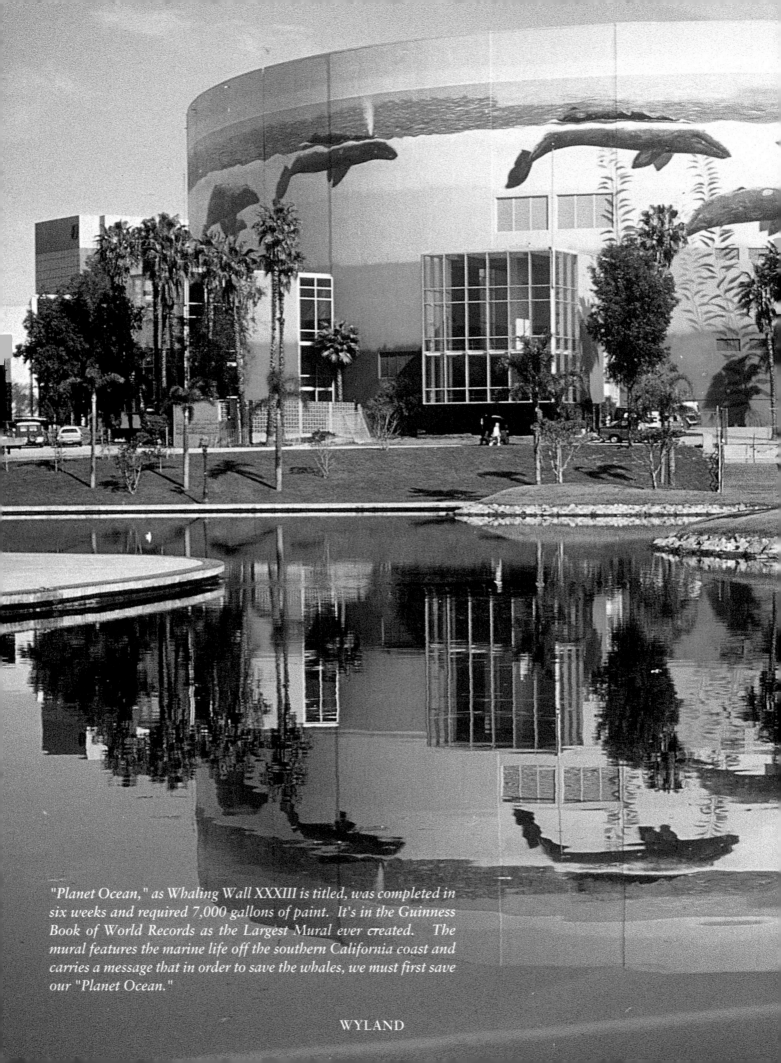

"Planet Ocean," as Whaling Wall XXXIII is titled, was completed in six weeks and required 7,000 gallons of paint. It's in the Guinness Book of World Records as the Largest Mural ever created. The mural features the marine life off the southern California coast and carries a message that in order to save the whales, we must first save our "Planet Ocean."

WYLAND

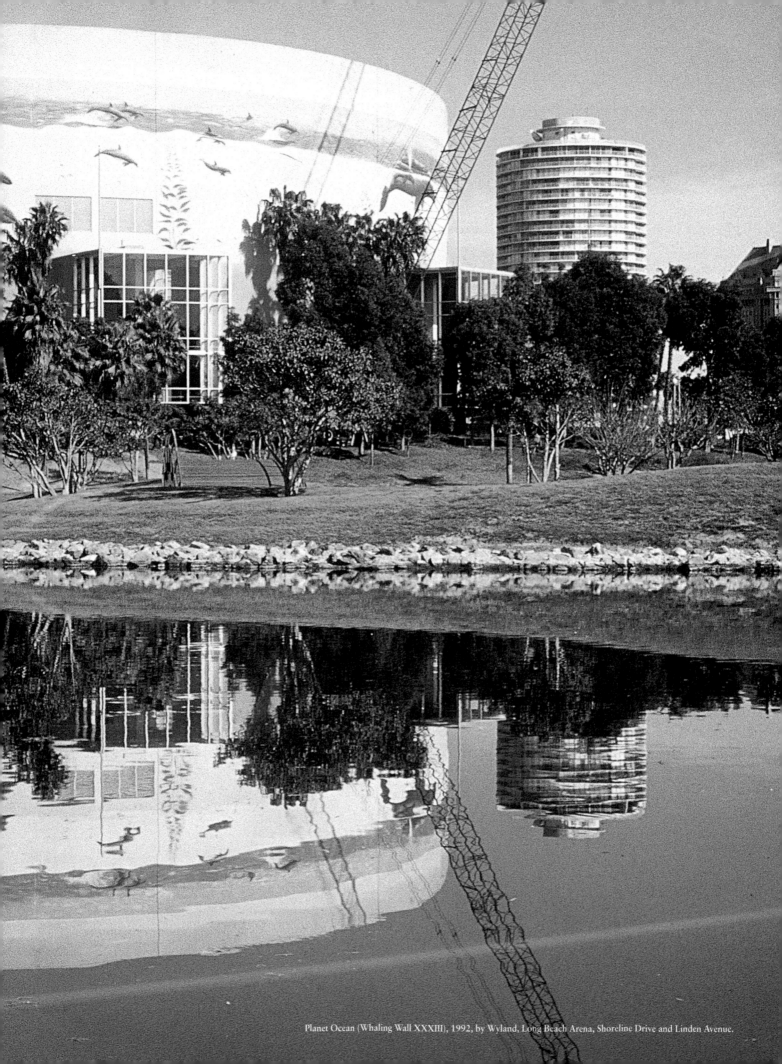

Planet Ocean (Whaling Wall XXXIII), 1992, by Wyland, Long Beach Arena, Shoreline Drive and Linden Avenue.

O il, Life and Ecology *was the first mural on a National Guard Armory in California, and the idea made the generals in Sacramento very nervous. At the end, however, they were delighted and all the big brass came down for the dedication. As a long-time anti-war activist, I felt rather strange at first working with the military, but I quickly discovered that they were human, made some friends, and had many lively discussions about life, politics, and environmental issues.*

The theme of oil and alternative energies was chosen because of the importance of oil in the history of Long Beach in particular and California in general. It also fit with my strong feelings about the need for environmental activism, especially in the aftermath of the Exxon Valdez wreck. During my research, however, I became aware that while the use of petroleum as a fuel is no longer viable, it did serve important functions for development historically, and is still necessary for the manufacture of plastics–even the paint we were using on the wall.

EVA COCKCROFT

Oil, Life and Ecology, 1990, by Eva Cockcroft, California National Guard 7th Street Armory, 845 East 7th Street.

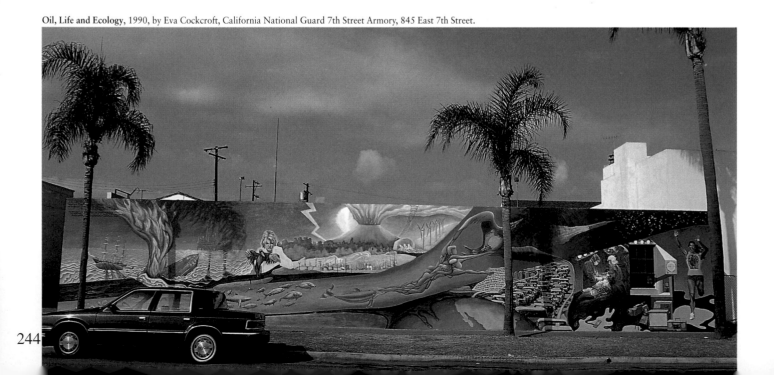

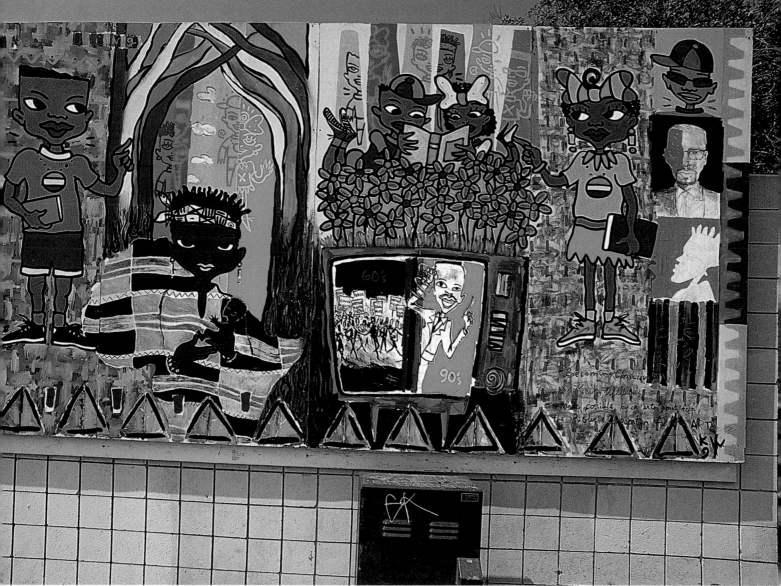

Becoming Conscious, 1991, by Keith Williams, Martin Luther King, Jr. Recreation Center, Orange Avenue between 19th and 20th Streets.

M ost of my murals basically are about youth–situations they're in and trying to provide positive images and messages in a clear way that they can understand. This one is a visual menagerie. There are African images as well as pictures of Martin Luther King, Jr. and Malcolm X. There's also a TV screen split in half with one image showing people demonstrating in the 1960s and the other a little character of Arsenio Hall (a former late-night talk show host). It is a quick little history lesson, but in a playful and colorful enough way that kids want to spend time looking at it.

KEITH WILLIAMS

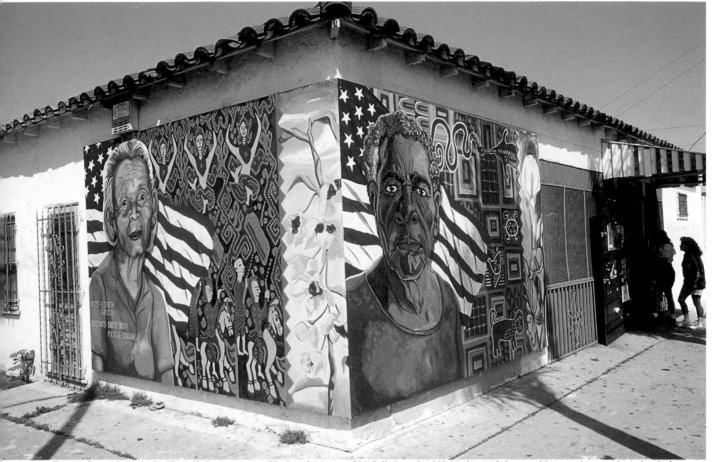

Storytellers (2 of 3 panels), 1991, by Elizabeth Garrison (assisted by Dareth Morm and Michelle Saucedo), NQ Market, 14th Street and Peterson Avenue, MacArthur Park.

O*lder women are often a family's storytellers. They are the ones who pass down a family's history to younger members.*

ELIZABETH GARRISON

This triptych features elderly women from Cambodia, Mexico and Africa. They are each surrounded by native plants, textiles and crafts from their cultures. These three ethnicities are all found in the neighborhood where the mural was painted. Unifying the panels is the American flag behind each woman, symbolizing the way in which the cultural legacies of such immigrants such as these have enriched our country's heritage.

This mural is a celebration of the universal language of music ranging from tribal traditions to contemporary jazz. As a way of linking the old with the new, in the center a modern man is blowing an Amazonian bark horn tied together by reeds.

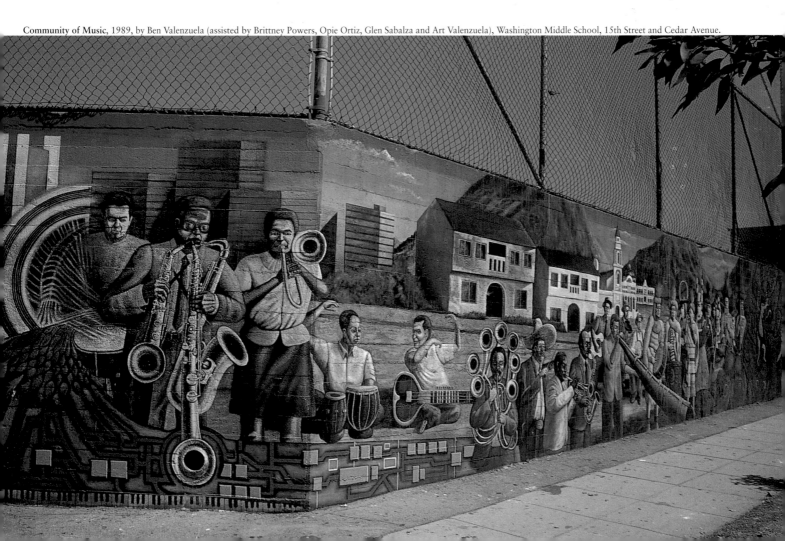

Community of Music, 1989, by Ben Valenzuela (assisted by Brittney Powers, Opie Ortiz, Glen Sabalza and Art Valenzuela), Washington Middle School, 15th Street and Cedar Avenue.

I came up with the title after a series of meetings with the local neighborhood association. The idea was to include the community in the design and the actual production of the mural. There are a lot of different cultures living in the immediate area, and there's tensions between different ethnic groups, especially gang members.

I envisioned this big festival where the people assembled and danced as one. The Samoan dancer was a student at the school. Her teacher organized a photo session, and I took three rolls of film until I got the perfect shot. I put my face on the breakdancer.

I enjoy mural painting because it brings art to the general public. All kinds of people approach me on the street. Almost all of their feedback is positive. It's a wonderful feeling.

RICHARD BRANDT

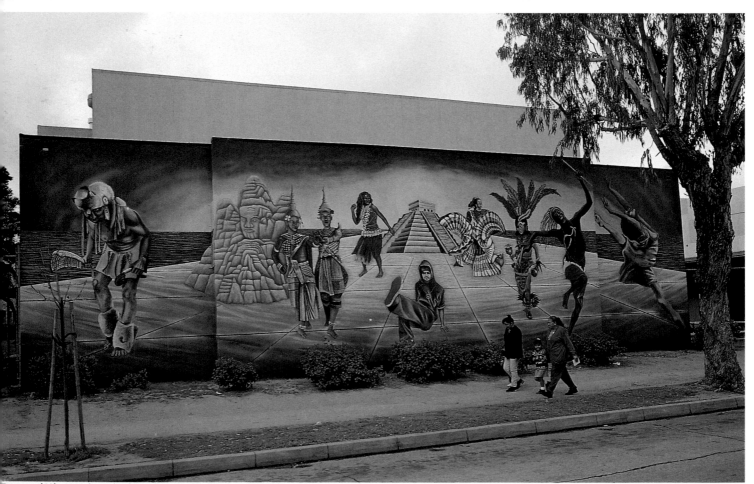

Dancers of Life, 1995, by Richard Brandt (assisted by José Arce, Kiven Meyer, Henry Jones, Danny Corona and neighborhood volunteers), Washington Middle School, Pacific Avenue between 14th and 15th Streets.

Prometheus, 1930, by José Clemente Orozco, Pomona College, Frary Dining Hall.

At the time Orozco painted this fresco, he was already famous as a revolutionary muralist in Mexico—one of *Los Tres Grandes* (with Diego Rivera and Siqueiros)—but he was little known in the United States. He spent two months working on the mural, using a student and faculty wife as models. According to Greek mythology, the god Prometheus stole fire from the sun god and gave it to humanity, laying the basis for human progress. Orozco later completed murals at Dartmouth College in New Hampshire and at the New School for Social Research in New York City.

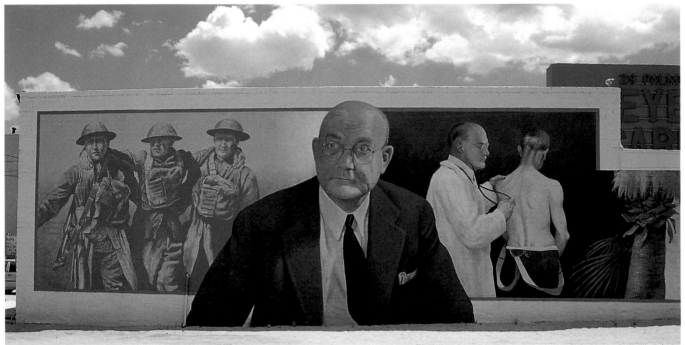

Doctor Luckie and the World War One Veterans, 1995, by Don Gray, 6159 Adobe Road.

Dr. Luckie was a Pasadena physician who treated veterans suffering the effects of poison gas. Other doctors believed there was little to be done for these men and that their lives would be short. Dr. Luckie encouraged them to resettle in Twentynine Palms because of its dry, clean air. Many of these vets bought homesteads and lived to a ripe old age. Dr. Luckie is called the 'Father of Twentynine Palms.'

Many of the mural projects springing up all over are in small towns that find themselves faced with lethargic economies. A mural program is proposed as a way to bring visitors (and their money) to town. A core group of energetic folks gets the ball rolling.

Then, an interesting thing happens. Friendships flourish as activists rub shoulders to choose mural themes, meet artists, hold fundraisers, prepare walls for painting, attend to the countless details that arise. The enthusiasm is contagious. More and more volunteers jump in.

Suddenly, all this shared energy blossoms into a renewed sense of community pride that can't be measured simply in economic terms. They are revitalized in spirit as well.

It was my great pleasure to witness this spirit in Twentynine Palms, and feel myself a part of it.

DON GRAY

The mural below is a tribute to pioneer homesteaders Bill and Frances Keys and their home, the Desert Queen Ranch. It was located in what is now Joshua Tree National Park. This was Twentynine Palms' first major mural, painted by artists from Chemainus, British Columbia, Canada.

The Keys' Family Mural, 1994, by Dan and Peter Sawatzky, Plaza Furniture, Route 62 just west of Adobe Road.

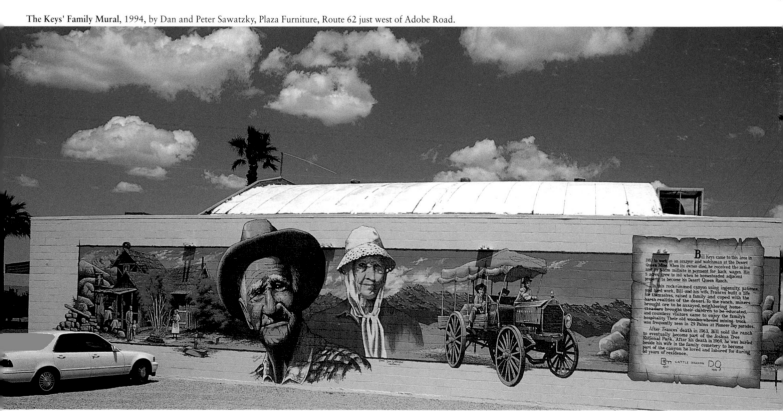

251

Untitled, 1990, by George Sportelli, 1595 Potter Road, north of central Hemet.

T his automotive place had just opened. The owner had some terrible lettering on the wall. I showed him a couple of pictures of my work and asked if he wanted me to paint something nice. He went along with it. He gave me a few bucks, then gave my car a tune-up and rebuilt my transmission—so it was a trade. I cleaned up his building, made it look like he was in business instead of going out of business.

I've done about 20 murals in Hemet since 1989. I finally got fed up with the hard time the City of Hemet gave me and the business owners about sign permits. I started talking to nightclubs and restaurants in L.A. Out in L.A., you can almost do whatever you want.

GEORGE SPORTELLI

252

T his was my first outdoor mural. The owner of the building had an unfinished mural, started but never finished four years earlier. I showed him some pictures of my first official mural–done in a nearby restaurant–to see if he wanted me to finish his mural. He said he'd rather have a whole new mural altogether, and wanted to know if I could paint a woman on the side of his building. It's based on a modeling photograph I had of this girl I had been dating. Just as I was finishing, the owner asked me if I could paint his dog somewhere in the mural. That dog died, but the one that posed for this photo is one of his new ones.

GEORGE SPORTELLI

Untitled, 1989, by George Sportelli, 220 San Jacinto Street, Downtown Hemet.

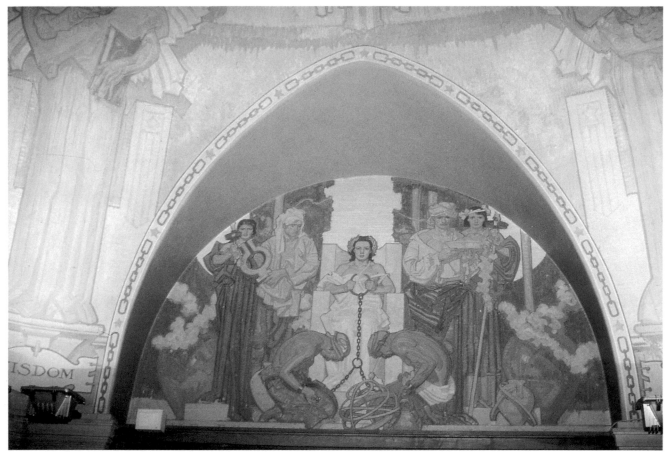

Freeing of the Slaves, 1932, by Dean Cornwell, Lincoln Memorial Shrine, 125 West Vine Street. Photo courtesy of the Lincoln Memorial Association.

Dean Cornwell painted this mural in a temporary Los Angeles studio while also working on a larger commission for the Los Angeles Central Library. The Lincoln Shrine mural includes another lunette, **Preservation of the Union**. Together the two lunettes allegorically depict the major accomplishments of Abraham Lincoln's presidency. Eight large-scale female muses further portray qualities of Lincoln's character: Strength, Justice, Patience, Courage, Faith, Tolerance, Wisdom and Loyalty.

The Lincoln Memorial Shrine is a 2,000-square-foot octagonal building containing thousands of items relating to Lincoln and the Civil War period. It was erected by English-born Robert Watchorn, a one-time coal miner who made his fortune in the oil industry, and spent some of it collecting Lincoln memorabilia.

The room where this mural is located was originally Fullerton's City Council Chambers. When the Fullerton Police Department took over the building in the 1960s, the mural was seriously damaged during remodeling. Restored in 1992, it depicts the history of California from Juan Cabrillo's landing in 1542 to the arrival of the railroad in Southern California in 1869.

Helen Lundeberg (born 1908) is one of the Los Angeles area's most important modernists. During the 1930s and 40s, while privately pursuing her own vision as a painter, she worked for the Federal Art Project as a mural designer. Still extant are petrochrome murals at Canoga Park High School in the San Fernando Valley and at Centinela Park in Inglewood.

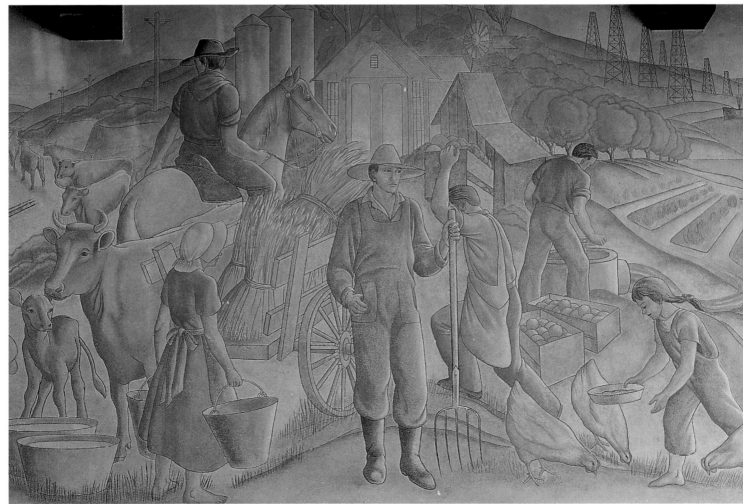

History of the State (detail), 1942, by Helen Lundeberg, Fullerton Police Department, 237 W. Commonwealth Avenue.

The Mexican intellectual Ricardo Flores Magón once wrote, *'Tenemos que crear un mundo de bellezas, en donde sean desconocidas las lagrimas y las cadenas.'* He desired to see humanity create a beautiful world in which tears and chains would be unknown, to see mankind freed from the scourges of war, poverty, ignorance and oppression.

Niños del Mundo (**Children of the World**), 1994, by Emigdio Vasquez, Lemon Park, 701 South Lemon Street.

In this mural, I express similar sentiments by portraying children in their innocence with a healthy world environment devoid of the ugliness of social strife, divisiveness and hatred. This is an idyllic vision of a world at peace, in harmony and brotherhood. A world that I hope my grandchildren will live in someday.

Emigdio Vasquez

T*he mural is a romanticized version of what Mexico was like. It is based on the small town in the state of Jalisco where my Dad was raised. I went there in 1982 and took a lot of photos. That part of Mexico is still very rural. It has barely entered the 20th century.*

EMIGDIO VASQUEZ

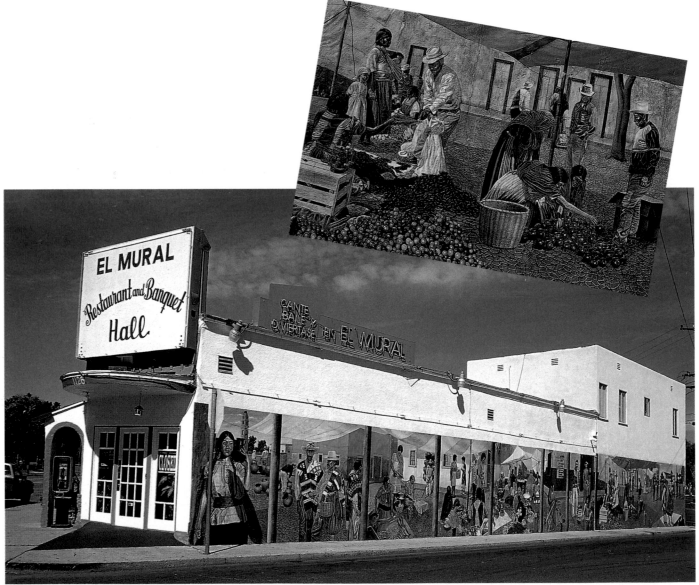

Un Dia en el Mercado (A Day in the Marketplace), 1983, by Emigdio Vasquez, El Mural Restaurant and Banquet Hall, 1126 North Anaheim Boulevard (repainted in 1993).

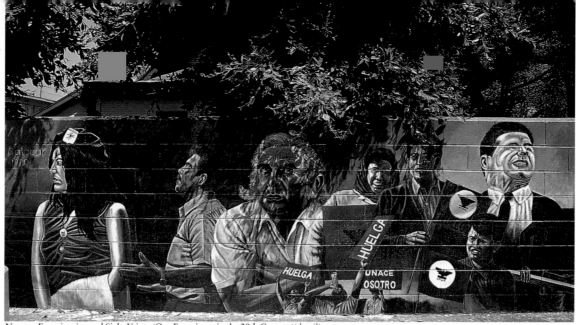

Nuestra Experiencia en el Siglo Veinte (Our Experience in the 20th Century)(detail)

This mural shows a panorama of Chicano history, organized in decades. The first historical event depicted is a coal strike in Northern Mexico that some believe was a prelude to the Mexican Revolution of 1910. The labor movement is especially well represented through images of leading organizers (such as Bert Corona), key regional strikes and worker portraits.

Nuestra Experiencia en el Siglo Veinte (Our Experience in the 20th Century)(detail), 1980, by Emigdio Vasquez, Salvation Army, 201 East Cypress Street (repainted in 1996).

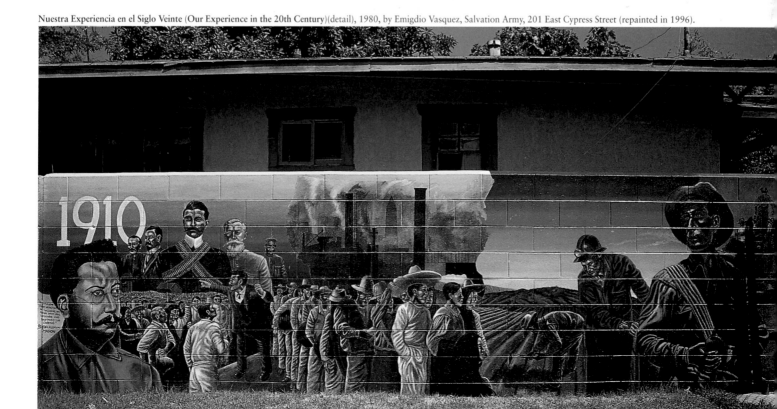

This mural shows the social, political and economic forces that shaped the Chicano experience, starting with the Mexican Revolution. It includes the Latin-American experience–the United States propping up fascist, military regimes in El Salvador and elsewhere in Central and South America. 'Tierra y Libertad' was the battle cry of the revolutionary campesino forces led by Emiliano Zapata in southern Mexico. As the most militant advocate of agrarian reform, Zapata enunciated his demands through his Plan de Ayala that called for the overthrow of the repressive latifundio system and the redistribution of the land to the landless peasantry.

EMIGDIO VASQUEZ

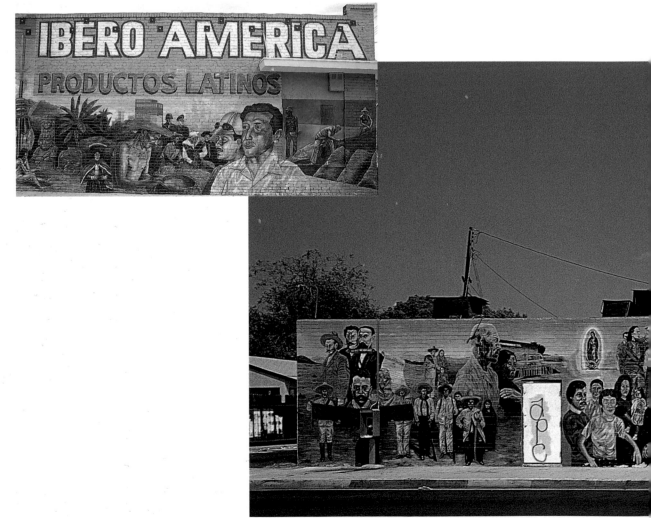

Memories of the Past, Images of the Present, 1978, by Emigdio Vasquez,
Ibero-American Market, 327 South Lemon Street.

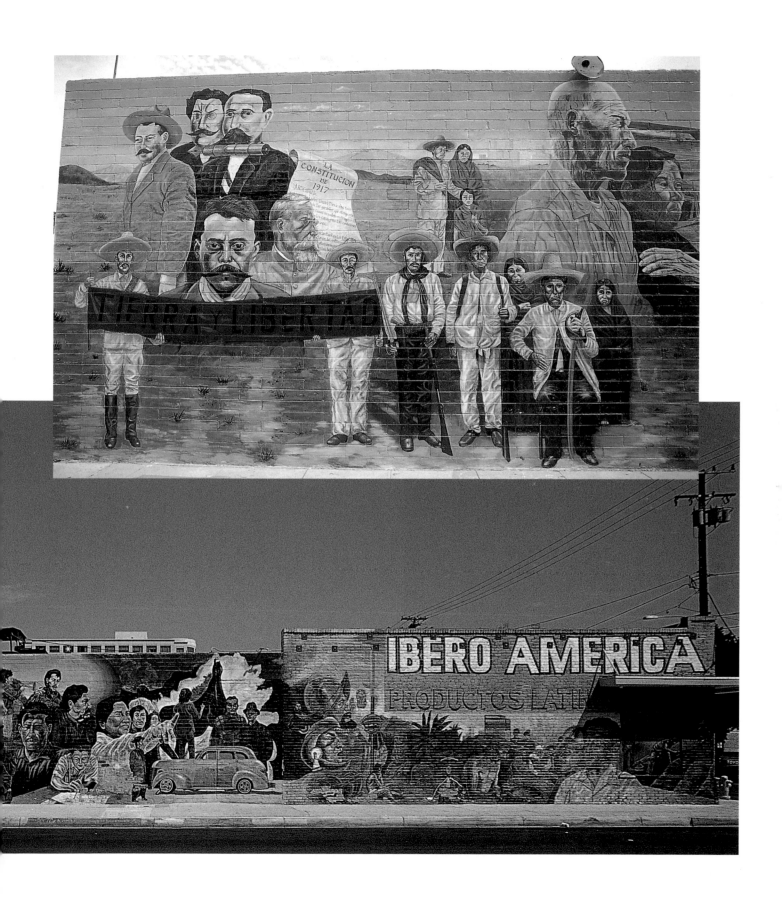

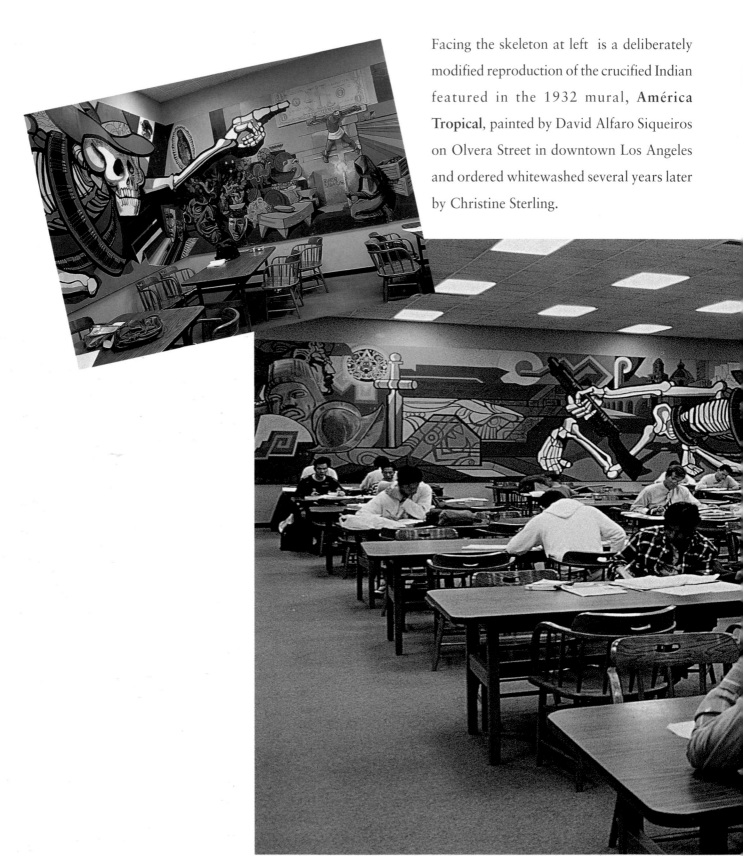

Facing the skeleton at left is a deliberately modified reproduction of the crucified Indian featured in the 1932 mural, **América Tropical**, painted by David Alfaro Siqueiros on Olvera Street in downtown Los Angeles and ordered whitewashed several years later by Christine Sterling.

History and Evolution of the Chicano in the United States, 1974, Sergio O'Cadiz, project director, assisted by Doris Barker, Emigdio Vasquez and Jennifer Winn, plus a team of 33 student members of the campus MEChA Club, Santa Ana College (Nealley Library), 1530 West 17th Street.

The inspiration for this project, coordinated by art historian Shifra M. Goldman, came from a student field trip to see the murals of East Los Angeles, and a showing of the Jesus Salvador Treviño film, '*América Tropical.*' The history of Mexico is traced on the left side, while to the right are images of the Chicano experience in the United States. The two sides are joined by a large animated skeleton (calavera) wearing the military garb of the 1910 Mexican Revolution and a pachuco hat. The mural was originally painted outdoors on 20 eight-foot by four-foot plywood panels attached to a construction fence.

Endangered Species, 1996, by Peter Stewart, The Emerald Forest Restaurant Bar & Grill, 309 North Palm Street, Balboa Peninsula, Newport Beach. Photo courtesy of the artist.

Power to the People (destroyed), 1995, by Nasa, Huntington Beach.

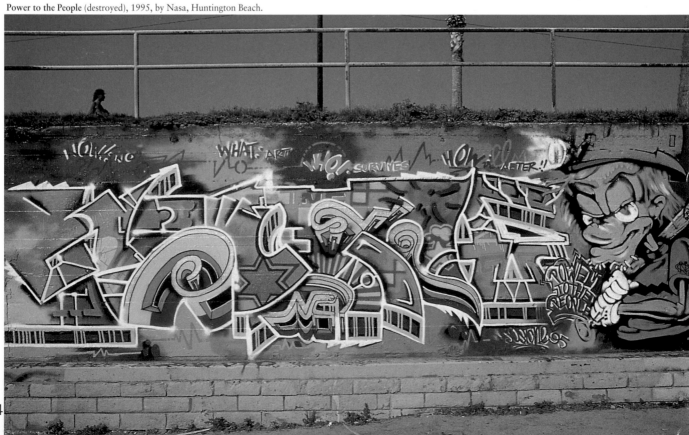

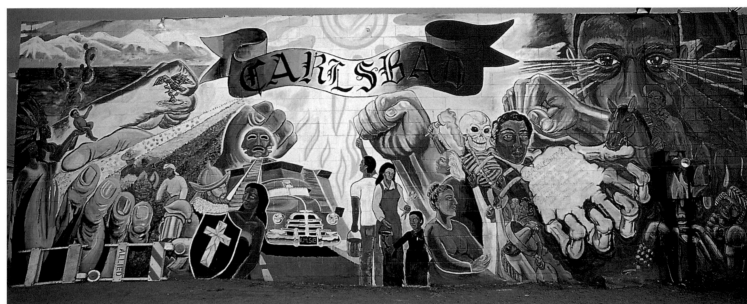

Raza Unida, c.1982, by Victor Ochoa with youth, Oak and Roosevelt Circle.

W*e have something like 45 barrios in the county of San Diego. To me El Centro Cultural de la Raza (in San Diego's Balboa Park, where Victor Ochoa has been artist in residence for many years) is a base of operations. One of my efforts has been to go out to these extreme areas from the border to the northern-most part of the county and do things. The last time I counted, I'd done over 100 murals and at least 75 of them have been in outlying areas.*

Carlsbad is in North County, 35 miles from downtown San Diego. I was invited by La Raza Unida, which was a neighborhood social club of young adults. They wanted to do a mural, and in fact had most of the concept pretty together. So I began doing workshops with them at a church hall. I taught basic drawing and color theory.

<div align="right">

VICTOR OCHOA

</div>

The Logan Heights neighborhood was always real central to San Diego. It was flourishing, gaining a lot of strength locally. We had markets, doctors' offices and movie houses–all the stuff that made a community. The white power structure felt bothered by Logan Heights because it was gaining political strength and responsibility as a community, so they put a lot of effort into trying to destroy that. They designed Interstate 5 (mid-1960s) to split the residential area from the commercial area, cutting it off. It was a death blow to the community. Six thousand families had to move.

They started to tear stuff down for the Coronado Bridge in 1967 or 68. Another 500 families were taken out of the area. We went to meetings, saying we'd like to restore the community. We heard a lot of promises–they were planning to do a park, but nothing really happened. When the Highway Patrol decided to build their patrol station and parking lot there, that's when people just blew up and finally took over the land. We started on our own to plant flowers and maguey plants. People brought nopales and trees and tools. That was April 22, 1970.

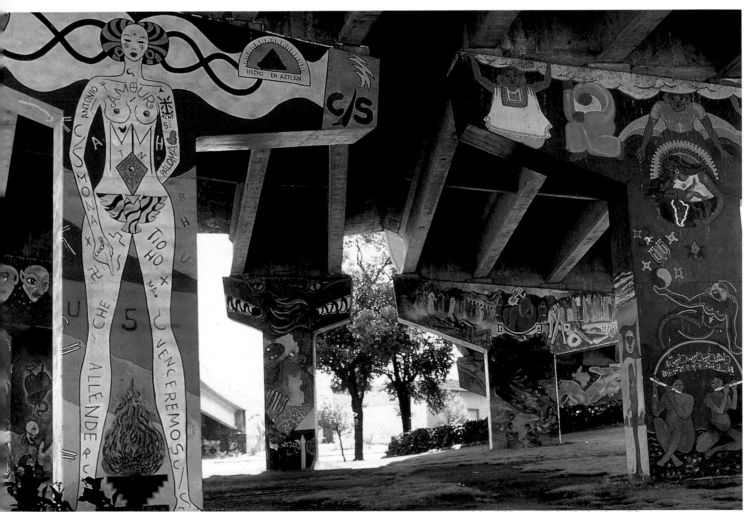

From left to right: **Mujer Cosmica (Cosmic Woman)**, 1975, by Esteban Villa; **Educacion y los Niños (Education and the Children)**, 1975, by Charles 'Gato' Felix; **Resurrection**, 1975, by Guillermo Aranda and Felipé Adame.

We knew that we wanted to paint murals down there, so we did some research. The Department of Transportation (now CalTrans) put us through a lot of red tape. We didn't actually start painting anything in Chicano Park until March 1973. We've been painting murals since then on different Chicano issues, such as the farmworkers, our indigenous art history, bilingual education, immigration, police brutality, the downfall of Allende in Chile, role models of history, boycotts of Coors, Gallo and lettuce, and things going on in Latin America that we feel close to. Cuba influenced us quite a bit.

In 1975 we became aware that mural painting was going on in other areas as well. It was like a nuclear reaction was going on throughout Aztlán. We got messages that there were muralists in New Mexico, Texas, Northern California, Chicago–all over the place. We started getting in touch with these people and having concilios. Right away we began inviting people. In '75 we prepared five pillars just for invitational projects–groups from Santa Ana and Albuquerque, artists from Estrada Courts in L.A. (including Charles Felix) and Royal Chicano Air Force women from Sacramento.

It was toward the end of 1995 that we began hearing rumors that the so-called (earthquake) retrofit was going to go on for the bridge. It really upset me because all these little negotiations were going on, but most of the artists weren't informed.

We finally put a stop to it. The Chicano Park Artist Task Force re-formed and began working with the Chicano Park Steering Committee (formed in 1970). We held several meetings with up to 300 people at one time. It started a lot of excitement, energy. It's interesting that when something like that comes up, people really come out of the woodwork to back it up. There were youth and old people, all kinds of people who said, 'We're going to tie ourselves to the pillars. We're not going to let you mess with our murals.' To me it re-awoke that the community is still alive and kicking. I think we did throw CalTrans a blow. We've gotten them to bring out many more options than just encasing the pillars with concrete.

VICTOR OCHOA

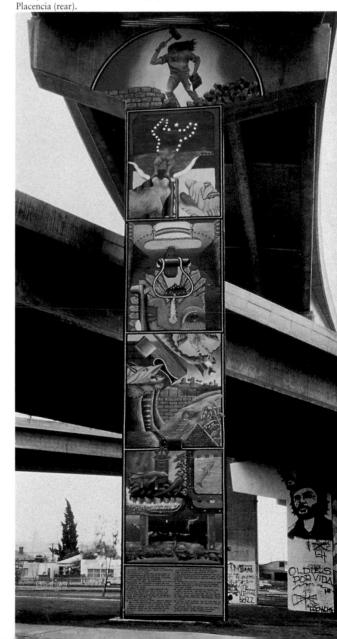

Breaking the Wall, 1981, by Michael Schnorr and the Tijuana Artists Group (front). **Che Guevara**, 1978, by Victor Ochoa and Octavio Placencia (rear).

Laura Rodriguez (1909-1994) was the grandmother of Chicano Park, because, when we took it over in 1970, she was there in front leading the takeover. I think she was a housewife, maybe a widow. She knew that we were going to be safe because the Elders were with us students and community people. After we took over the park, she would bring us food, tamales. She went on to found the Chicano Free Clinic. I did a poster of her first for the 25th anniversary of Chicano Park (in April 1995). And from the poster, we made the mural as a community–all the organizations.

MARIO TORERO

Laura Rodriguez, 1995, designed and painted by Mario Torero and Carmen Kalo, Chicano Park, Crosby Street.

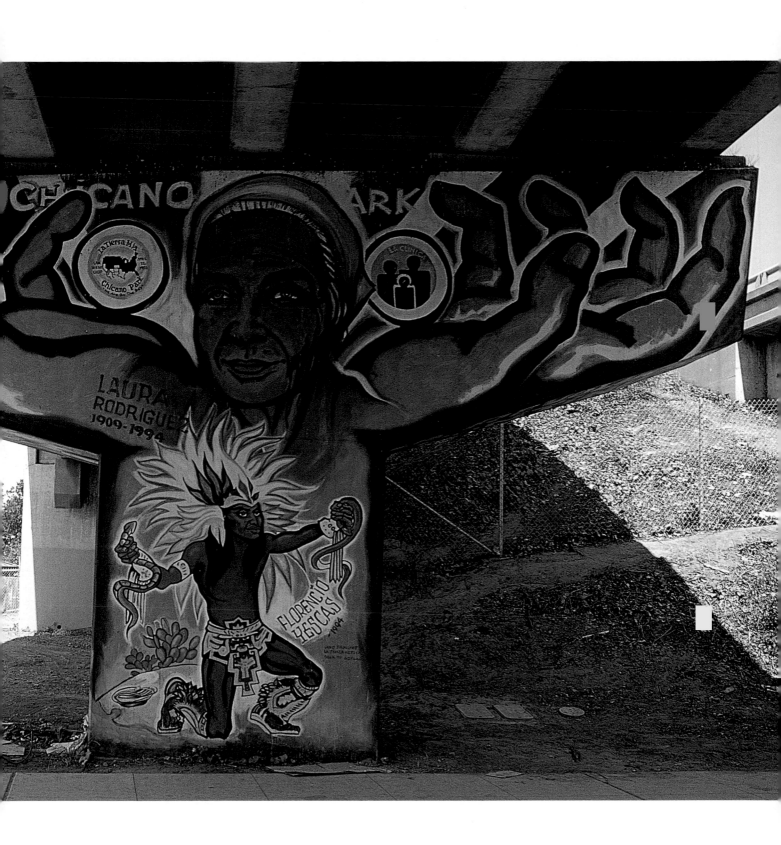

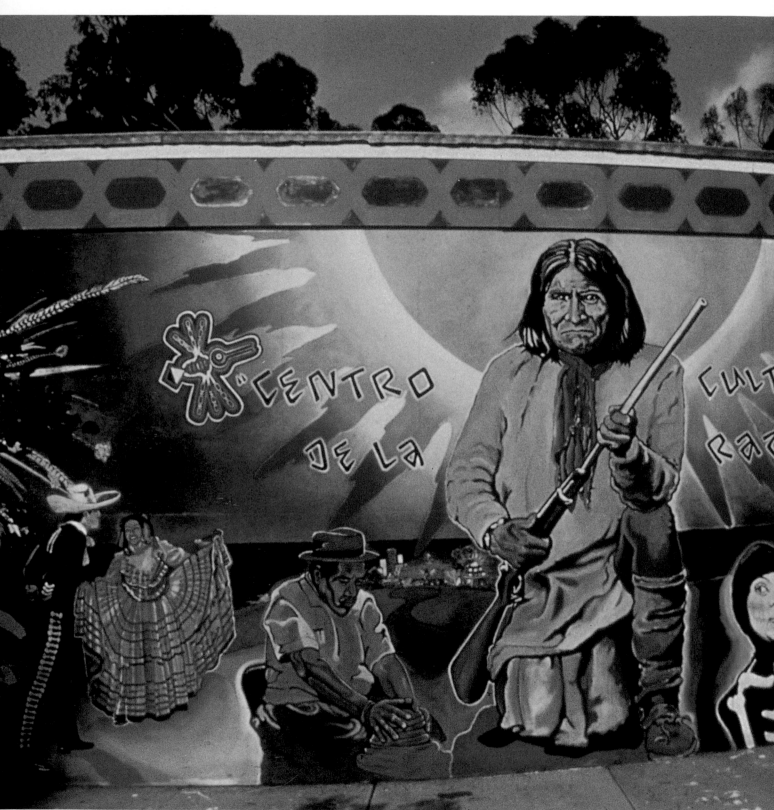

Geronimo, 1980-81, by Victor Ochoa, El Centro Cultural de la Raza, Balboa Park.

The original mural there by Ernesto Paul showed a large skeleton holding a hypodermic needle with a United States flag on it. It was painted in the early 1970s. When I came back from seven months in Europe (in 1980), to my astonishment the director had submitted to protests and whitewashed the whole thing out.

El Centro's Board of Directors wanted something else on there, so they were asking for submissions. I had been researching Geronimo for about a year. I had noticed that 'people' from John Wayne to the Ninja Turtles shouted 'Geronimo' (as a battle cry) and that made me inquisitive to know more about him. I related to him because he was born close to the border, he spoke Spanish, English and Chiricahua. I found out that the Mexicans persecuted him as well as the U.S. Cavalry. I learned that no military power beat the Chiricahua Apache in a fight, but mainly by burning their villages and killing their women, children and older people. My dad was from Sonora, spoke Papago and was part Yaki-Mayo. There were a lot of similarities–such as the border–with the Apache. So I felt that closeness about it too.

I placed Geronimo in the exact same position as the skeleton that was there before.

The mural also includes a 70-foot section showing the workshops and other activities at the Centro, as well as the different art disciplines that we practice.

VICTOR OCHOA

The Eyes of Picasso #2, c.1991, by Mario Torero, Reincarnation Project, 10th Avenue at J Street.

I painted the original on the Community Arts Building in 1978. It came from an 8' x 4' banner that was given from writer Gertrude Stein (a collector of Picasso's work) to a French writer who brought it to San Diego. I met her at Chicano Park in 1973. She entrusted us with the care of this banner, the spirit of Picasso. The building and the mural were destroyed in 1982. In 1990 or 1991 we were trying to buy a building for a new community arts center, but hadn't yet reached agreement with the bank. Without permission I repainted the mural with the help of a Czech artist, a friend of a friend. A few months later the bank whited it out. We went up and painted it again. It stayed up a year and then the bank painted it out again. When it went up for the third time, the bank couldn't touch it because of the community outcry. Since then the building has been bought and is becoming a community arts center.

MARIO TORERO

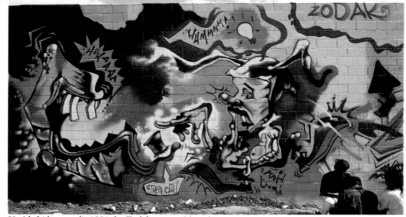

Untitled (destroyed), 1991, by Zodak, competition piece.

I wanted to call attention to the fact that there are orcas off the San Diego coast, so I painted a whole pod of orcas swimming across Point Loma. It's almost a participatory piece, because when swimming in this public pool you feel like you're in the ocean. The Whaling Walls evolved out of the difficulty of painting such a large animal as a whale on canvas. I needed larger canvases, so I started looking at the sides of buildings. After I painted the first wall on my 25th birthday in Laguna Beach in 1981, I decided that I would do 100. So far there are 67 life-size Whaling Walls completed in seven countries. I do them for free to create awareness about whales, clean water and healthy oceans. It's a hobby that got out of control.

WYLAND

Orcas Off Point Loma (Whaling Wall XVI), 1989, by Wyland, The Plunge, Mission Beach.

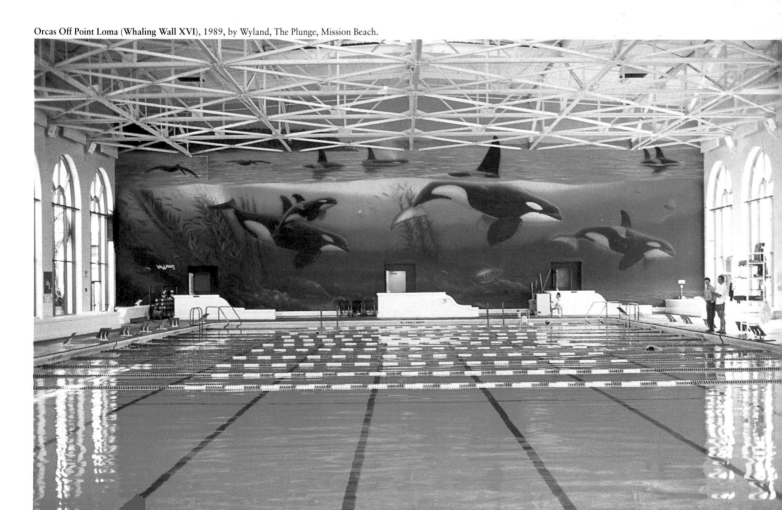

Health Care, 1980, by Michael Schnorr, San Ysidro Health Center, 4004 Beyer Boulevard.

People from the community and the clinic and the board of directors were all involved in creating the subject matter with me. The mural reads from left to right, from the past to the future. One of the interesting dilemmas that we had is that they wanted the presence or the idea of God in the mural. I couldn't assume that all the people coming here would be Christians. So, at the beginning of the mural on the left, there is a large blue figure giving light out of the end of his finger. This figure is modeled in a way after Michelangelo's figure of the 'Creation of Adam' in the Sistine Chapel. Out of the end of the figure comes creation, which is the children.

At the other end of the mural a mother is playing with a child, and the child looks a little strange. The landscape is slightly dangerous. The idea is that the children are our future and there is a danger and risk involved with their future that we should be aware of. So, the mural begins and ends with the children.

MICHAEL SCHNORR

MURAL RESOURCE GROUPS

Lassen County Arts Commission
Post Office Box 91
Susanville, CA 96130
(916) 257-5222

Precita Eyes Mural Arts Center
348 Precita Avenue
San Francisco, CA 94110
(415) 285-2287

Mural Resource Center
South of Market Cultural Center
934 Brannen Street
San Francisco, CA 94103
(415) 552-2131

The Luggage Store/509 Gallery
1007 Market Street
San Francisco, CA 94103
(415) 255-5971

Public Art Program
City of Oakland
Division of Cultural Arts
505 14th Street, Suite 715
Oakland, CA 94612
(510) 238-2103

Sacramento Metropolitan Arts Commission
800 Tenth Street, Suite 1
Sacramento, CA 95814
(916) 264-5558

Cayucos Mural Society
97 Tenth Street #3
Cayucos, CA 93430
(805) 995-3539

Lompoc Mural Society
Chamber of Commerce
111 South I Street
Lompoc, CA 93436
(805) 736-4567

Let a Thousand Parks Bloom (detail), 1997, by Edythe Boone
and homeless women, Haste Street and Telegraph Avenue, Berkeley.

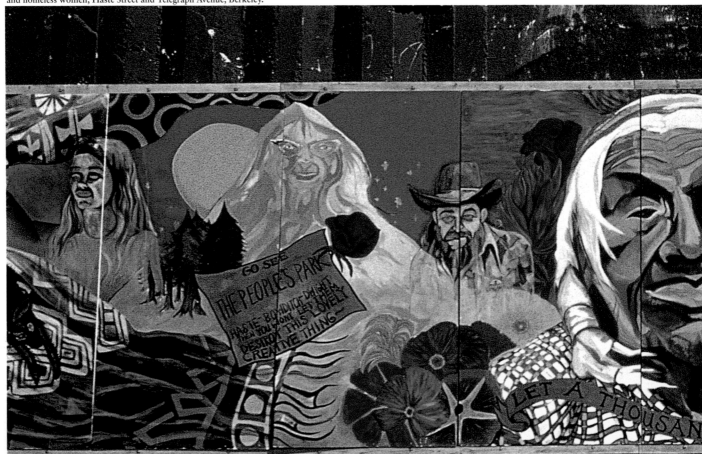

Santa Barbara County Arts Commission
Post Office Box 2369
Santa Barbara, CA 93120
(805) 568-3430

Social and Public Art Resource Center
685 Venice Boulevard
Venice, CA 90291
(310) 822-9560

Mural Conservancy of Los Angeles
Post Office Box 86244
Los Angeles, CA 90086
(213) 481-1186

Cultural Affairs Department
City of Los Angeles
433 South Spring Street, 10th floor
Los Angeles, CA 90013
(213) 485-9548

Mural and Cultural Arts Program
City of Long Beach
Department of Parks, Recreation and Marine
3500 East Anaheim Street
Long Beach, CA 90804
(562) 570-3100 extension 1786

Public Corporation for the Arts
100 West Broadway, Suite 360
Long Beach, CA 90802
(562) 983-3820

The Action Council for Twentynine Palms
73491 Twentynine Palms Highway
Twentynine Palms, CA 92277
(619) 361-2286

Centro Cultural de la Raza
2130-1 Pan American Plaza #1
San Diego, CA 92101
(619) 235-6135

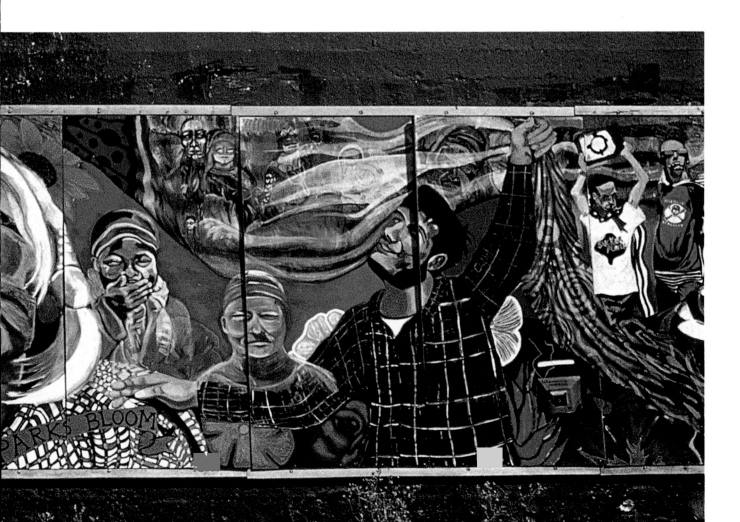

BOOKS

Barnett, Alan W., **Community Murals: The People's Art.** The Art Alliance Press, Inc., Philadelphia, 1984, 505pp.

Barthelmeh, Volker, **Street Murals.** Alfred A. Knopf, New York, 1982. (English-language edition of book first published in German.)

Castleman, Craig, **Getting Up: Subway Graffiti in New York.** MIT Press, Cambridge, Massachusetts, 1982, 192pp.

Chalfant, Henry and James Prigoff, **Spraycan Art.** Thames and Hudson Inc., New York, 1987, 96pp.

Charlot, Jean, **The Mexican Mural Renaissance 1920-1925.** Yale University Press, New Haven, 1963, 368pp.

Cockcroft, Eva, John Pitman Weber and James Cockcroft, **Toward a People's Art: The Contemporary Mural Movement.** E.P. Dutton & Co., Inc., New York, 1977, 286pp. (New edition due out from University of New Mexico Press.)

Cockcroft, Eva and Holly Barnet-Sanchez, editors, **Signs From the Heart: California Chicano Murals.** Social and Public Art Resource Center, Venice, California, 1990, 105pp.

Community Redevelopment Agency, City of Los Angeles, **Public Art in Downtown Los Angeles.** 1986, 114pp. (A pocket guide with maps.)

Dixon, John, **The Art and Life of Maynard Dixon.** Peregrine-Smith.

Doss, Erika, **Spirit Poles and Flying Pigs: Public Art and Cultural Democracy in American Communities.** Smithsonian Institution Press, Washington, D.C., 1995, 274pp.

Drescher, Tim, **San Francisco Murals: Community Creates its Muse.** Pogo Press, St. Paul, Minnesota, 1994, 128pp.

Dunitz, Robin J., **Street Gallery: Guide to 1000 Los Angeles Murals.** RJD Enterprises, Los Angeles, 1993, 467pp.

Elliott, Marco, **Le Pied du Mur.** Le Temps Apprivoisé, Paris, France, 1990, 93pp. (Murals done with youth in France and California. The author teaches art at Venice High School.)

Environmental Communications, **Big Art, Megamurals & Supergraphics.** Running Press, Philadelphia, 1977, 84pp.

Foner, Philip S. and Reinhard Schultz, **The Other America: Art and the Labor Movement in the United States.** Journeyman Press, West Nyack, New York, 1985, 176pp.

Gebhard, David and Robert Winter, **Architecture in Los Angeles a Compleat Guide.** Peregrine Smith Books, Salt Lake City, 1985, 526pp.

Gebhard, David and Harriette Von Breton, **Los Angeles in the Thirties: 1931-1941.** Hennessey and Ingalls, Inc., Los Angeles, 1989, 185pp.

Goldberger, P., **Richard Haas: An Architecture of Illusion.** Rizzoli, New York, 1981, 160pp.

Goldman, Shifra, **Dimensions of the Americas: Art and Social Change in Latin America and the United States.** University of Chicago Press, Chicago, 1994, 494pp.

Goldman, Shifra and Tomas Ybarra-Frausto, **Arte Chicano: A Comprehensive Annotated Bibliography of Chicano Art, 1965-1981.** Chicano Studies Library Publications Unit, University of California, Berkeley, 1985.

Hager, Steven, **Hip Hop: The Illustrated History of Rap Music, Breakdancing and Graffiti.** St.Martin's Press, New York, 1985.

Hurlburt, Laurance P., **The Mexican Muralists in the United States.** University of New Mexico Press, Albuquerque, 1989, 320pp. (Focuses primarily on Diego Rivera, David Alfaro Siqueiros and José Clemente Orozco.)

Jewett, Masha Zakheim, **Coit Tower San Francisco, Its History and Art.** Volcano Press, San Francisco, 1983, 134pp.

Koppany, Bob, **The Murals of Griffith Observatory.** Griffith Observatory, Los Angeles, 1979.

Kunzle, David, **The Murals of Revolutionary Nicaragua 1979-1992.** University of California Press, Berkeley, 1995, 203pp.

Kuzdas, Heinz J. and Michael Nungesser, **Mural Art: Berlin, Los Angeles, México, D.F.** Schwarzkopf & Schwarzkopf, Germany, 1995, 93pp.

Lacy, Suzanne, editor, **Mapping the Terrain: New Genre Public Art.** Bay Press, Seattle, 1995, 291pp.

Levick, Melba, **The Big Picture.** Little, Brown and Company, Boston, 1988, 128pp.

Lewis, Samella, **Art: African American.** Hancraft Studios, Los Angeles, 1990, 298pp. (Sections on mural art, the legacy of the WPA and street art.)

Lippard, Lucy R., **Mixed Blessings: New Art in a Multicultural America.** Pantheon Books, New York, 1990, 270pp.

Little, Nina Fletcher, **American Wall Painting, 1700-1850.** E.P. Dutton, New York, 1989, 162pp. (Originally published in 1952.)

Lovoos, Janice and Edmund Penney, **Millard Sheets: One Man Renaissance.** Northland Press, Flagstaff, Arizona, 1983.

Magnin, Rabbi Edgar F., **The Warner Murals in the Wilshire Boulevard Temple.** Wilshire Boulevard Temple, Los Angeles, 1974.

Marling, Karal Ann, **Wall-to-Wall America: A Cultural History of Post-Office Murals in the Great Depression.** University of Minnesota Press, Minneapolis, 1982, 336pp.

Merken, Betty and Stefan Merken, **Wall Art, Megamurals & Supergraphics.** Running Press, Philadelphia, 1987, 126pp.

Monhoff, Hildegarde Flanner, **The Unknown Paintings of Kay Nielsen**. Bantam Books, New York, 1977.

Moore, Patricia Anne, **The Casino Avalon**. Catalina Island Museum Society, Inc., Avalon, California, 1979, 90pp.

Moore, Sylvia, editor, **Yesterday and Tomorrow: California Women Artists**. Midmarch Arts Press, New York, 1989, 372pp. (Includes sections on women of the WPA art projects and women's community murals.)

Mueller, Mary Korstad, **Murals: Creating an Environment**. Davis Publications, Inc., Worcester, Massachusetts, 1979, 88pp.

O'Connor, Francis V., **Art for the Millions**. New York Graphic Society Ltd., New York, 1973. (Essays from the 1930s by artists and administrators of the WPA Federal Art Project.)

Park, Marlene and Gerald E. Markowitz, **Democratic Vistas: Post Offices and Public Art in the New Deal**. Temple University Press, Philadelphia, 1984, 247pp.

Rivera, Diego (with Gladys March), **My Art, My Life: An Autobiography**. Dover Publications, New York, 1991, 197pp. (Originally published in 1960 by The Citadel Press.)

Rochfort, Desmond, **Mexican Muralists: Orozco, Rivera, Siqueiros**. Universe, New York, 1993.

Rolston, Bill, **Politics and Painting: Murals of Northern Ireland**. Associated University Presses, Cranbury, New Jersey, 1991, 140 pp.

Rolston, Bill, **Drawing Support** and **Drawing Support 2**. Beyond the Pale Publications, Belfast, Northern Ireland, 1992 and 1995, 60 pp each.

Seligman, Patricia, **Painting Murals: Images, Ideas and Techniques**. North Light Books, Cincinnati, Ohio, 1988. (How-to book on painting interior murals.)

Several, Michael, **El Pueblo de Los Angeles Historic Monument: Public Art of Los Angeles, Part 1**.

Several, Michael, **Little Tokyo: The Public Art of Los Angeles, Part 2**. 1994, 48pp.

Small, George Raphael, **Ramos Martinez: His Life and Art**. F & J Publishing Corp., Westlake Village, California, 1975.

Stein, Philip, **The Mexican Murals**. Editor, S.A., Mexico City, 1984, 54pp.

Stern, Jean, **Alson Skinner Clark**. Petersen Publishing Company, 1983.

Taracena, Berta, **Diego Rivera: Su Obra Mural en la Ciudad de Mexico**. Galeria de Arte Misrachi, Mexico City, 1981. (Text in Spanish and English.)

Vautier, Mireille and Aline De Nanze, **Die Sweite Dimension. Wandmalereien in Los Angeles**. Harenberg Kommunikation, Dortmund, Germany, 1984.

Von Blum, Paul, **Other Visions, Other Voices: Women Political Artists in Greater Los Angeles**. University Press of America, Lanham, Maryland, 1994, 189pp.

Walsh, Michael, **Graffito**. North Atlantic Books, Berkeley, California, 1996, 136pp.

Weber, Monseignor Francis J., **Leo the Great: A Biographical Study of Leo Politi**. Archival Center, Mission Hills, California, 1989.

EXHIBITION CATALOGS

Anderson, Susan M., **Regionalism: The California View, Watercolors 1929-1945**. Santa Barbara Museum of Art, Santa Barbara, California, June 25-August 14, 1988.

Griswold de Castillo, Richard, Teresa McKenna and Yvonne Yarbro Bejarano, editors, **Chicano Art: Resistance and Affirmation**. Wight Art Gallery, University of California, Los Angeles, September 9-December 9, 1990.

Hinkey, Douglas M., **Federal Art in Long Beach: A Heritage Rediscovered**. FHP Hippodrome Gallery, Long Beach, California, September-December, 1991.

Karistrom, Paul J. and Susan Ehrlich, **Turning the Tide: Early Los Angeles Modernists 1920-1956**. Santa Barbara Museum of Art, Santa Barbara, California, 1990.

Mecklenburg, Virginia, **The Public as Patron: A History of the Treasury Department Mural Program Illustrated with Paintings from the Collection of the University of Maryland Art Gallery**. University of Maryland Art Gallery, College Park, Maryland, 1979.

Robinson, Jontyle Theresa, curator, **Bearing Witness: Contemporary Works by African American Women Artists**. Spelman College and Rizzoli International Publications, Inc., New York, 1996.

Vitale, Lydia Modi and Stephen M. Gelber, **New Deal Art: California**. De Saisset Art Gallery and Museum, University of Santa Clara, Santa Clara, California, 1976.

Alfredo Ramos Martinez. Louis Stern Galleries, Beverly Hills, California, October 1, 1991-January 6, 1992.

Le Demon des Anges: 16 Artistes Chicanos. Centre de Recherche pour le Developpement Culturel, Nantes, France, May-July, 1989.

Painting : Mural Art in the New Deal Era. Midtown Galleries, New York, March 2-April 8, 1988.

A Time and Place from the Ries Collection of California Painting. Oakland Museum, Oakland, California, 1990.

Vapor Dreams in L.A., Terry Schoonhoven's Empty Stage. University Art Museum, California State University, Long Beach, November 15-December 12, 1982.

UNPUBLISHED WORKS

Acord, Nancy Odessky, **WPA Women Muralists in California, 1933-1943**. M.A. Thesis, California State University, Northridge, 1989.

Garcia, Rupert, **La Raza Murals of California.** M.A. Thesis, University of California, Berkeley, 1981.

Kunkel, Gladys M., **The Mural Paintings by Anton Refregier in the Rincon Annex of the San Francisco Post Office, San Francisco, California.** M.A. Thesis, Arizona State University, 1969, 195pp.

Rubalcava, Roberto, **Graffiti Art.** Art History class paper, UCLA, Winter 1990, 10 pp.

Rubalcava, Roberto, **hIp HoPerspective.** Afro-American Studies paper, UCLA, Spring 1991, 14pp.

Stein, Pauline Alpert, **A Vision of El Dorado: The Southern California New Deal Art Programs.** PhD. Dissertation, University of California, Los Angeles, 1984.

Steinberg, Carol, **Hugo Ballin.** M.A. Thesis, California State University, Los Angeles, 1993.

Wyman, Marilyn, **A New Deal For Art In Southern California: Murals and Sculpture Under Government Patronage.** PhD. Dissertation, University of Southern California, 1982, 2 volumes, 564pp.

NEWSLETTERS, MAGAZINES AND PAMPHLETS

Cayucos Mural Society Newsletter, published in March and November by the Cayucos Mural Society, 97 Tenth Street #3, Cayucos, California 93430. (805) 995-3539. The group has also put out a pamphlet on **The Murals of the Central Coast.**

Community Murals Magazine, published 1981-1987, Berkeley, California. Back issues available in some libraries.

Los Angeles Conservancy News, newsletter of the Los Angeles Conservancy, a nonprofit organization dedicated to the recognition, preservation and revitalization of cultural and historic resources in the Los Angeles area. Leads weekly walking tours of historic downtown buildings. 727 West 7th Street, Suite 955, Los Angeles, California 90017 (213) 623-CITY.

Mural Conservancy of Los Angeles Newsletter, published quarterly. MCLA leads mural tours, does maintenance on a select number of murals each year, and provides information and other services. P.O. Box 86244; Los Angeles, California 90086-0244 (213) 481-1186.

Religious Architecture In Los Angeles. Los Angeles Conservancy, 1988.

SPECIAL COLLECTIONS

Archives of the Golden State Mutual Life Insurance Company, Special Collections, UCLA. Contains material surrounding the creation of the company's two murals, including correspondence with the artists, minutes of meetings, published articles and photographs. UCLA Special Collections is located on the lower level of the Undergraduate Research Library. (310) 825-4988.

Berkeley Public Library Art and Music Section, 2090 Kittredge Street, Berkeley, California 94704 (510) 649-3930. Art clippings files.

Mural Resource Center, Social and Public Art Resource Center, 685 Venice Boulevard, Venice, California 90291 (310) 822-9560. Large repository of information on the community mural movement. Books, videos, pamphlets, magazine articles, documentation from the Citywide Mural Project, and thousands of slides of California and United States murals as well as spraycan art.

San Francisco Public Library Art Department, Art Clippings files.

Smithsonian Archives of American Art, Huntington Library, 1150 Oxford Road, San Marino, California 91108 (818) 405-7847. Large collection of materials on all aspects of the New Deal art projects. What isn't on hand locally often can be ordered from Washington, D.C. Researchers need to call ahead for an appointment.

Charles White Papers, Smithsonian Archives of American Art, Huntington Library, 1150 Oxford Road, San Marino, California 91108. (818) 405-7847. On microfilm rolls 3189-3195, 3099 and 2041. Letters and printed material.

FILMS/ VIDEOS

Bay Area Graffiti, Justin Kuzmanich, 7575 East Arkansas #9-204, Denver, Colorado 80231 (video, $23, includes shipping).

Bomb!, PO Box, 124811, San Diego, California 92112 (619) 232-3675 (VHS video, $20).

Graffiti Verité, Bryan World Productions, 125 South Wilton Place, Los Angeles, California 90007 (video, $21).

Rivera, Humberto and Heather Howell, **The Murals of East L.A., A Museum Without Walls.** 16mm film, RKO, 1976, 37 minutes.

Silver, Tony and Henry Chalfant, **Style Wars**, $29.95, available in video stores or from website www.cinenet.net/stylwars/style1.html. Classic film of New York subway art.

Trevino, Jesus (writer and producer), **América Tropical**. Directed by Barry Nye, 1971, 30 minutes. Story of David Alfaro Siqueiros' controversial Olvera Street mural.

Varda, Agnes, **Mur Murs**. Cine Tamaris, Paris, 1980. A full-length documentary produced for French television.

Video Graf, SoHo Down and Under, 300 West Broadway, New York, New York 10013 (212) 343-2557 (video). Covers action on both coasts.

Wild Style, 1983. Produced by Charlie Ahearn. One of the first hip hop movies. The story is about a graffiti writer named Zoro who finds it hard to accept the mainstream art community's sudden commercial interest in aerosol art.

31 video interviews were done by De Saisset Gallery and Museum, University of Santa Clara, Santa Clara, California, in 1975- 1976, in conjunction with the exhibition, New Deal Art: California. Available through the Smithsonian Archives of American Art, Huntington Library.

Other oral and video histories of New Deal muralists are available from the Smithsonian Archives of American Art, Huntington Library, 1150 Oxford Road, San Marino, California 91108 (818) 405-7842.

UCLA Oral History Program. Written transcripts available at the Arts Library, Dickson Hall (310) 825-3817. Los Angeles Art Community Group Portrait interviews.

World Wide Web Sites

Academia de Arte Yepes
 http://www.wdc.net/academia/
 Nonprofit arts academy founded in 1992 by Los Angeles muralist George Yepes. The site showcases murals by the school's students.

Action Council for Twentynine Palms, Inc.:
 http://www.cci-29palms.com/murals.html

Art Crimes: The Writing on the Wall
 http://www.graffiti.org/
 Online graffiti resource center, U.S. and Europe.

Chemainus "The Little Town That Did" (in British Columbia, Canada):
 http://www.ibnd.com/murals.html

Centro Cultural de la Raza (San Diego)
 http://www.solar studio.org

Diego Rivera Web Museum:
 http://www.diegorivera.com/diego_home_eng.html
 Photos of some of Diego Rivera's murals in Mexico. English and Spanish versions.

Dzine (graffiti writer)
 http://www.levi.com/fly-zone/vol1/iss1/dzine/
 Interview, sponsored by Levi-Strauss.

David Gordon
 http://www.dsgordon.com
 Showcases the work of this Northern California muralist (formerly of Los Angeles).

Humboldt County Murals
 http://www.northcoast.com/unlimited/cultural_center/palette/murals.html
 A listing of mural sites in the Eureka area, sponsored by the Humboldt Arts Council.

Latino Link (Stanford University):
 http:/www.latinolink.com (then do keyword search)
 Stories about muralist José Antonio Burciaga, former Stanford professor, who died in 1996.

Los Angeles Freeway Murals
 http://www.ci.la.ca.us/tourist/freeway.htm
 A Los Angeles City Government project with information by Michael Several, author of guides to public art in Downtown L.A.

Los Angeles Murals Home Page.
 http://latino.sscnet.ucla.edu/murals/index1.html
 Sponsored by CLNet and Social Sciences Computing at UCLA, the Social and Public Art Resource
 Center and the Mural Conservancy of Los Angeles.

Mural Conservancy of Los Angeles:
 http://www.artscenecal.com/MCLA.html
 Detailed directory of Los Angeles murals with photos, technical information for muralists and
 a list of mural tours for the year.

Political Wall Murals in Northern Ireland:
 http://www.ulst.ac.uk/services/library/ni/murals/murals.htm (not "html")
 Includes murals from both sides of the conflict.

John Pugh Master of Illusion
 http://www.illusion-art.com/
 Showcases the work of this Los Gatos-based trompe l'oeil muralist.

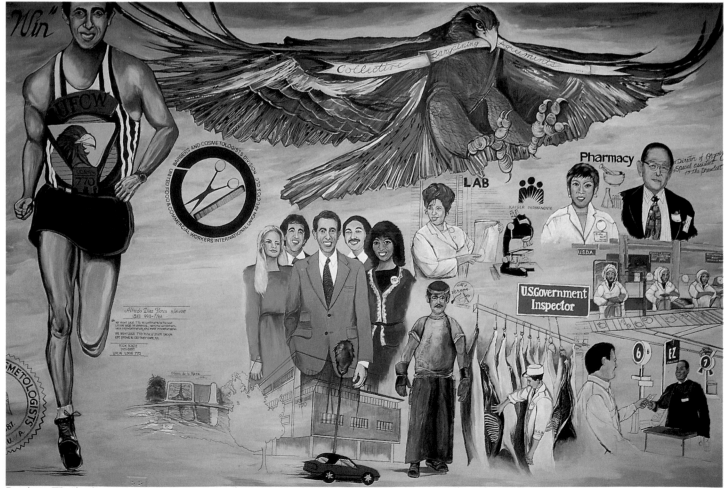

Running to Win (detail), 1997, by Alfredo Diaz Flores, Local 770 United Food and Commercial Workers Union, 630 Shatto Place, Mid-City Los Angeles.

C

D

E

F

I

J

K

L

M

N

O

S

T

U

V

W

Y

Z

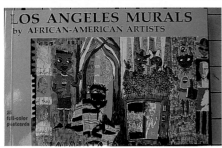